Batsford's
London
THEN AND NOW

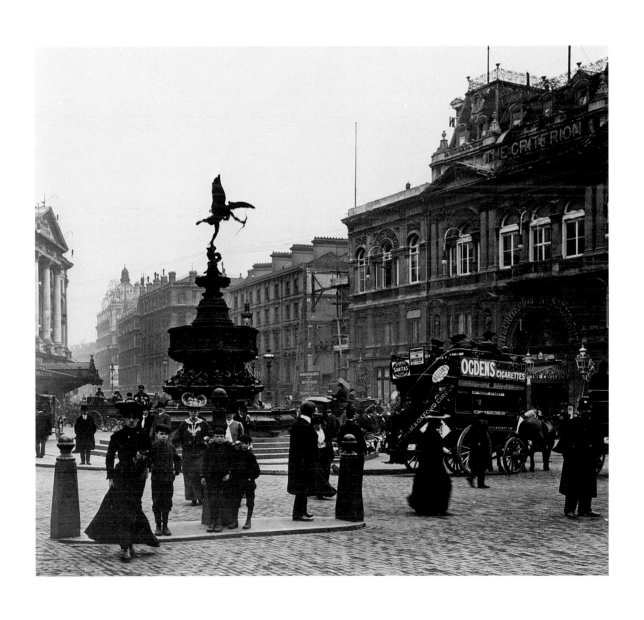

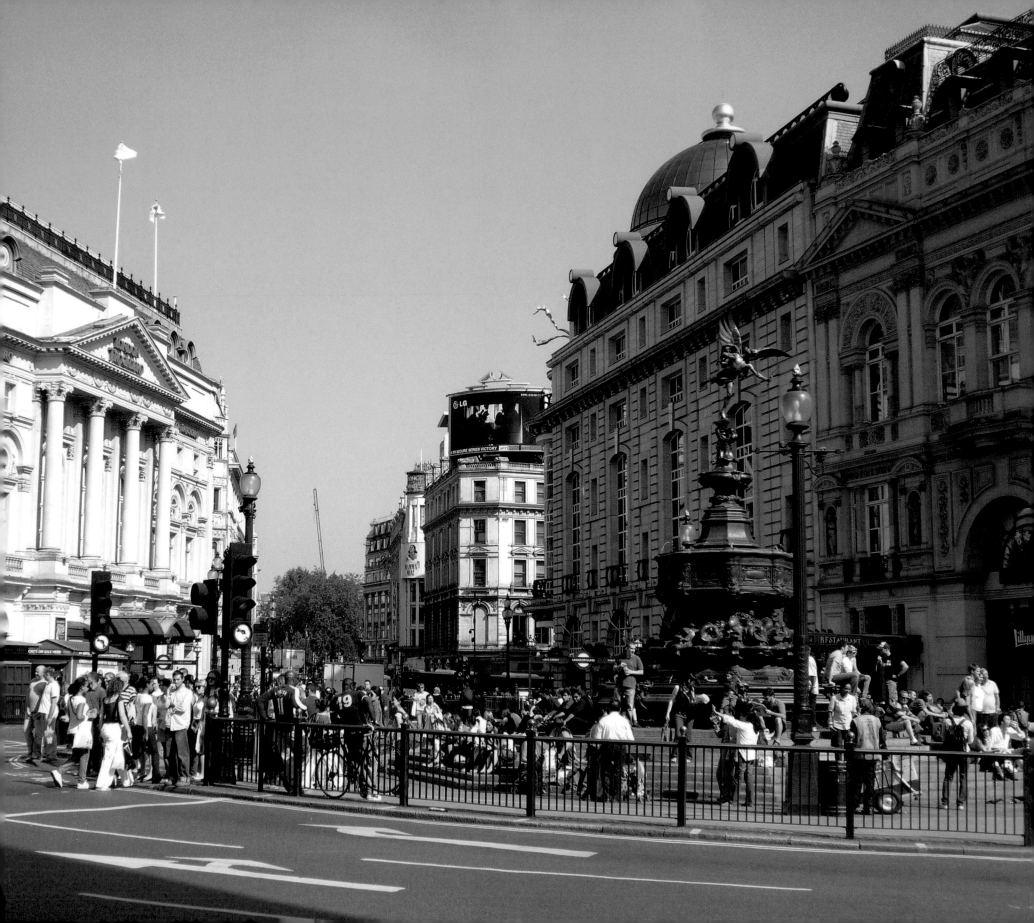

BATSFORD'S
London
THEN AND NOW

Diane Burstein

BATSFORD

First published in the United Kingdom in 2009 by
Batsford
10 Southcombe Street
London
W14 0RA

An imprint of Anova Books Company Ltd

ISBN 978 190 638 838 6

A CIP catalogue record for this book is available from the British Library.

16 15 14 13 12 11 10
10 9 8 7 6 5 4 3

Reproduction by Rival Colour Limited, U.K.
Printed and bound by 1010 Printing International Limited, China

This book can be ordered direct from the publisher at the website: www.anovabooks.com

To my mother, Sylvia Burstein, and to the memory of my father, David Burstein.

Acknowledgments: Thank you to my partner, Gerry Ingram, for his love and support. To all my tutors on the London Blue Badge, City of London, and Clerkenwell/Islington Guiding Courses, particularly Katrine Prince and Pamela Shields, whose enthusiasm for London and its history set me on the road to a new career.

Professional Acknowledgments: To all the staff at the National Monuments Record, London Metropolitan Archive, Museum of London Picture Collection, Southwark Local Studies Library, and Guildhall Library for assistance with picture research.

Book Acknowledgments: *London Encyclopaedia* by Ben Weinreb and Christopher Hibbert, *Theatres of London* by Mander and Mitcheson, *Walks in Old London* by Peter Jackson, *Streets of Holborn* by Steve Denford and David Hellings, *East of Bloomsbury* by David A. Hayes, *The City of London* by Bryan Girling, *London's West End Cinemas* by Allan Eyles and Keith Stone, *Westminster* by Jill Barber, and *Regent's Park* by Anne Saunders.

PHOTO CREDITS

The publisher wishes to thank the following for kindly providing the "then" photographs for this book:

Pages 6, 14, 54, 58, 92, 94, 124, 126, 128, and 140 courtesy of Anova Image Library;
Pages 8, 10, 20, 22, 28, 34, 42, 66, 82, 90, 98, and 102 courtesy of Memories;
Page 12 courtesy of Hulton Archive;
Pages 1, 16, 24, 26, 30, 36, 38, 40, 48, 50, 52, 56, 60, 72, 80, 84, 88, 96, 100, 104, 106, 108, 110, 112, 114, 134, 138, and 142 courtesy of English Heritage/National Monuments Record;
Pages 18, 32, 46, 62, 64, 76, and 136 courtesy of © Museum of London;
Pages 44, 68, 70, 74, 78, 86, 118, 122, 130, and 132 courtesy of London Metropolitan Archives;
Page 116 courtesy of the Company Archive, Harrods Limited, London;
Page 120 courtesy of Corporation of London Libraries and Guildhall Art Gallery.

Thanks to Simon Clay for taking all the "now" photography in this book, with the exception of the following: Anova Image Library (pages 11, 15, 17, 23, 29, 33, 55, 57, 65, 71, 75, 77, 81, 85, 93, 105, 107, 109, 131); Craig Aurness/CORBIS (page 117).

Front and back covers show: St. Paul's from Bankside c. 1900 (photo: English Heritage/National Monuments Record) and today (photo: Simon Clay/Anova Image Library).

Introduction

"Ships, towers, domes, theatres, and temples lie,
Open unto the fields, and to the sky"

This was the view from Westminster Bridge that greeted the poet Wordsworth in 1802. Should he return today, he would find the open fields gone but the splendid chaos of London's towers, domes, and theatres remaining. Unlike many other cities, London's streetscape was not planned. This great city grew in a haphazard way, bursting from the confines of ancient walls as the population increased, embracing new fashions in architecture, while in many places still following a medieval street pattern.

The growth of "Londinium" began in A.D. 43 when invading Romans established a settlement on the River Thames. It became a thriving city boasting a basilica, forum, and amphitheatre, all of which, from A.D. 200, were surrounded by a defensive wall. In A.D. 410 the Romans withdrew from Britain to defend their beleaguered empire and little is known about the immediate post-Roman period. London's chronicled history recommences in the early seventh century with the Saxon settlers. The Saxon period saw the establishment of Christianity in London with the first religious foundations being built on the sites of today's St. Paul's Cathedral and Westminster Abbey. After years of turmoil, including Viking raids, King Alfred the Great (849–899) established peace for a while and the City of London began to take its present shape. In 1052 King Edward the Confessor (c. 1002–1066) moved his court west of the City to Thorney Island and built the Palace of Westminster and Westminster Abbey. This laid the foundation for Central London's two "cities" – the City of London, the seat of commercial power, and the City of Westminster, the great seat of royal and political power.

The year 1066 saw the Norman Conquest and the coronation of King William I (c. 1028–1087), who, to demonstrate his power over the people of London, built the mighty Tower of London. Threat of attack led to the defences of the Tower being augmented later, with two outer walls added in the thirteenth century. The old Roman wall surrounding the City was also strengthened.

Beyond the confines of the City wall, which would stand until 1760, grand palaces and houses lining the Thames began to be built between the City, which had become a bustling commercial centre, and the new court at Westminster. However, most of London was still open countryside. People would hunt in the fields that are now covered by Soho and revel at the May Fair (now Mayfair). In fact, the first residential area to be developed outside the City itself was Covent Garden on the Duke of Bedford's estate. After the Reformation when King Henry VIII requisitioned monastic property, noblemen replaced the church as landowners and made money leasing land to developers. Wealthy people moved out of the overcrowded City to Covent Garden and St. James's.

In 1666 London was devastated by the Great Fire, which destroyed most of the City's buildings. The City looked to mathematician, astronomer, and architect Sir Christopher Wren to rebuild. He had ambitious plans for a more spacious city built along European lines, but the fervour to rebuild as quickly as possible unfortunately resulted in the new City following the old plan. Wren's 51 City churches and the glory of St. Paul's Cathedral were built on existing plots, often hemmed in between other buildings on narrow sites.

As the march of bricks and mortar gained momentum, Londoners continued to move west. The late seventeenth and early eighteenth centuries saw the development of Bloomsbury, Soho, and Mayfair. Until 1750 London had only one bridge, the famous London Bridge, but as the community felt the benefit of improved communications brought by the new Westminster Bridge, others soon followed. An efficient canal system was also installed and the commercial docks were built, changing the face of the hamlets to the east of the City.

By the nineteenth century, London had become a great city, with an extremely wealthy elite who rubbed shoulders with extreme poverty. While former fields in East London were covered with humble dwellings for dock and factory workers, the rich flocked to the new area of Belgravia on the Duke of Westminster's estate. Belgravia's desirability was increased in 1837 when Queen Victoria moved into nearby Buckingham Palace, making it London's major royal residence. The 1851 Great Exhibition, attracting six million visitors, helped finance the building of South Kensington with educational institutions such as Imperial College and museums such as the Natural History Museum.

Victorian London also revolutionized transportation with the 1863 opening of the first underground railway. Improved transportation meant that workers no longer had to live near their workplace and many moved out of Central London to newly created suburbs. As modern London emerged, there were still reminders of past ages – until 1868 it was possible to take the new Underground to Farringdon to watch a public hanging outside nearby Newgate Gaol.

The face of London changed again in the 1940s during the Blitz when the city was badly damaged by German bombs, leading to rebuilding and slum clearance. The city was also improved by the subsequent Clean Air Act, which ended the famous London fogs. Buildings were cleaned and tourists flocked to the "swinging London" of the sixties. London's docks were closed during the 1970s, leading to their redevelopment as a residential and commercial area. Fortunately, town planners of the 1970s and 1980s saw the need for conservation and historic areas were protected.

At the time of this writing, the London skyline is dotted with cranes working on the construction of gleaming new glass towers – temples of commerce to join Wordsworth's temples of worship. A modern-day Wordsworth would abandon Westminster Bridge for a view from the London Eye, the new giant wheel affording breathtaking views of the capital. Written 200 years after Wordsworth's famous poem, *London Then and Now* takes you on a journey through the centre of the city to compare old with new.

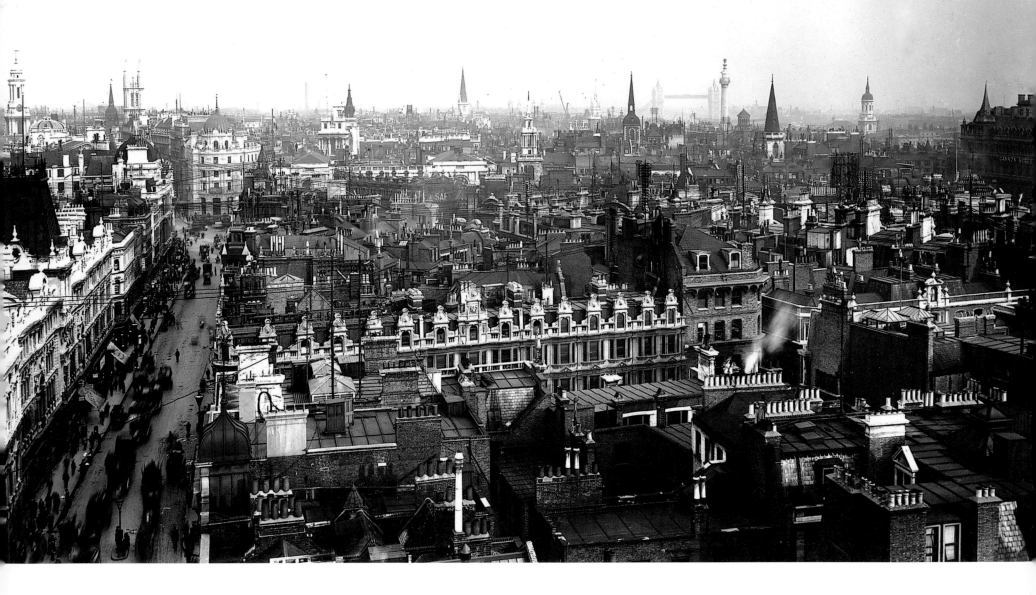

VIEW FROM
ST. MARY LE BOW

The City of London from Cheapside

The first thing to strike the viewer of this photograph is the proliferation of church towers. Most of these churches were rebuilt after the Great Fire of London by Sir Christopher Wren on the sites of medieval churches. The busy street to the left is Cheapside, which was London's main shopping centre until the late nineteenth century when it was superseded by Oxford Street. Its name is derived from the Old English word *ceap*, which means "market".

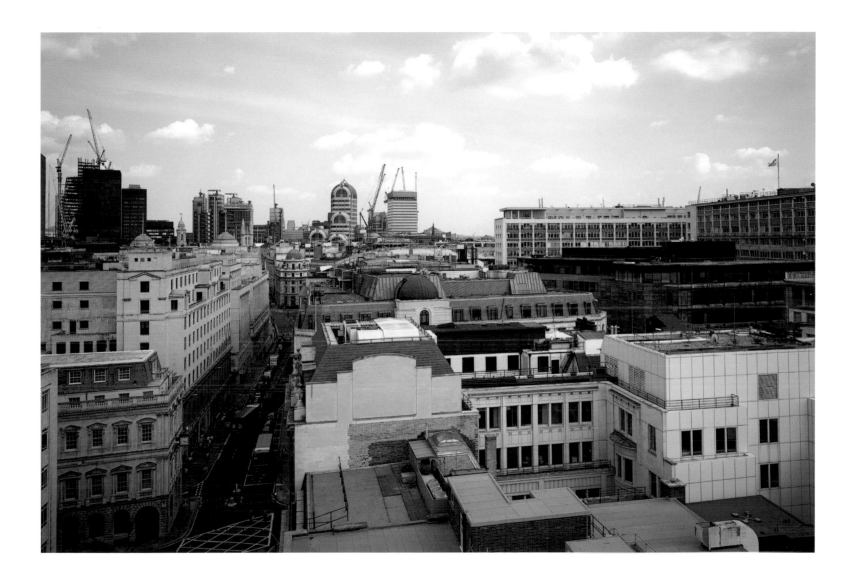

Today the view is very different. Many of the churches remain, reconstructed after bombings during World War II, but are now hidden from view by modern office buildings. The City is London's financial centre with more than 300,000 people flocking in each day to work here. On weekends, however, the streets are deserted, so Cheapside's shops are open on weekdays only.

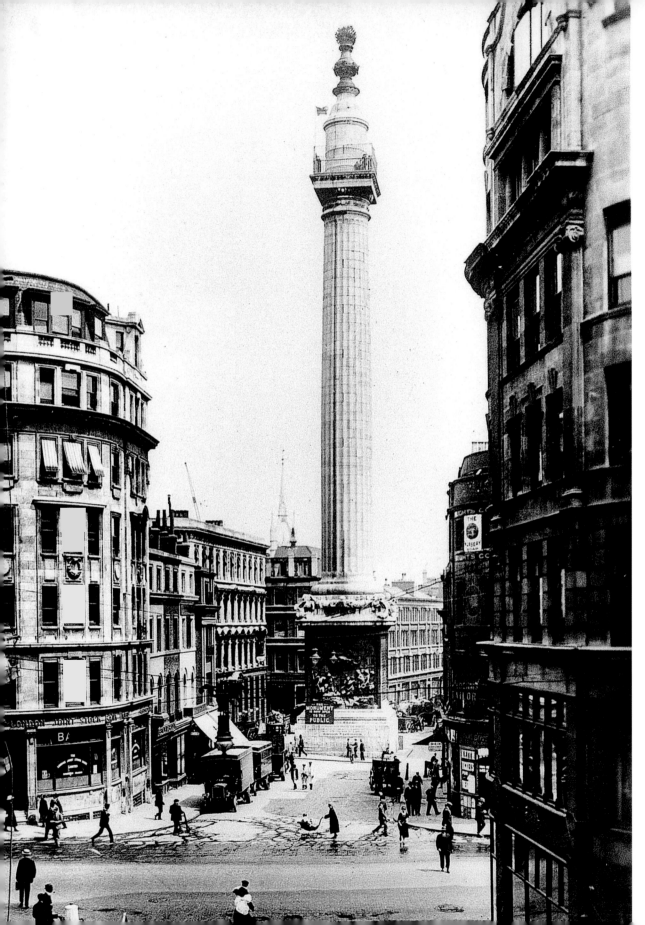

MONUMENT TO THE GREAT FIRE

Designed by Robert Hook and Sir Christopher Wren

The Monument to the Great Fire of London, c. 1920. The Great Fire started on 2 September, 1666, and raged for four days, destroying 80 per cent of the City's buildings but killing only a handful of people. The Monument, designed by Robert Hook and Sir Christopher Wren, commemorated this event. It stands 61.5 metres (202 feet) high and is 61.5 metres away from the starting point of the fire, Thomas Farynor's bakery.

Today the Monument still stands, but flanked by tall buildings, it no longer dominates the skyline. However, for a few pounds, the public can still climb a winding staircase of 311 steps for an aerial view of the City. When writer James Boswell made this climb in 1762, he was very nervous and shuddered each time a wagon passed by, worrying that the vehicle's movement would cause the Monument to tremble. One wonders how he would feel about today's heavy traffic.

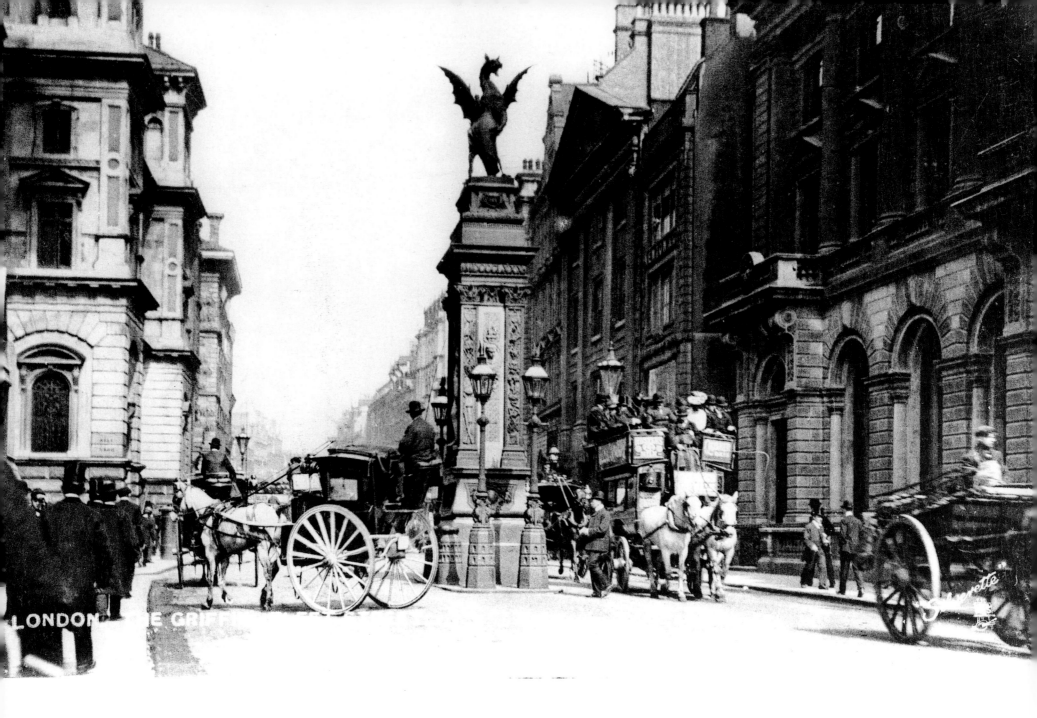

FLEET STREET

Temple Bar, the entrance to the City

Whenever visitors enter the City of London, they are greeted by a heraldic winged dragon on a plinth. Temple Bar in Fleet Street, designed by Sir Horace Jones in 1876 and pictured here c. 1890, is the grandest of these dragons. Taking its name from the old chain that spanned Fleet Street in medieval times, this monument replaced a grand gateway designed by Sir Christopher Wren. The gateway stood here from 1670 to 1876, when it was moved for road widening.

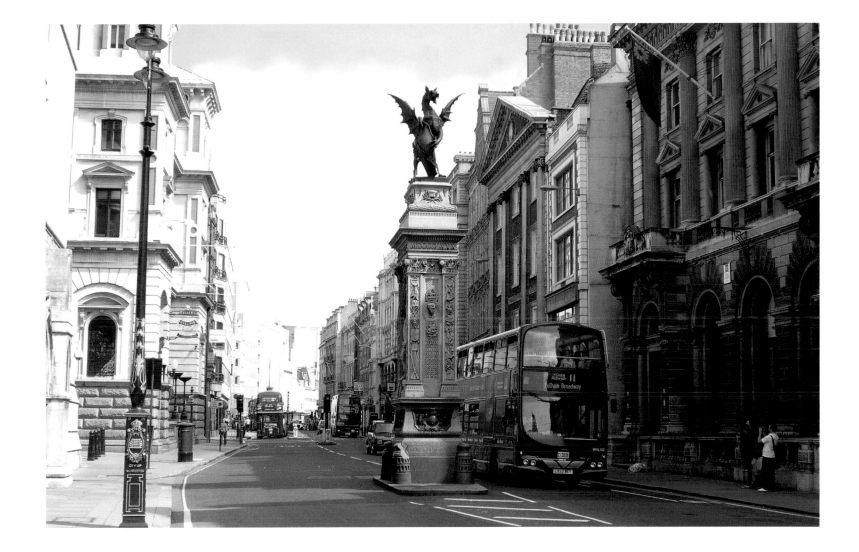

Recently cleaned for the Queen's Golden Jubilee celebrations,
Temple Bar still greets the traveller entering the City from London's
West End. On ceremonial occasions such as the Jubilee, the
sovereign is greeted here by the Lord Mayor of London and offered
the City Sword as a sign of loyalty. To the left of Temple Bar is the
old Law Courts branch of the Bank of England, which has now
followed a popular City trend and become a pub.

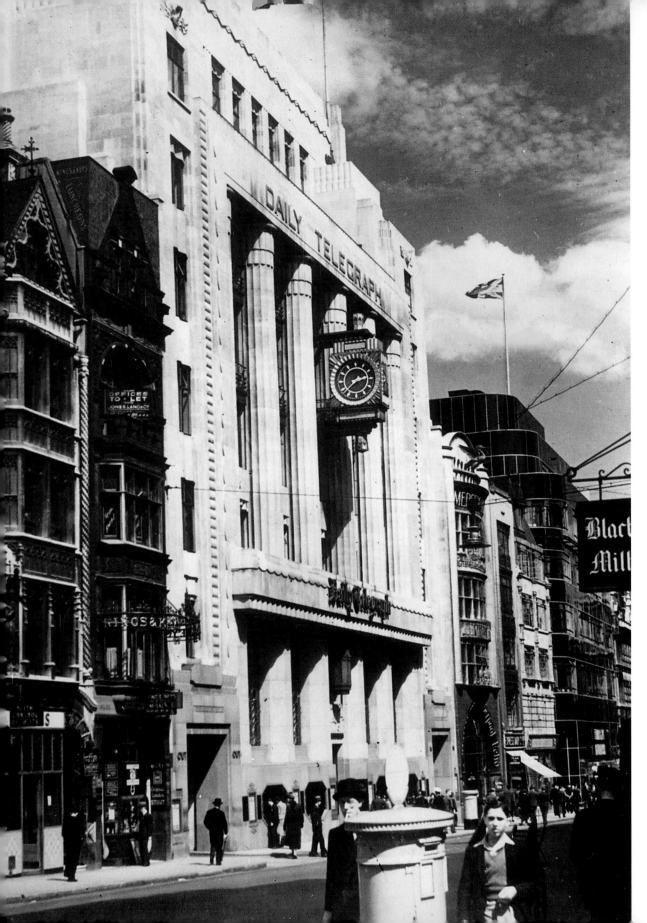

OLD DAILY TELEGRAPH BUILDING

Fleet Street, the centre of British publishing until the 1980s

Fleet Street has been a centre of publishing and printing since the sixteenth century. The world's first daily newspaper, *The Daily Courant*, was published here in 1702. During the late 1920s and early 1930s there was a building boom, which culminated in new headquarters for the *Daily Telegraph* and *Daily Express* newspapers. This picture, taken in 1932, shows the Daily Telegraph Building with its Egyptian-style columns and distinctive clock. The building boasted a director's penthouse with a terraced garden overlooking Fleet Street. To the right is the Daily Express Building – a sleek, curving structure of black Vitrolite glass and steel.

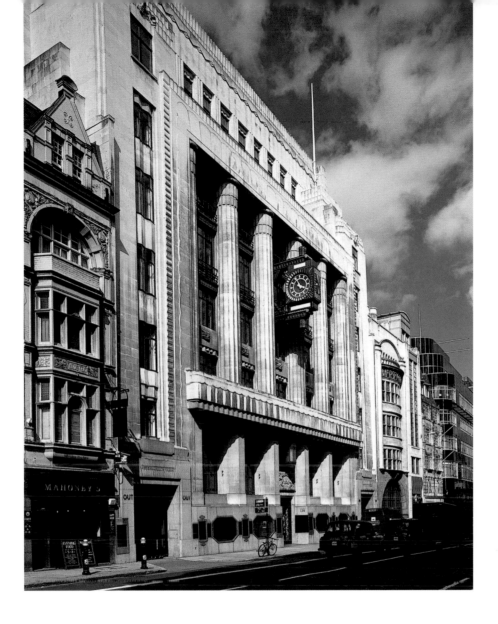

During the mid-1980s, the introduction of new technology and changes in production methods led to the relocation of newspapers away from the City. Journalists have been replaced in Fleet Street by bankers and both buildings are now occupied by Goldman Sachs. Today, the Daily Telegraph Building is unchanged. The Daily Express Building, with its exotic Art Deco–style lobby, caused a sensation in the 1930s.

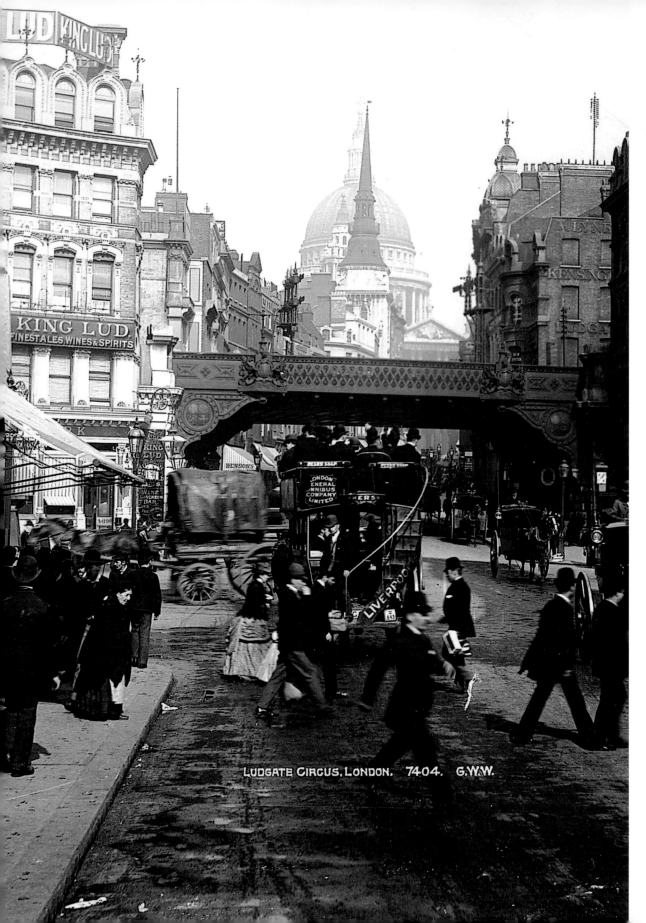

LUDGATE CIRCUS, LONDON. 7404. G.W.W.

VIEW ALONG LUDGATE HILL

With the dome of St. Paul's Cathedral and the spire of St. Martin within Ludgate

Ludgate Hill, a busy street in the City, was named after King Lud, a mythical ruler of London. On leaving Fleet Street, royal processions made their way up Ludgate Hill to services at St. Paul's Cathedral. A cast-iron bridge can be seen in the background, which carried steam trains to Ludgate Hill Station.

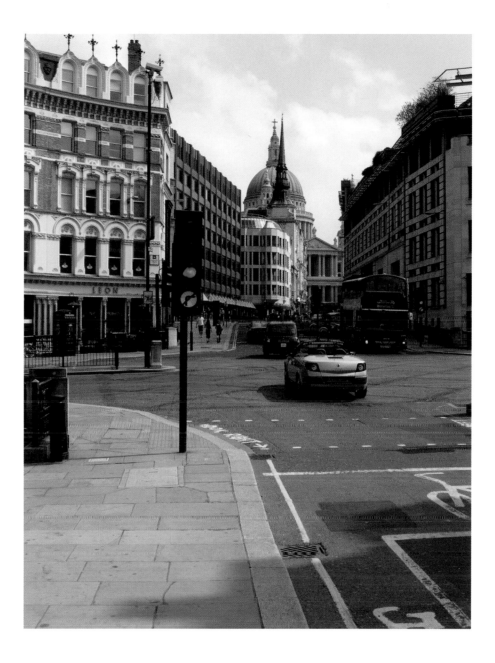

The cast-iron bridge was dismantled when the trains were diverted underground. Between the new buildings, the dome of Sir Christopher Wren's St. Paul's Cathedral can be seen and, in front of it, the spire of St. Martin within Ludgate, another Wren church. Captain William Penn, founder of Pennsylvania, was married in St. Martin's and Samuel Purchas, a rector, was a friend of Princess Pocahontas and her husband John Rolfe.

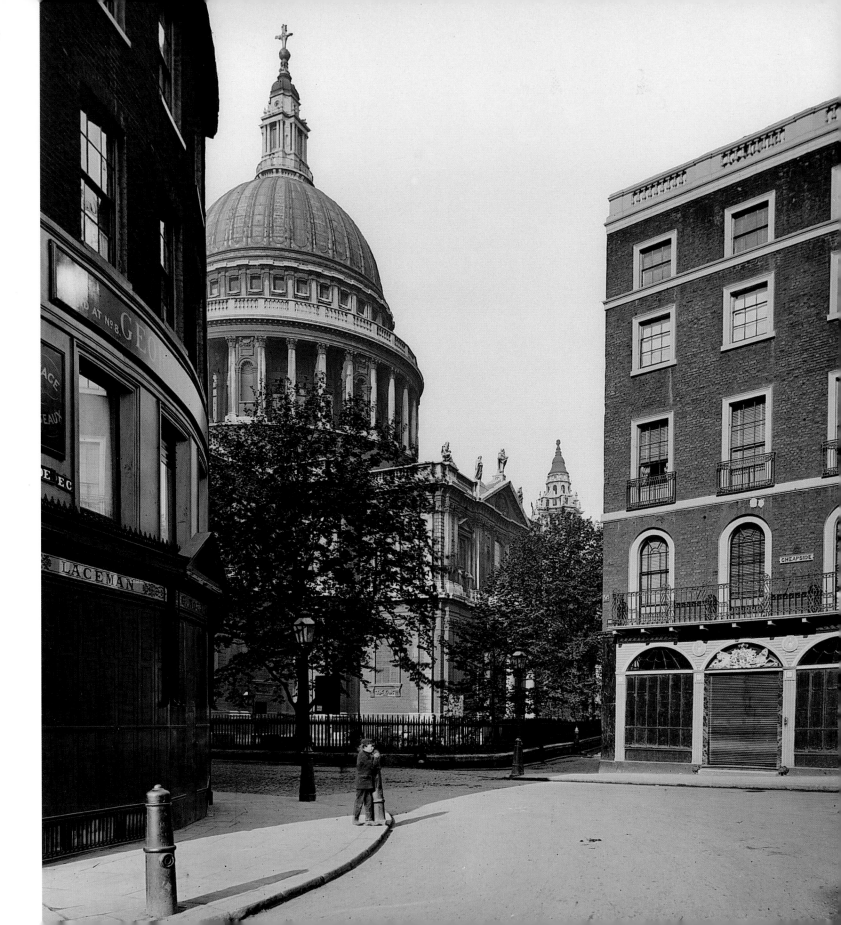

THE DOME OF ST. PAUL'S FROM CHEAPSIDE

Sir Christopher Wren's masterpiece

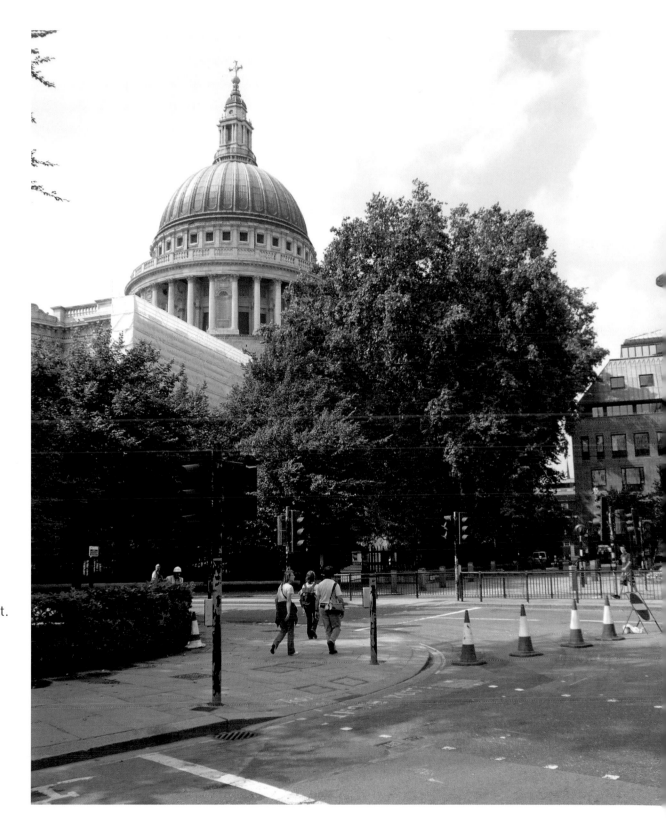

Left: The fifth cathedral on the site, St. Paul's was rebuilt after the 1666 Great Fire of London and completed in 1710. The city fathers were not keen on Sir Christopher Wren's initial designs, disliking the "European" notion of a domed cathedral. Wren was also criticized for taking 35 years to complete his masterpiece, though today we marvel at the fact that this grand building was erected within the working lifetime of one seventeenth-century architect.

Right: Today the dome of St. Paul's remains a major feature of the City's skyline, rising 111 metres (365 feet) above sea level. During World War II, the vigilance of the volunteer members of St. Paul's Firewatch helped to save the cathedral while surrounding buildings were destroyed. It is now surrounded by modern office buildings. In 2008, some of the 1960s buildings next to St. Paul's were being replaced with new structures that aim to be more architecturally similar to the cathedral.

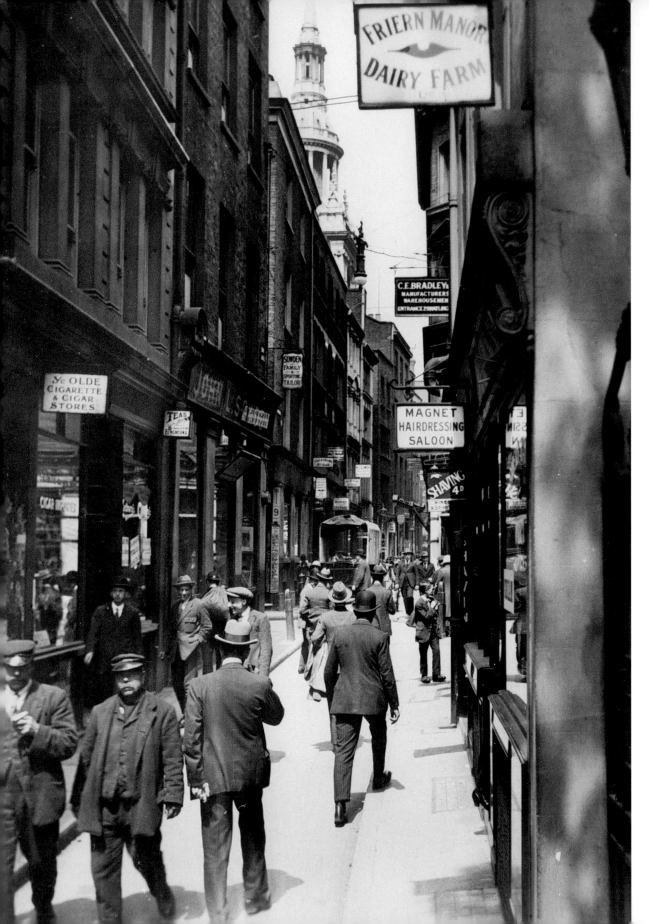

BOW LANE

Named after the Church of St. Mary Le Bow

At one time known as Cordwainer Lane and then as Hosier Lane after the cordwainers (boot makers) and hosiers (stocking makers) who worked here, this narrow lane was eventually renamed Bow Lane after the Church of St. Mary Le Bow. The church, towering over the top of the lane on the left side of the picture, was rebuilt by Sir Christopher Wren in 1673 after the Great Fire destroyed the medieval Church of St. Mary Le Bow. It is said that if you are born within the sound of the church bells, you are a true Cockney.

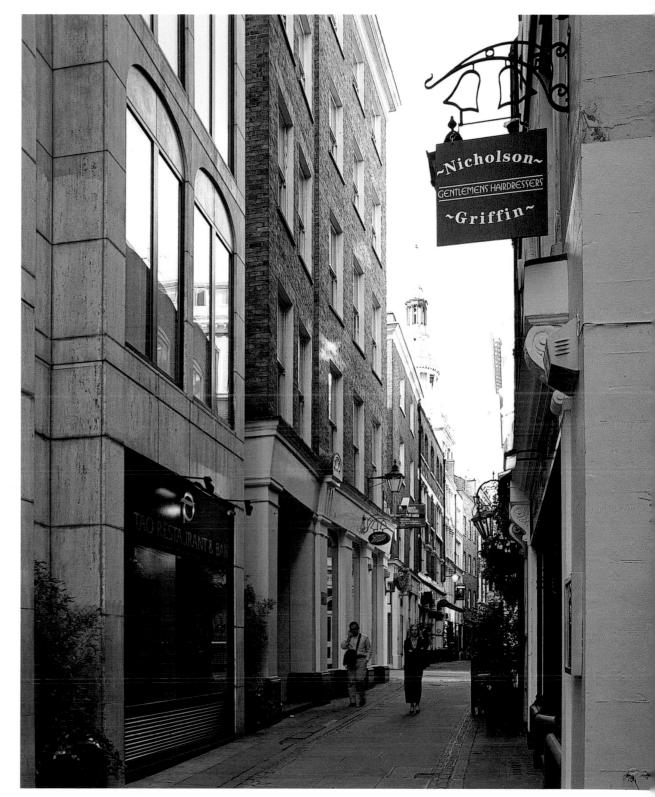

Today the local shops, such as the dairy in the forefront of the 1920s picture (left), have been replaced by a men's hairdresser, clothing shops, wine bars and a pharmacy. While the shops might be different, the street retains a traditional character with the church at the end attracting workers to its Crypt Café and lunchtime talks by a variety of public figures.

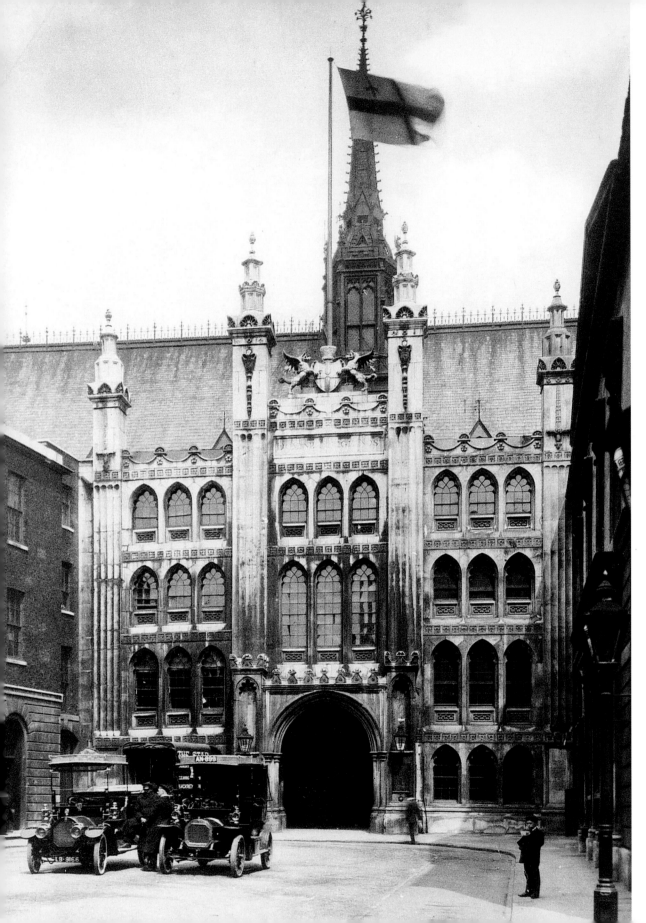

GUILDHALL

The centre of government in the City since 1411

The Guildhall has been the centre of government in the City of London since 1411 and the Gothic portico shown here dates to 1430. Inside the Guildhall, Lord Mayors were elected, meetings of the Court of Common Council were held, and famous trials, such as the trial of Lady Jane Grey, took place. Damaged in the Great Fire and the Blitz, this building is a great survivor. Here it is blackened by grime and hemmed in by buildings that have since been demolished.

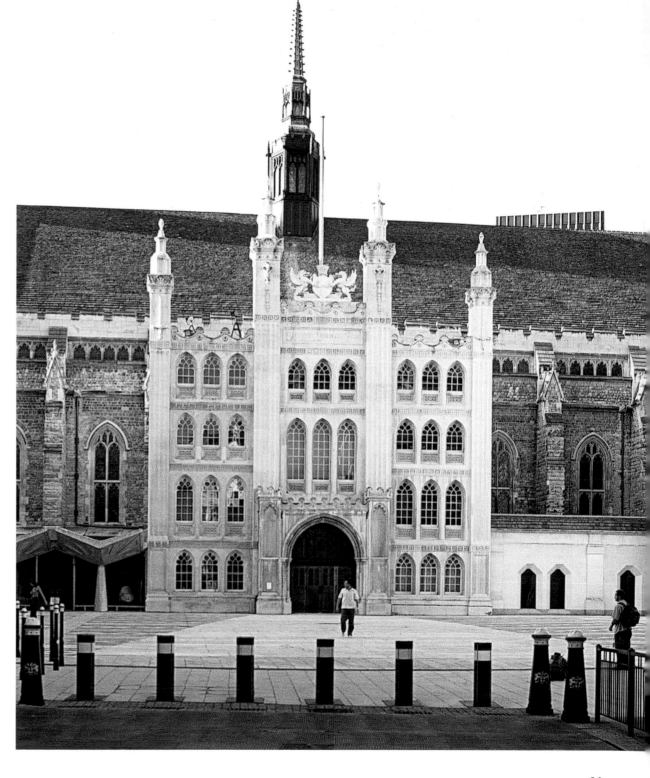

Today the Guildhall stands as a symbol of the City's ability to survive and retain its heritage while moving with the times. The yard in front of the main entrance has been opened out and a new art gallery has been built to the right. During the gallery's construction, remains of London's Roman amphitheatre were found under the forecourt. The City's government still meets here, Lord Mayors are still elected here, and in 2002 the Queen came here for a banquet to celebrate her Golden Jubilee.

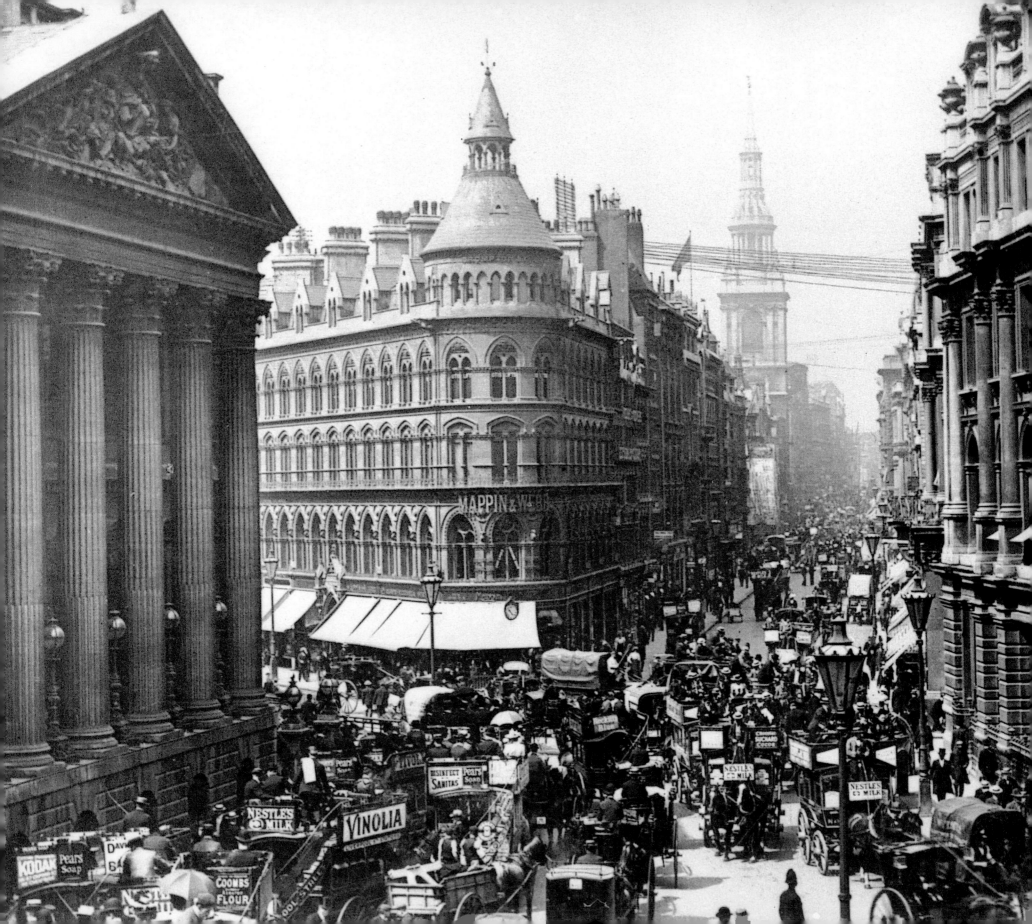

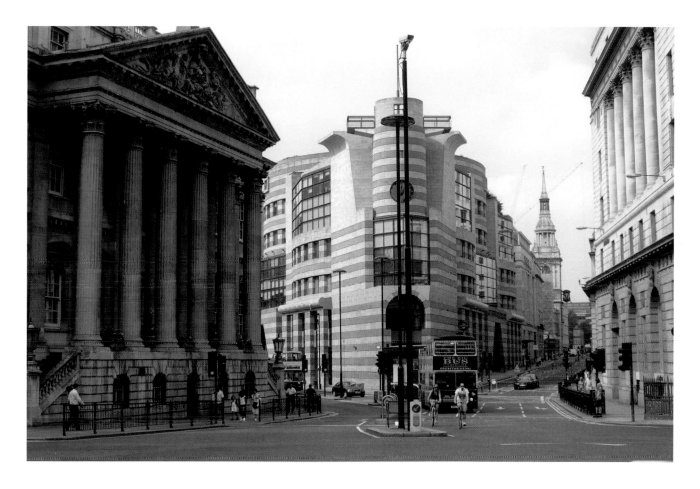

BANK JUNCTION AND
VIEW OF MANSION HOUSE

The official home of the Lord Mayor

Left: Taken around 1890, this photograph shows the residence of the most important figure in the City of London. The Mansion House, on the left, is the official home of the Lord Mayor and was finished in 1752, complete with the Egyptian Hall, marble statues and opulent furniture. Each November, the newly elected Lord Mayor travels through the streets at the head of a colourful procession that culminates in a grand dinner at the Mansion House. The building in the centre of the picture, occupied by the jewellers Mappin and Webb, was erected in 1870.

Above: Architect George Dance's Mansion House still stands in classical splendour, but the Mappin and Webb building has been replaced. Critics, including Prince Charles, lamented the demolition of a fine example of Victorian architecture, but its replacement, James Stirling's No. 1 Poultry, has also made its mark on the City's landscape. It contains offices, shops and a rooftop restaurant with excellent views.

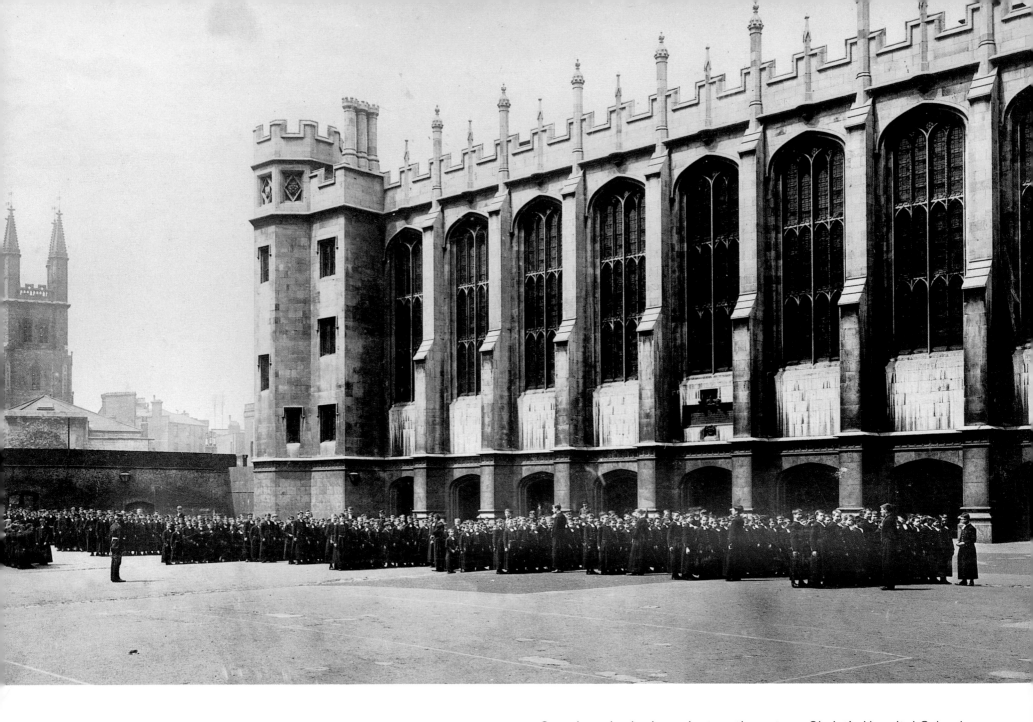

CHRIST'S HOSPITAL SCHOOL / MERRILL LYNCH BUILDING

Founded in 1553 as a school for orphans

Seen here in the late nineteenth century, Christ's Hospital School, Newgate Street, was founded in 1553 as a school for orphans in buildings belonging to the old Greyfriars Monastery. The students wore distinctive blue uniforms with yellow stockings, which were said to keep the rats away from their ankles. To the left is the tower of St. Sepulchre's Church, whose twelve bells ("the bells of Old Bailey") are referred to in the popular English nursery rhyme "Oranges and Lemons".

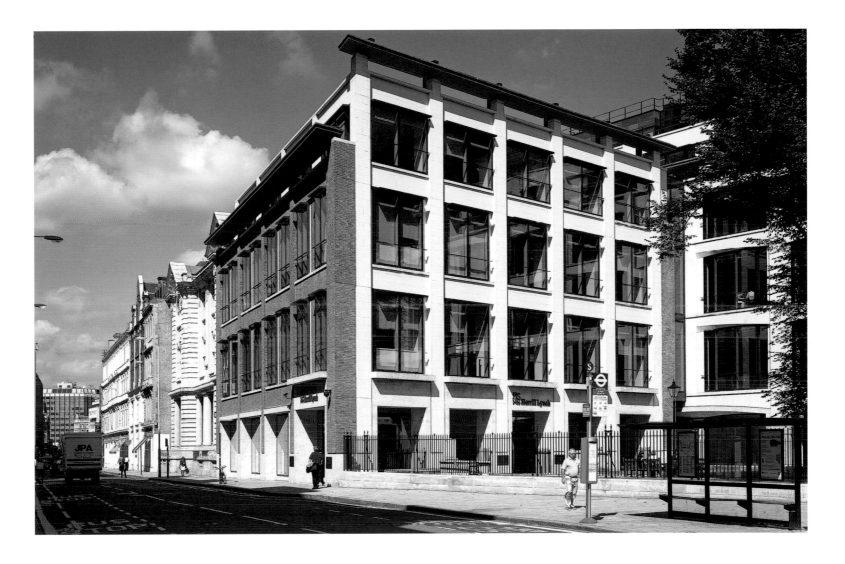

In 1902 Christ's Hospital School moved to Horsham in Surrey and part of the old site of the school is now covered by a brand-new office building, home of Merrill Lynch. The fifteenth-century tower of St. Sepulchre's is now obscured but the church still stands. St. Sepulchre's is the largest church in the City of London and it still offers weekly choral Evensong, as well as lunchtime and evening concerts. In 2010 funds were being raised to restore the church's seventeenth-century organ.

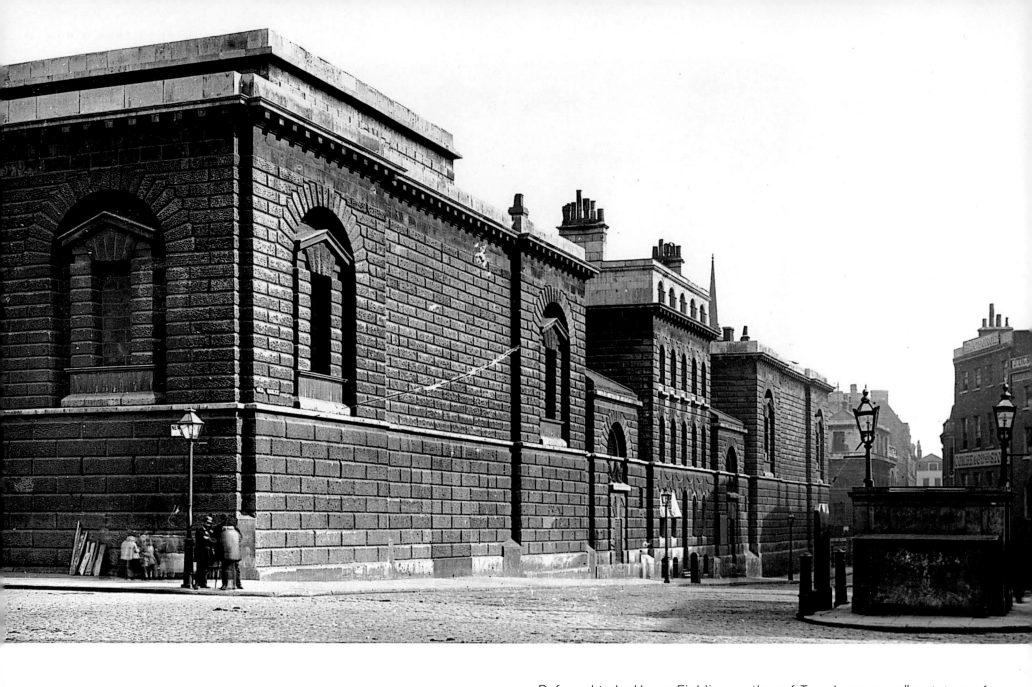

NEWGATE GAOL /
THE OLD BAILEY

Described by Henry Fielding as a "prototype of Hell"

Referred to by Henry Fielding, author of *Tom Jones*, as a "prototype of Hell", Newgate Gaol was London's most notorious jail. The prison in the photograph was built in 1783 after the previous building was razed to the ground during the anti-Catholic Gordon Riots. There has been a prison on the site since the thirteenth century, with inmates ranging from religious martyrs to thieves and highwaymen. Corruption was rife and conditions unsanitary. Shortly after the rebuilding, London's main place of execution was relocated from Tyburn to Newgate and, until the practice ceased in 1868, crowds flocked here to watch the public hangings.

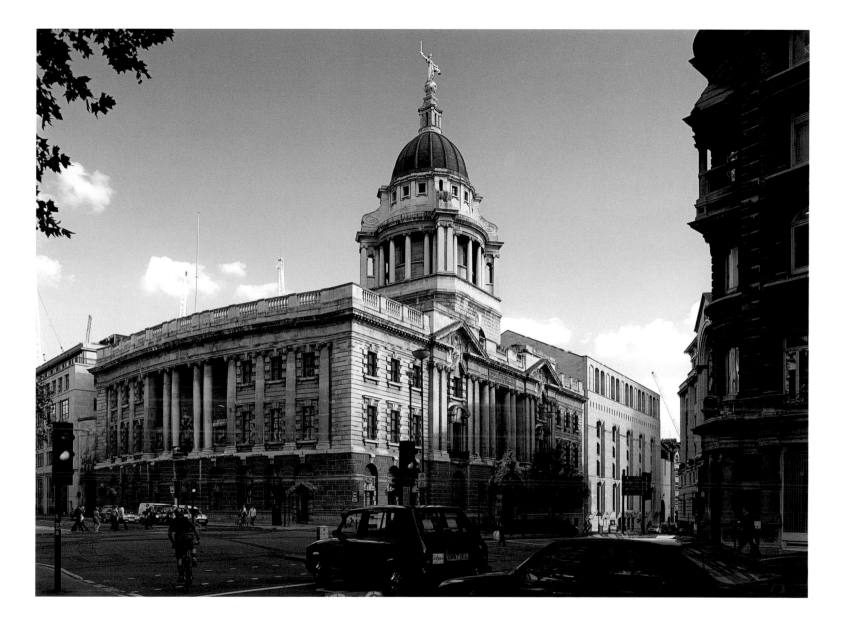

There had been a courthouse next to Newgate since the sixteenth century, but eventually the prison was demolished to make way for the Old Bailey, London's central criminal court. Designed by E. W. Mountford, the Old Bailey was opened in 1902 and has since hosted many famous trials, including that of Dr. Crippen, who poisoned his wife; William Joyce (Lord Haw Haw), who broadcast propaganda on behalf of the Nazis in 1945; and J. R. Christie, who murdered his wife and several lodgers at 10 Rillington Place, Ladbroke Grove, West London.

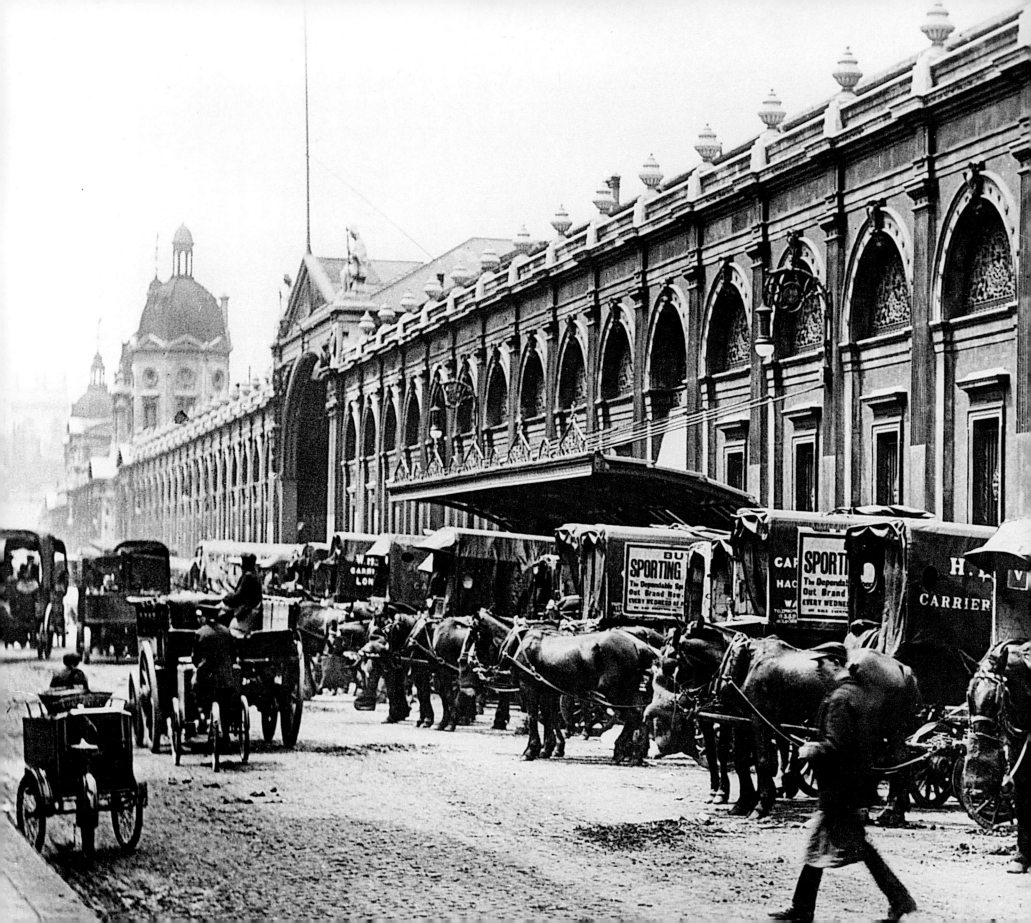

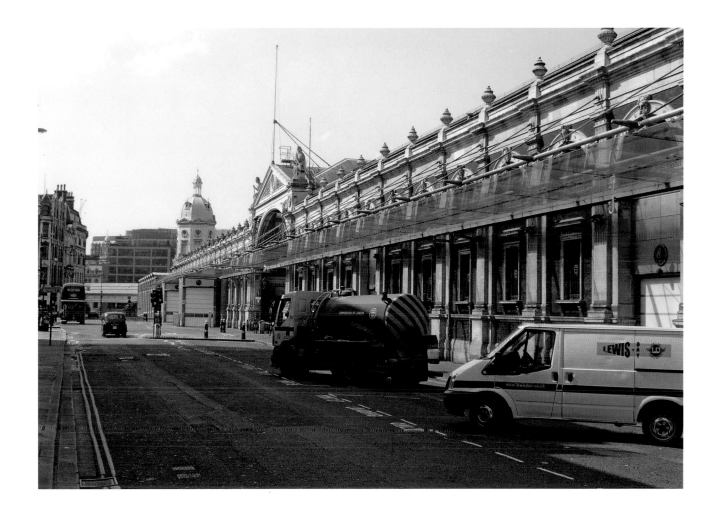

SMITHFIELD MARKET

Meat has been traded here since the tenth century

Left: At Smithfield Wholesale Meat Market, c. 1905, horse-drawn delivery carts line up outside to distribute meat throughout the capital. Designed by Sir Horace Jones, this building was erected in 1868, though there has been a cattle market on the site since the tenth century. In *Oliver Twist*, Dickens described the ground here as being covered "nearly ankle deep with filth and mire", a situation that led to the cattle market's relocation to Islington.

Above: This photograph was taken during one of the market's slow times, and the scene looks fairly quiet. Upgraded to comply with European regulations, the market's nineteenth-century character was retained but the interior is now sanitary and visitors no longer see carcasses displayed on hooks.

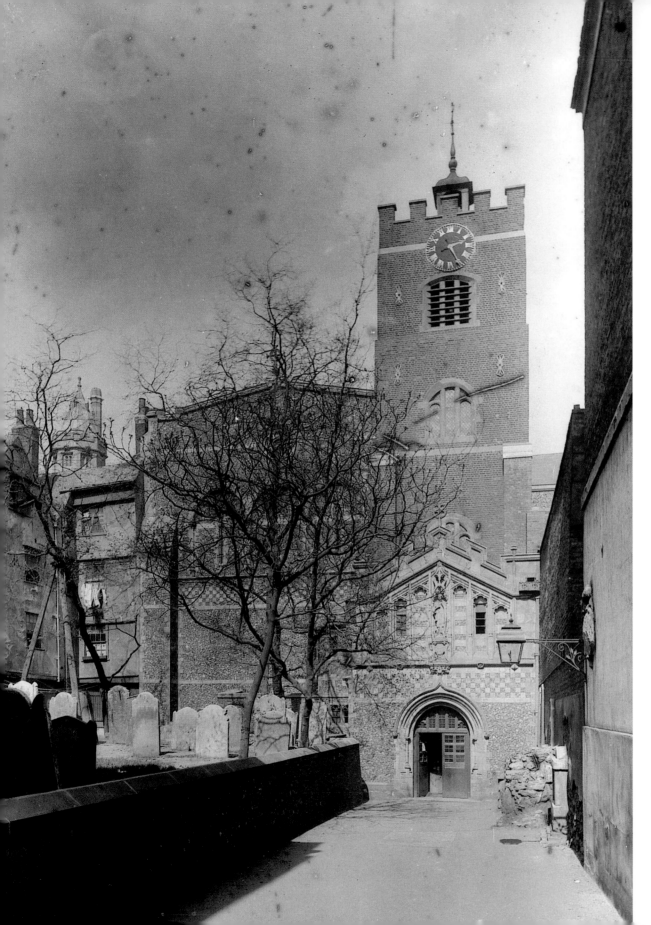

THE PRIORY CHURCH OF ST. BARTHOLEMEW THE GREAT, WEST SMITHFIELD

The oldest church in the City of London

The City is famous for its churches and shown here is St. Bartholemew the Great church from around 1903. Founded in 1123 by Rahere, a courtier of King Henry I, the church is the oldest in the City of London. The round arches over the door and windows tell us that this is a rare example of the Norman/Romanesque style of architecture. After the Reformation, parts of the church were used by a printer and Benjamin Franklin, one of the Founding Fathers of the United States of America, worked here for a while.

Not much has changed in a century, except that the churchyard has lost many of its gravestones. The height of the ground indicates the number of people buried underneath. Here the height is the same as in the earlier photograph, as burials in the City churchyards ceased in the mid-nineteenth century. The atmospheric church has been featured in several films, including *Four Weddings and a Funeral*, *Shakespeare in Love* and *The End of the Affair*.

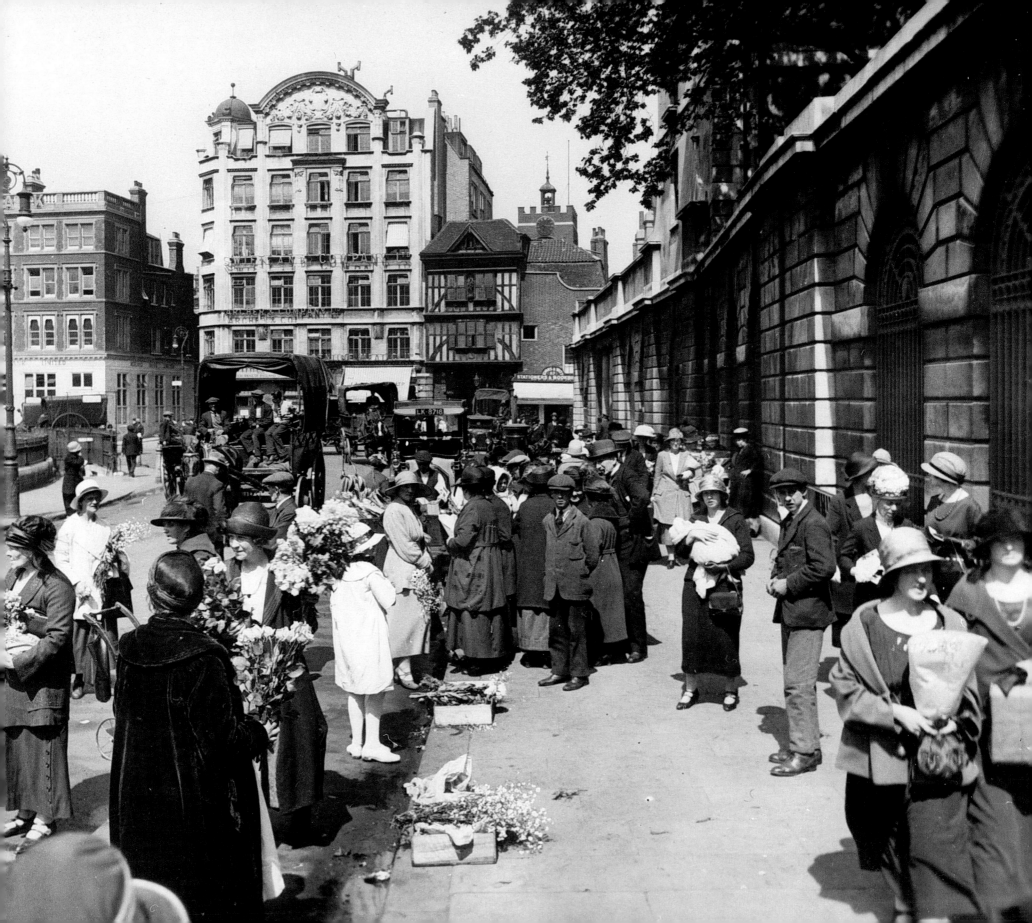

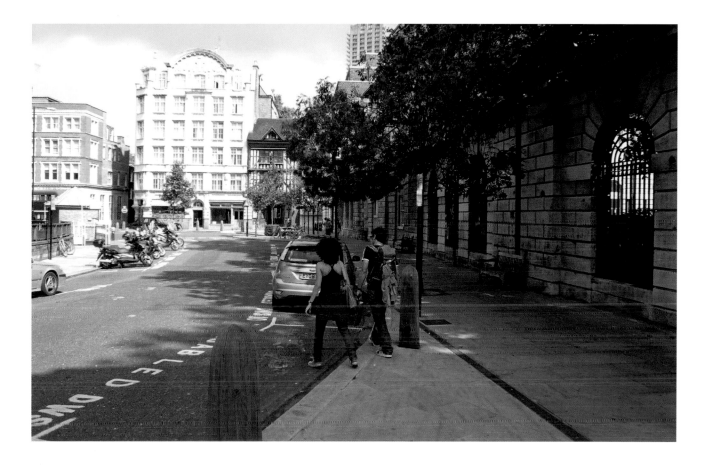

SMITHFIELD SQUARE AND ST. BART'S HOSPITAL

The oldest London hospital standing on its original site

Left: This photograph shows Smithfield Square c. 1920. The flower sellers in the forefront of the picture stand outside the main entrance to St. Bartholemew's Hospital on the right. Founded by Rahere at the same time as the Priory Church of St. Bartholomew the Great, the hospital was rebuilt in the 1730s. Among the many eminent physicians to have treated patients here are Roderigo Lopez, who was accused of trying to poison Queen Elizabeth I, and William Harvey, who discovered blood circulation.

Above: The flower sellers have gone but the hospital remains as the oldest London hospital standing on its original site. The half-timbered Tudor entrance to St. Bartholemew's can be seen in the centre of the photograph. After years of being hidden away, this entrance was revealed after a World War I zeppelin raid caused damage in the area in 1915.

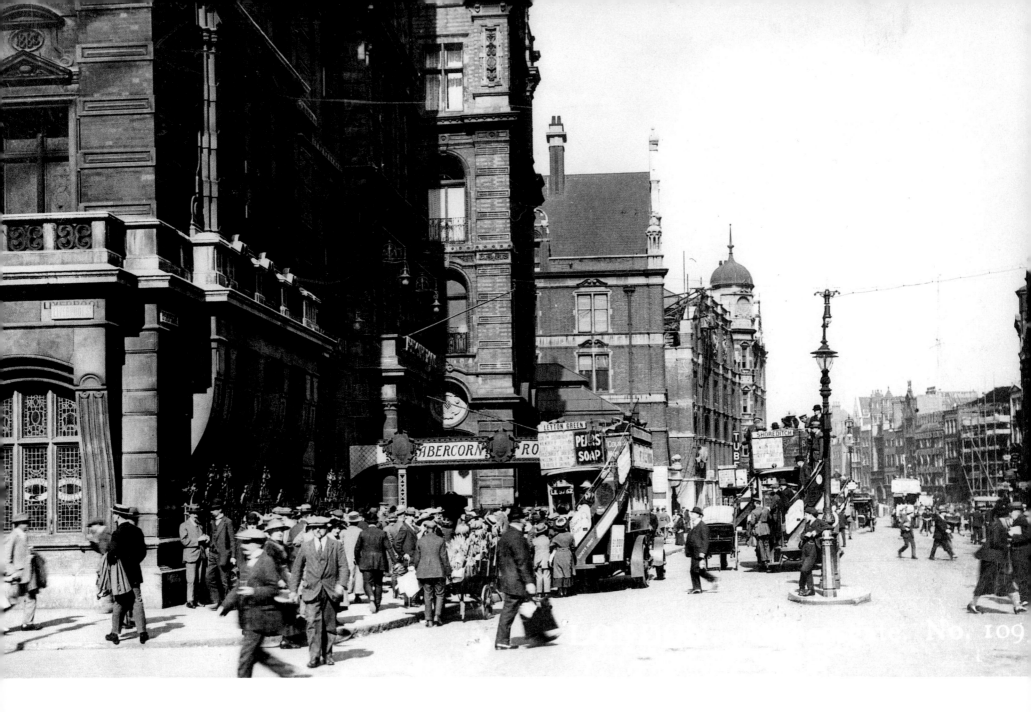

BISHOPSGATE

Named after one of the original seven gates in London Wall

On the eastern edge of the City, Bishopsgate has always been a busy thoroughfare with roots going back to Roman times. Once lined with the mansions of city merchants, Bishopsgate was also the address of Bethlehem Hospital, the famous "Bedlam" insane asylum. In 1874, Liverpool Street Station opened and soon became the busiest of the great London terminals. In the foreground of the picture, taken around 1920, is the Great Eastern Hotel designed by Charles Barry for those arriving via railway. Edward Wilson's station entrance is to the right.

The Great Eastern Hotel was recently refurbished. The canopy has gone, part of the hotel ballroom is now a busy pub for commuters, and the hotel boasts cool minimalist interiors beneath the Victorian facade. In 1992, Liverpool Street Station was also modernized. Beyond Liverpool Street, on the site of the old Broad Street Station, gleaming glass office buildings were built to meet the needs of the modern city. As a result, Bishopsgate is a pleasant mixture of old and new buildings.

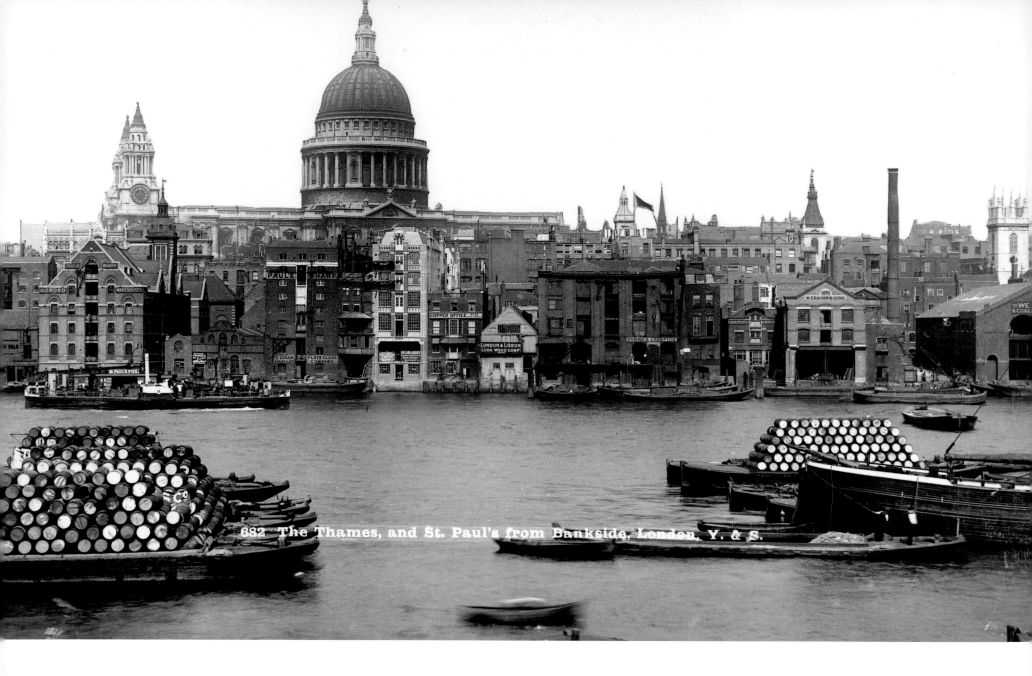

682 The Thames, and St. Paul's from Bankside, London, Y. & S.

In this photograph, taken around 1900, the distinctive dome of Wren's great cathedral has been blackened by the grime of industrial London and wharves and warehouses line the riverfront. In between the warehouses, narrow lanes led down to the river, but there was no riverside walkway and the public had little access to the Thames from here.

ST. PAUL'S FROM BANKSIDE

Industrial London with its wharves and warehouses

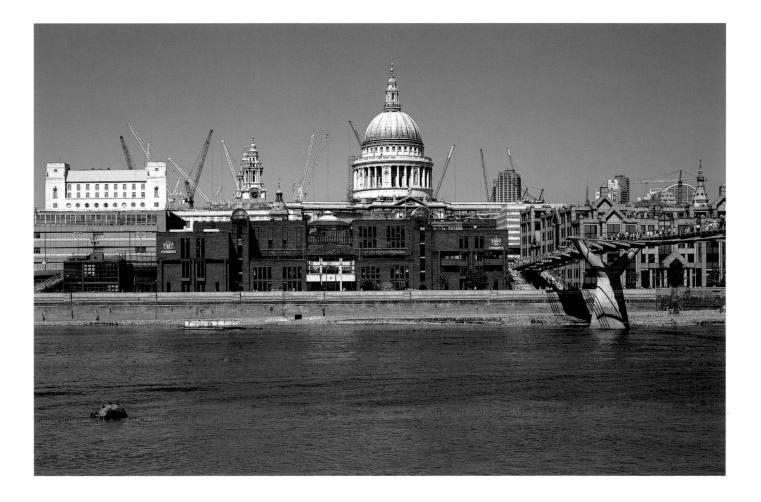

The Thames is no longer industrial and the warehouses have been replaced by new buildings such as the redbrick City of London School for Boys. Founded in 1834, the school, which boasts famous ex-pupils such as Prime Minister Asquith, writer Kingsley Amis and artist Arthur Rackham, moved here in 1984. The riverside walkway has been opened up on both sides of the Thames with access improved by the new pedestrian Millennium Bridge, seen here on the right, which links St. Paul's on the North Bank with Tate Modern, the gallery of modern art, on the South. At the time of writing, St. Paul's Cathedral was in the process of being cleaned inside and out.

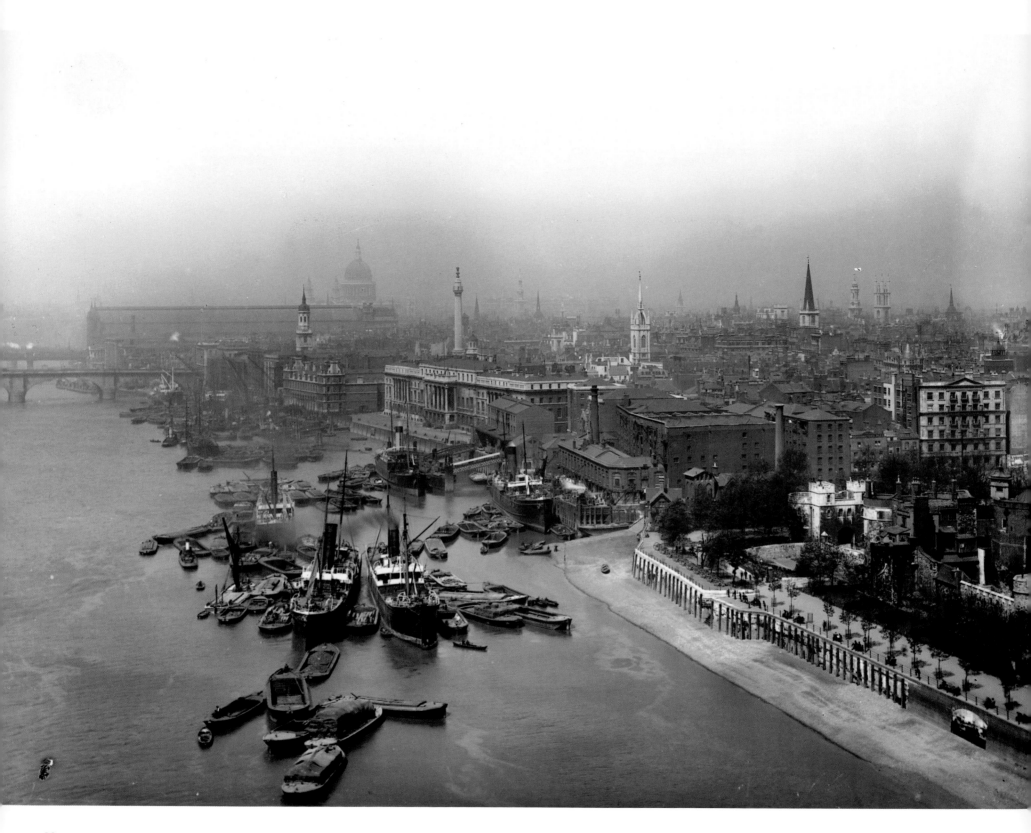

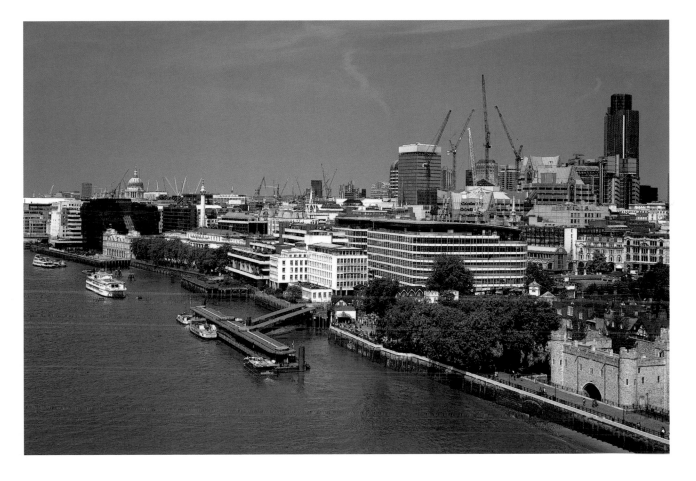

THE POOL OF LONDON FROM TOWER BRIDGE

Seen in 1900 from the newly erected Tower Bridge

Left: The Pool of London is the name given to the busy area between Tower Bridge and London Bridge. This photograph of the Pool, dating from 1900 and taken from the newly erected Tower Bridge, shows a busy shipping scene. The turrets of the Tower of London can be seen on the right and beyond the Tower can be seen the classical frontage of Custom House, Billingsgate Fish Market, the Monument to the Great Fire and numerous church towers.

Above: The most striking difference in this scene is the lack of traffic on the River Thames. Once the docks closed in the 1970s, ships no longer entered the Pool of London and the only vessels to be seen here when the photograph was taken were the red and white pleasure boats. The church towers that survived World War II bombing are now dwarfed by office towers and the skyline is filled with cranes working on the erection of new high-rise buildings.

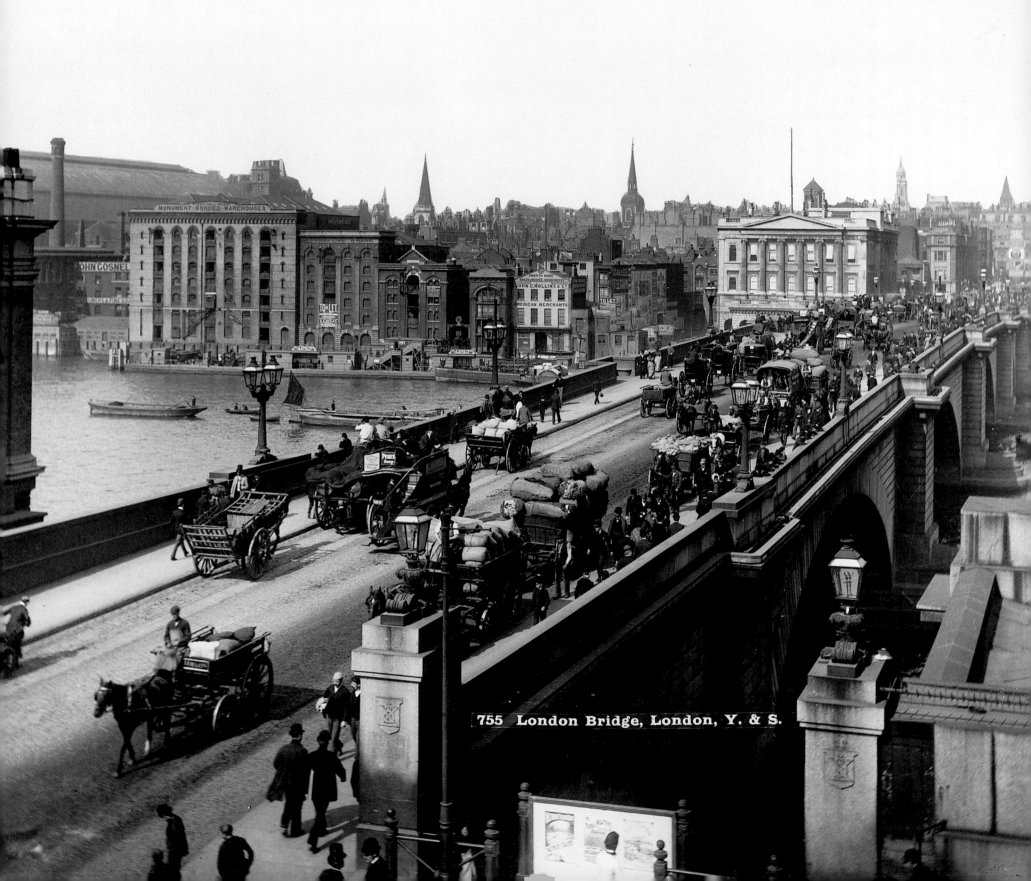

755 London Bridge, London, Y. & S.

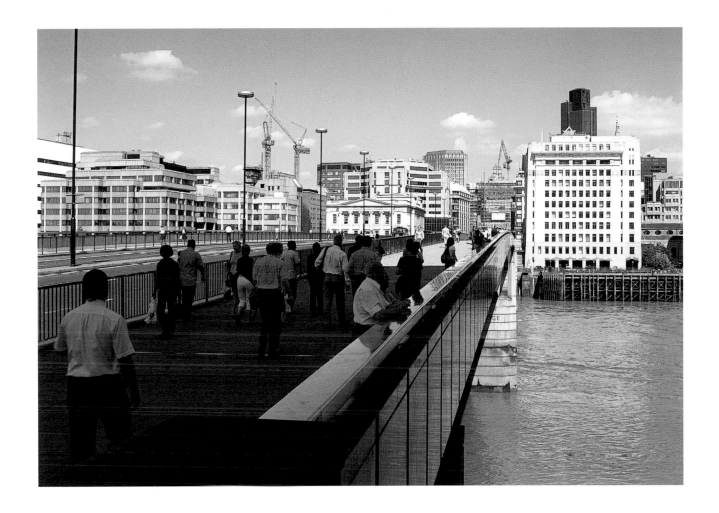

LONDON BRIDGE FROM SOUTHWARK

A bridge has been on this site since A.D. 50

Left: When the Romans founded London, they constructed a wooden bridge where the ground was firmest. The first stone bridge was begun in 1176 and when completed had houses, a chapel and a gateway on which heads of traitors were displayed. The photograph shows John Rennie's 1831 bridge, opened by King William IV and Queen Adelaide. To the right is the tower of St. Magnus the Martyr Church, and to the left is the 1834 Fishmongers' Hall.

Above: The current London Bridge was opened in 1973, replacing Rennie's bridge, which was shipped out to Lake Havasu City, Arizona. St. Magnus the Martyr's tower is hidden behind the 1925 Adelaide House. On the left of the bridge, we can still view the classical frontage of Fishmongers' Hall, home of the Worshipful Company of Fishmongers, one of the City's ancient livery companies, which have regulated trade since medieval times.

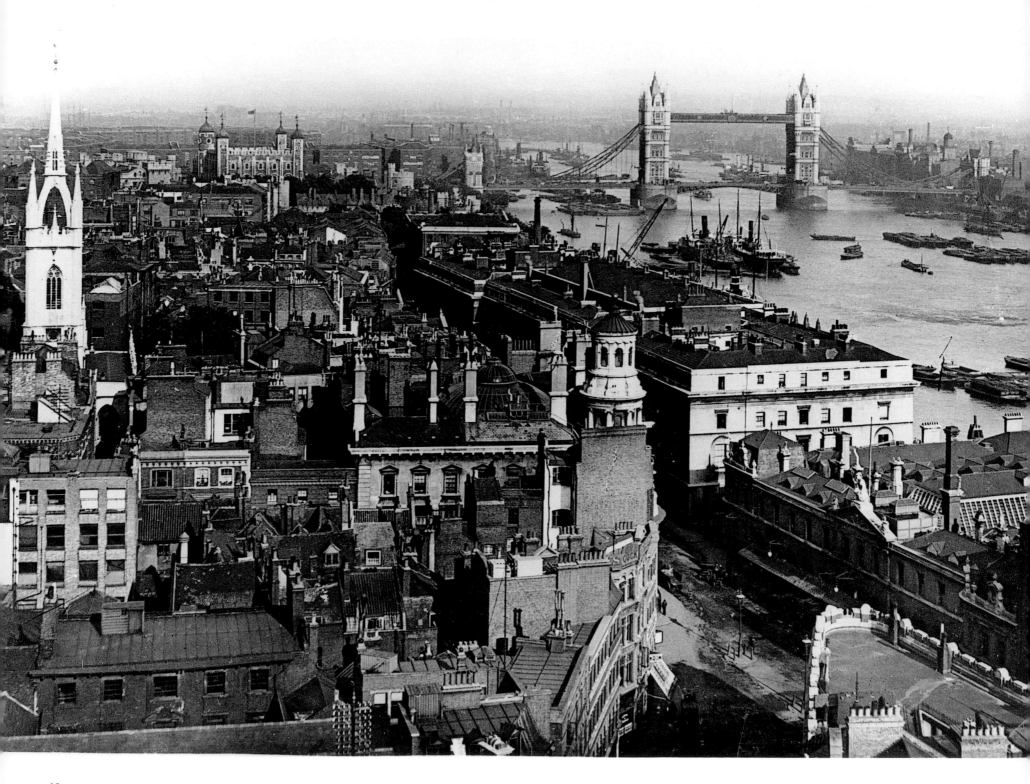

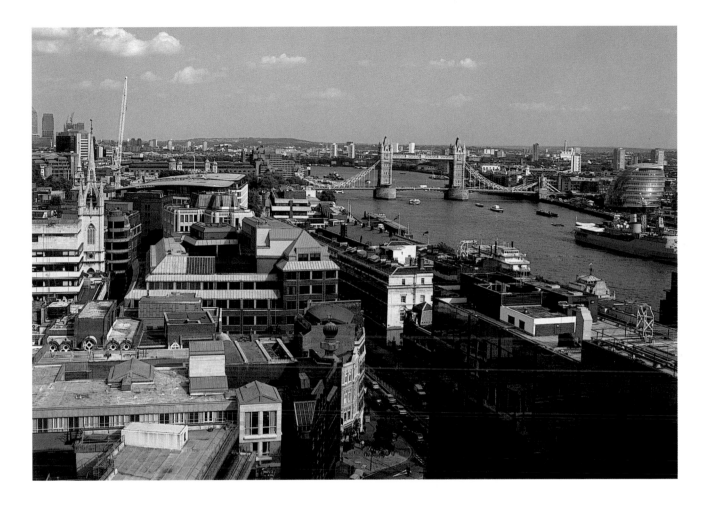

POOL OF LONDON

Tower of London, Tower Bridge and Billingsgate Fish Market

Left: Tower Bridge was designed in 1894 by architect Sir Horace Jones and engineer John Wolfe Barry. Confronted with the problem of designing a bridge that would give access to big ships entering the Pool of London, they came up with the idea of a bascule bridge that could be raised by hydraulic power. A further requirement was that the bridge would also fit in with the design of the Tower of London on the left. In the forefront of the picture is Billingsgate Fish Market, which was also designed by Jones. On the left can be seen the distinctive tower of St. Dunstan's in the East Church.

Above: Today the bascules of Tower Bridge are operated by electric power and, with the closure of the docks, are only raised a few times each week. Billingsgate Fish Market relocated to the east in 1982, and the old site is now used as offices. St. Dunstan's in the East's tower peeps out between twentieth-century office buildings. The tower is all that remains of the church – the rest of the building was destroyed in the Blitz. A new addition to the riverfront is the curved glass building on the right of the picture. Christened the "glass headlamp" by the press, this is London's City Hall, opened in 2002 and home to London's new governing body, the Greater London Authority.

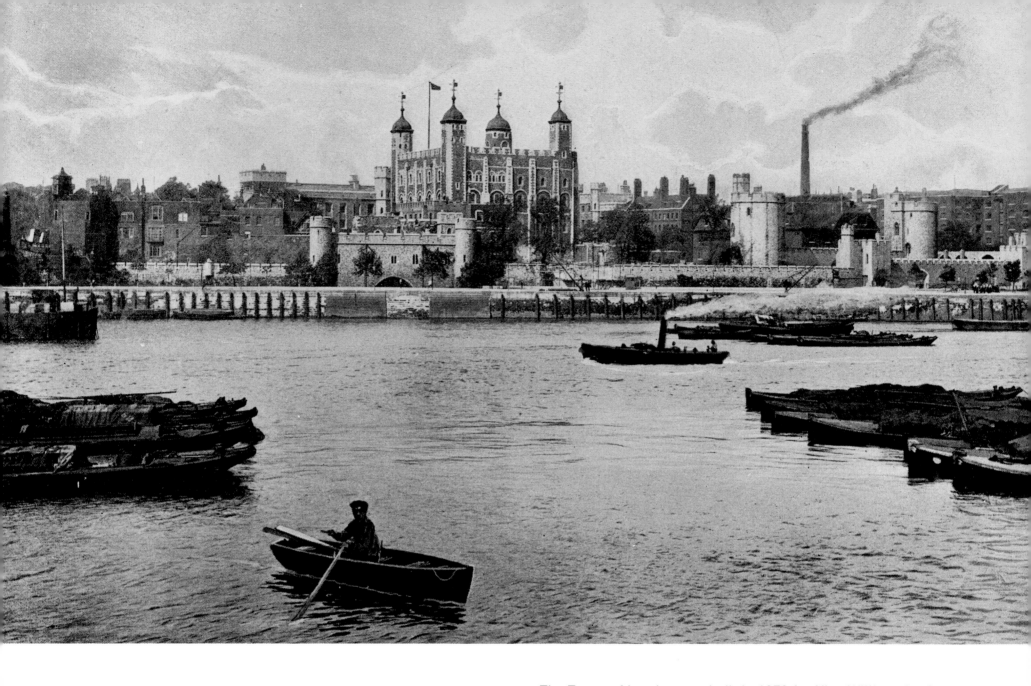

TOWER OF LONDON

Built in 1078 for King William the Conqueror

The Tower of London was built in 1078 for King William the Conqueror, who wanted to demonstrate his power over the people of the city. Subsequent kings added to the defensive walls and turrets. Over almost 1,000 years the Tower has been a royal palace, fortress, royal menagerie, royal observatory, royal mint and, most famously, a prison. Those incarcerated, and later executed, include Sir Thomas More, Sir Walter Raleigh, Lady Jane Grey, Queen Anne Boleyn and Queen Catherine Howard. After their trials, prisoners were transported to the Tower along the river and entered through Traitors' Gate, which can be seen in the forefront of the picture.

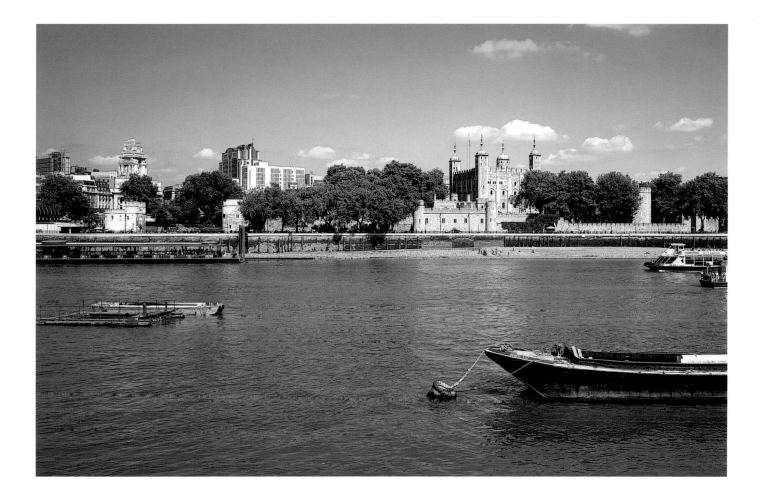

One of the last prisoners to be kept here was Nazi Rudolf Hess, imprisoned for just four days. No longer a prison or fortress, today's Tower of London is the preserve of tourists coming to visit the Crown Jewels and the Yeoman Warders, better known as Beefeaters, who live here. On the left of the picture is the tower of the Port of London Authority Building, erected in 1922 for the company that controlled the London docks and is now the home of Willis, an insurance company.

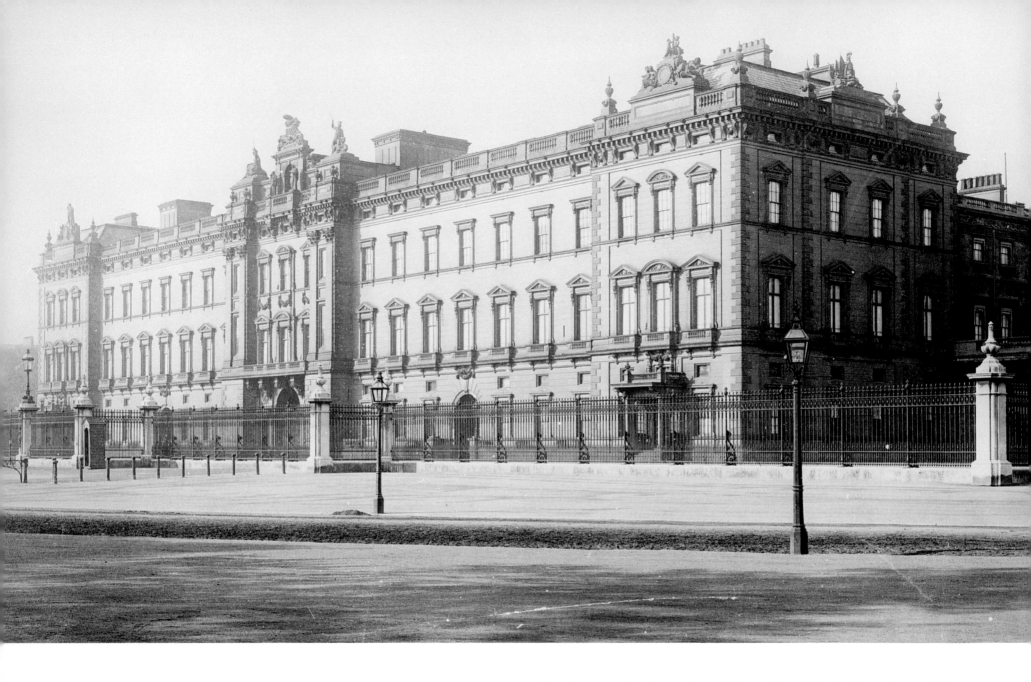

BUCKINGHAM PALACE

Queen Victoria was the first sovereign to make the palace a permanent home

Londoners affectionately call the palace "Buck House", possibly because it started life as Buckingham House, built for the First Duke of Buckingham and purchased by King George III in 1762 for his wife, Queen Charlotte. After the Queen's death, her son, King George IV, asked his architect, John Nash, to transform the house into a grand palace. The king died before the work was completed and Queen Victoria was the first sovereign to make the palace a permanent home. Dismayed by faulty drains and poor ventilation, she employed Edward Blore, who created a building that she came to enjoy.

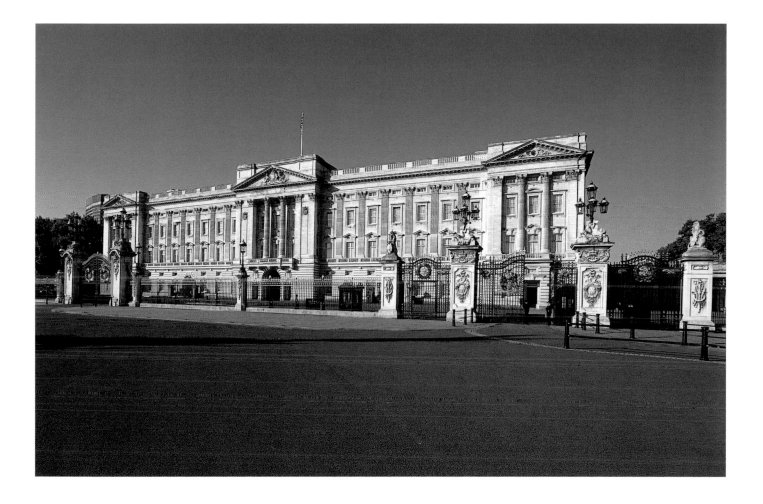

This photograph shows the palace after the refacing of the east front by Sir Aston Webb. Of the 600 rooms they have to choose from, today's royal family occupies a suite of approximately 12. After the 1992 Windsor Castle fire, the state rooms of Buckingham Palace were opened to the public for two months a year to raise funds for the renovations. The openings proved so popular that they have continued long after the Windsor restoration, and the public has an annual chance to admire grand rooms such as the ballroom where investitures take place, the music room, and the 45-acre garden.

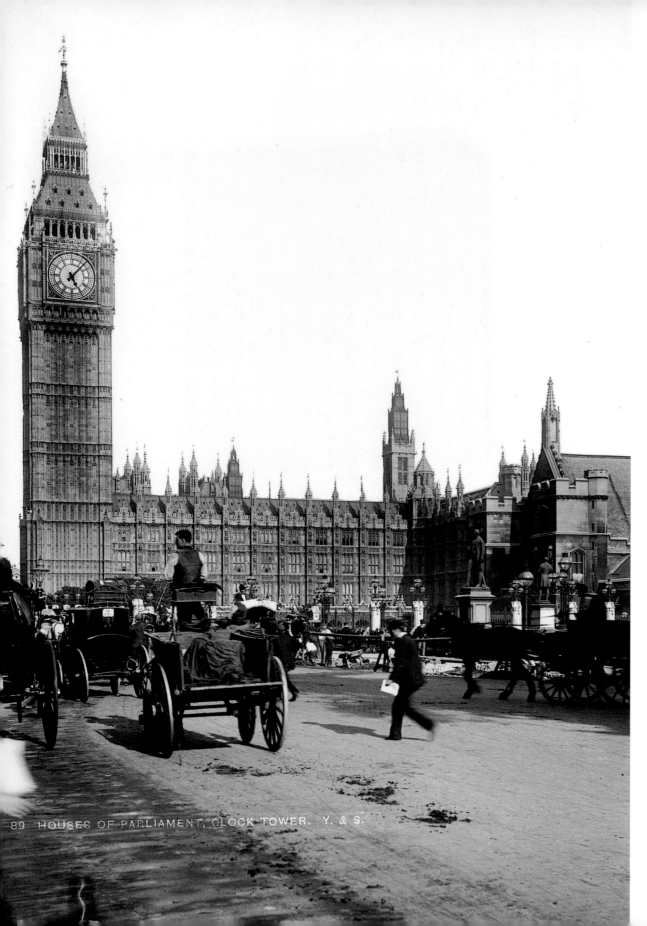

89 HOUSES OF PARLIAMENT, CLOCK TOWER. Y. & S.

PALACE OF WESTMINSTER

Parliament has met on this site since 1265

Dating from around 1910, this photograph shows the Palace of Westminster, home of the Houses of Parliament. This grand example of Gothic Revival architecture, designed by Barry and Pugin, was built between 1840 and 1860 to replace an earlier palace that was gutted by fire in 1834. To the right of the picture can be seen the sloping roof of Westminster Hall, part of the medieval palace that survived the fire. Once the home of kings, Parliament also met in the palace from 1265 onwards. The clock tower to the left houses Big Ben, the famous bell named after either Sir Benjamin Hall, Chief Commissioner of Works at the time of the bell's installation, or Benjamin Caunt, a Victorian boxer.

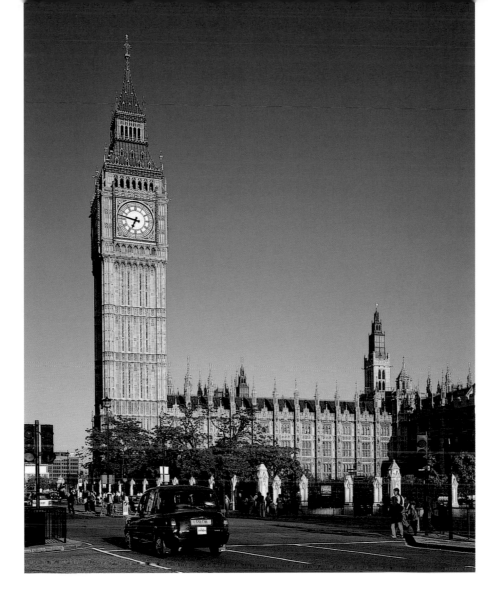

The horses and carts on Westminster Bridge to the left have been replaced by modern vehicles, but the Palace of Westminster looks much the same. However, the type of people who walk the corridors of power here have changed over the years. Once dominated by members of the landed gentry, Parliament is now much more representative of the general population. The first female Member of Parliament, the American Nancy Astor, took her seat in 1919. The medieval Westminster Hall, once the scene of trials and coronation banquets, is now known for Royal Lyings in State. In 2002 thousands of people lined up for hours to view the Queen Mother's coffin before her funeral at nearby Westminster Abbey.

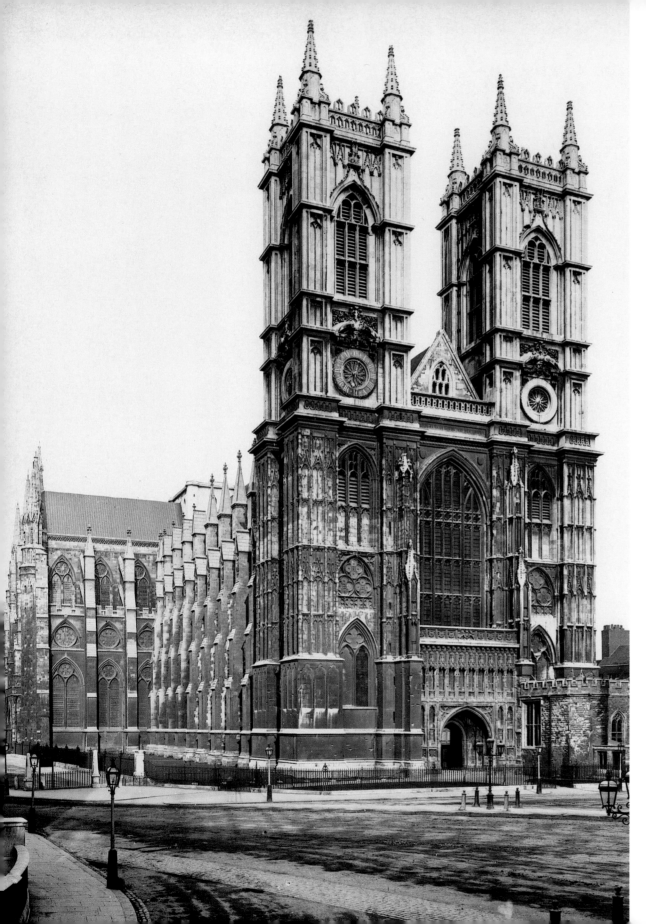

WESTMINSTER ABBEY

Founded by King Edward the Confessor in 1065

Westminster Abbey, shown here c. 1910. Founded by King Edward the Confessor in 1065 and rebuilt in 1245 during the reign of King Henry III, Westminster Abbey is the coronation church. Since the coronation of King William I in 1066, every English monarch has been crowned here with the exception of King Edward V, who was murdered in the Tower of London, and King Edward VIII, who abdicated to marry Wallis Simpson. Over 3,000 kings, queens, poets, musicians, scientists and statesmen are buried here.

Today the west front of Westminster Abbey, designed by Nicholas Hawksmoor in 1745, looks much the same as it did in 1910. However, on closer inspection there are ten new statues above the entrance depicting twentieth-century Christian martyrs. These were added in 1997 and include African-American civil-rights leader Martin Luther King, Jr. Westminster Abbey is constantly commemorating new people and recent memorials include stained glass window panels dedicated to playwrights Oscar Wilde and Christopher Marlowe.

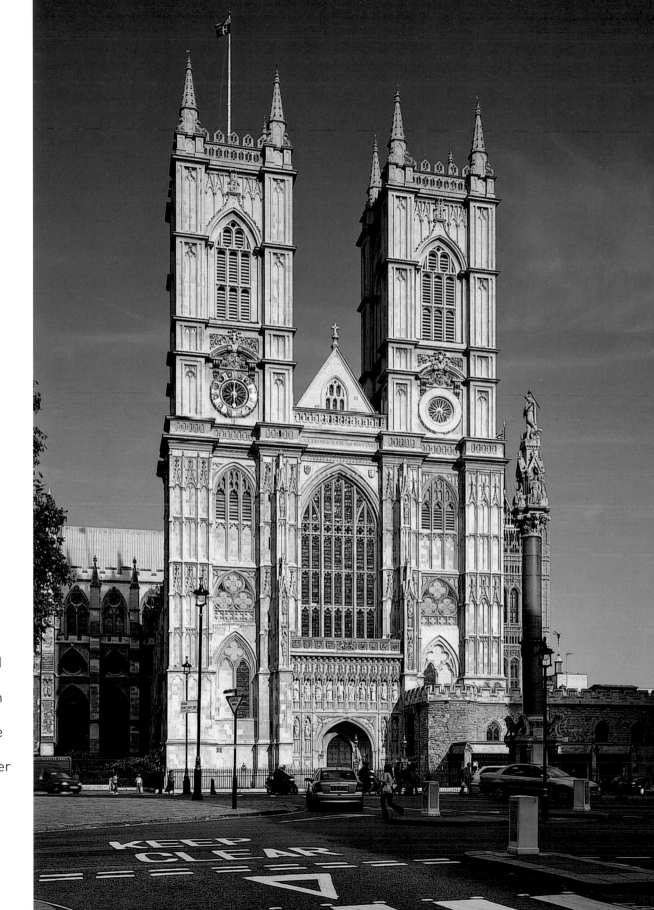

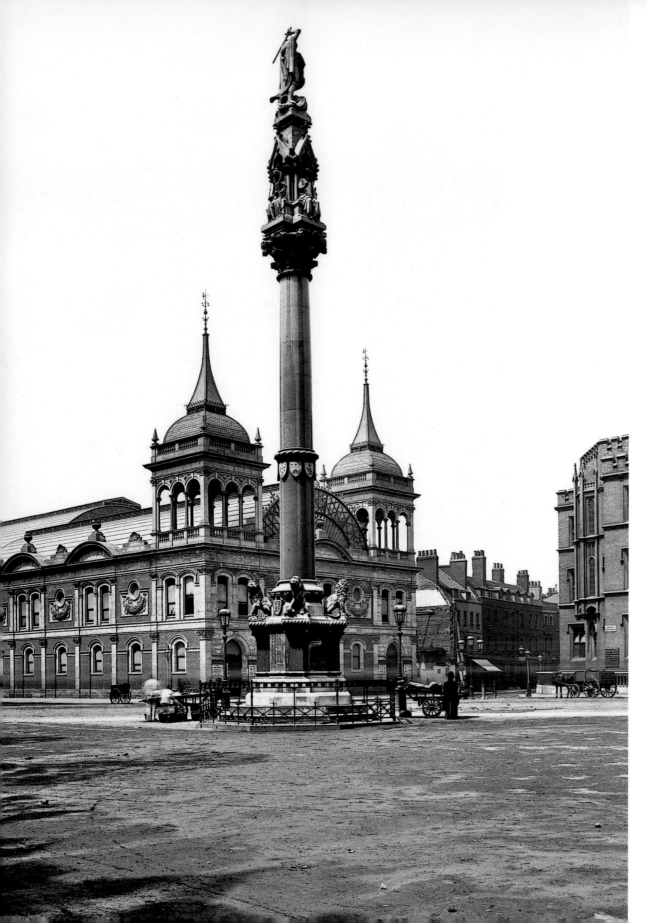

WESTMINSTER AQUARIUM / METHODIST CENTRAL HALL

With the Old Westminsters' memorial of 1861

Opened in 1876, the Royal Aquarium in Westminster boasted an art gallery, restaurant, skating rink, theatre and, of course, fish tanks. Uplifting entertainment was later replaced with the less refined spectacle of scantily clad female swimmers performing "aquatic feats" in the fish tank. The tall column in front of the aquarium is the memorial to the Old Westminsters, students from Westminster School who lost their lives in the Crimean War. The castellated building to the right is Westminster Hospital, which had beds for one hundred sick and needy patients who had to share two baths.

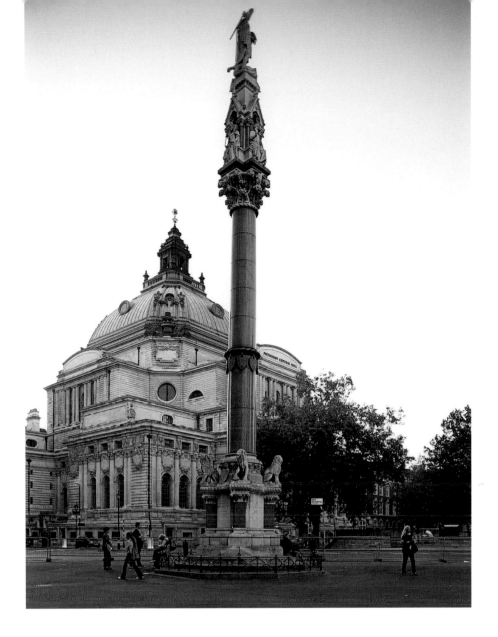

Today George Gilbert Scott's Old Westminsters' memorial remains but the aquarium and hospital have gone. The aquarium was replaced by the Methodist Central Hall in 1911. The idea for the hall came in 1891, the centennial of the death of John Wesley. Money was raised via the "Million Guinea Fund" whereby Methodists, regardless of income, were asked to contribute one guinea each. In addition to Methodist worship, the hall is used for public meetings, collectors' fairs and concerts. The UN Assembly met here in 1948.

WHITEHALL

The centre of Her Majesty's Government

Whitehall, as it was around 1900, with the Old Treasury Building on the left. The street covers the site of the old Whitehall Palace, one of the many palaces inhabited by King Henry VIII. A fire in 1698 destroyed most of the palace and it was replaced by government buildings in the nineteenth century. To the right of the Treasury Office is the entrance to Horseguards Parade, built in 1758 on the site of King Henry VIII's tiltyard. Mounted guards from the Household Cavalry stand guard here from 10 a.m. to 4 p.m. each day.

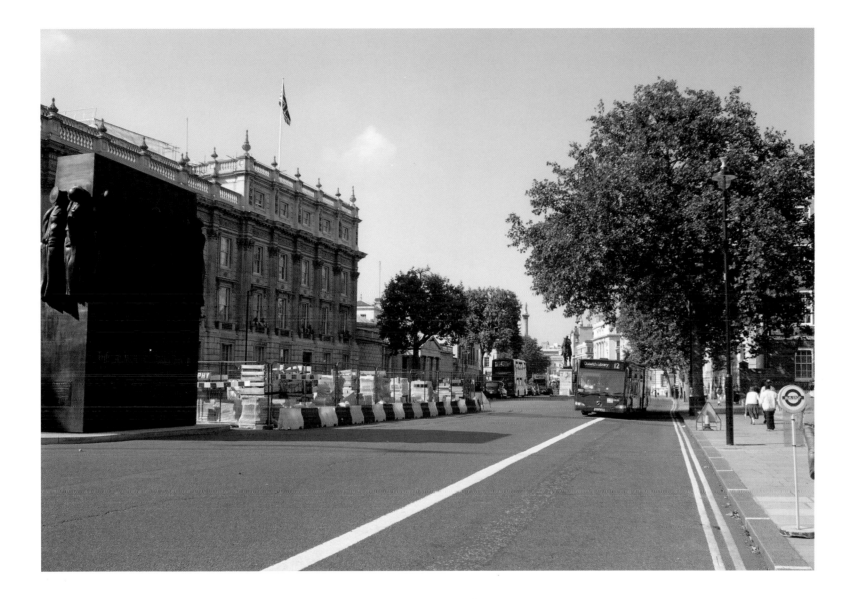

Whitehall is still the home of government. The Treasury moved out
of the building on the left and it is now the office for the Cabinet and
Privy Council, the inner sanctum of government. During renovation
of this building in the 1960s, some remains of Whitehall Palace
were discovered, including the wall of an indoor tennis court
complete with a turret. The public has a chance to see these
archaeological finds during London Open House weekend, held
each September.

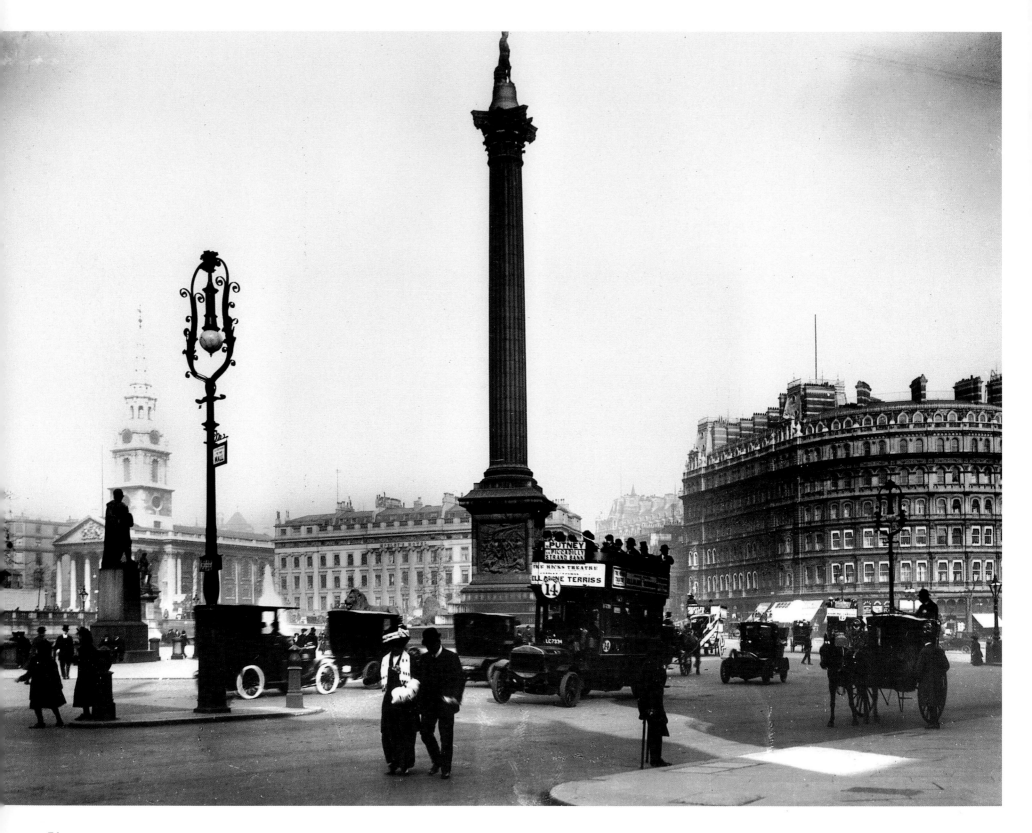

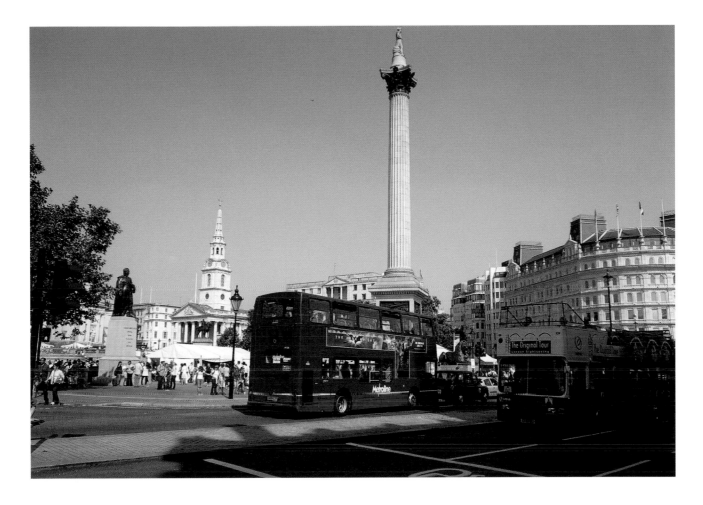

TRAFALGAR SQUARE

Named to commemorate Nelson's victory at the Battle of Trafalgar

Left: Trafalgar Square was laid out in 1840 on the site of the old Royal Mews and named to commemorate Nelson's famous 1805 victory at the Battle of Trafalgar. The square is dominated by Nelson's Column, which was erected in 1843 and designed by William Railton. At the top is a statue of the great naval commander sculpted by E. H. Bailey. To the left of the famous monument stands Morley's Hotel and St. Martin in the Fields, the royal parish church that was built in 1724 by James Gibbs. Note the advertisement on the bus for acclaimed actress Ellaline Terriss, who was appearing at the new Hicks Theatre in nearby Shaftesbury Avenue. The photo dates from c. 1906.

Above: Trafalgar Square has always attracted the public for events, such as New Year's celebrations and protest meetings. In recent years, the square has undergone dramatic changes and its facilities have been improved. The north side of the square was pedestrianised in 2003 and the central staircase built, creating a large terrace at the top of the square. A café, lifts and public toilets were also part of the changes. Changes are not uncommon in the square; Morley's Hotel was replaced in 1935 by South Africa House, designed by Sir Herbert Baker.

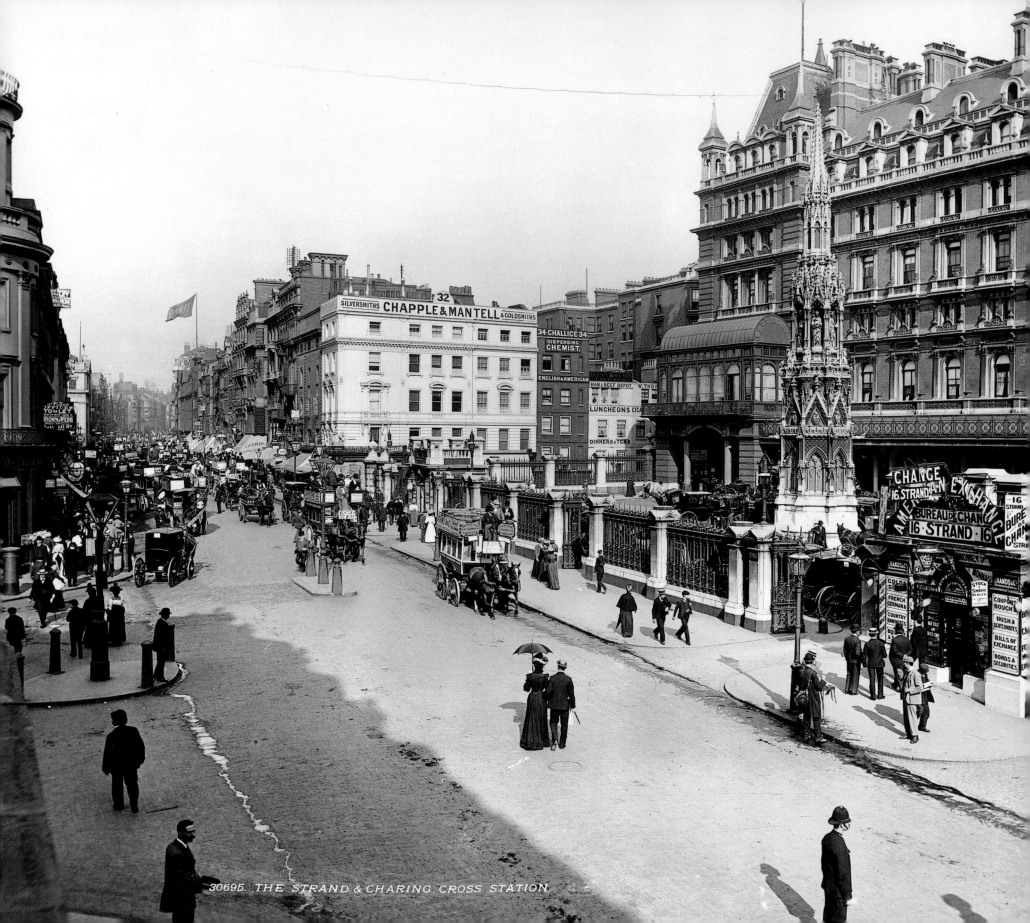

30695. THE STRAND & CHARING CROSS STATION

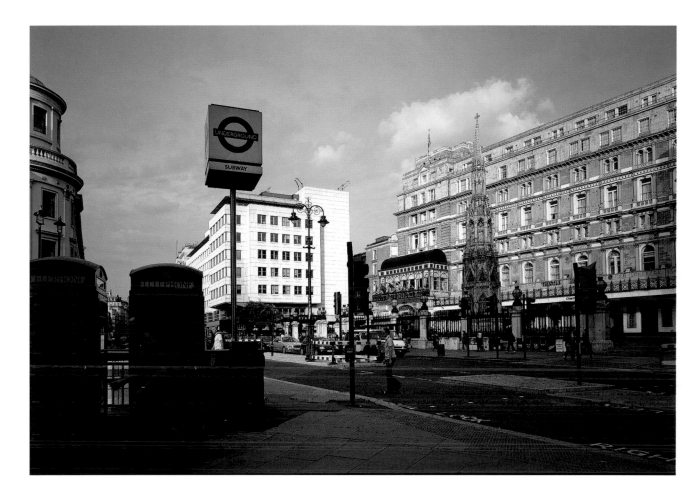

CHARING CROSS STATION

With Edward Barry's Victorian replica of the medieval Eleanor Cross

Left: Charing Cross Station, on the Strand, opened in 1864 on the site of the old Hungerford Market, a fruit and vegetable market that rivalled nearby Covent Garden. Like most London stations, it boasted a grand railway hotel designed by Edward Barry. Passengers could travel to Dover and on to France from Charing Cross, hence the foreign money exchange in front of the station. In addition to the hotel, Barry also designed a replica of the medieval Eleanor Cross, which is in the forefront of the picture. When Queen Eleanor, wife of King Edward I, died, a cross was placed at each of the locations where her funeral cortege rested en route to burial at Westminster Abbey.

Above: Today horse-drawn buses have been replaced by the London Underground, which opened at this location in 1907. The distinctive London Underground logo, which dates to the 1930s, can be seen on the left of the photograph. Travellers to France now prefer to take the Eurostar train from St. Pancras International, but Charing Cross is still a popular terminal for workers commuting into central London from the southeast.

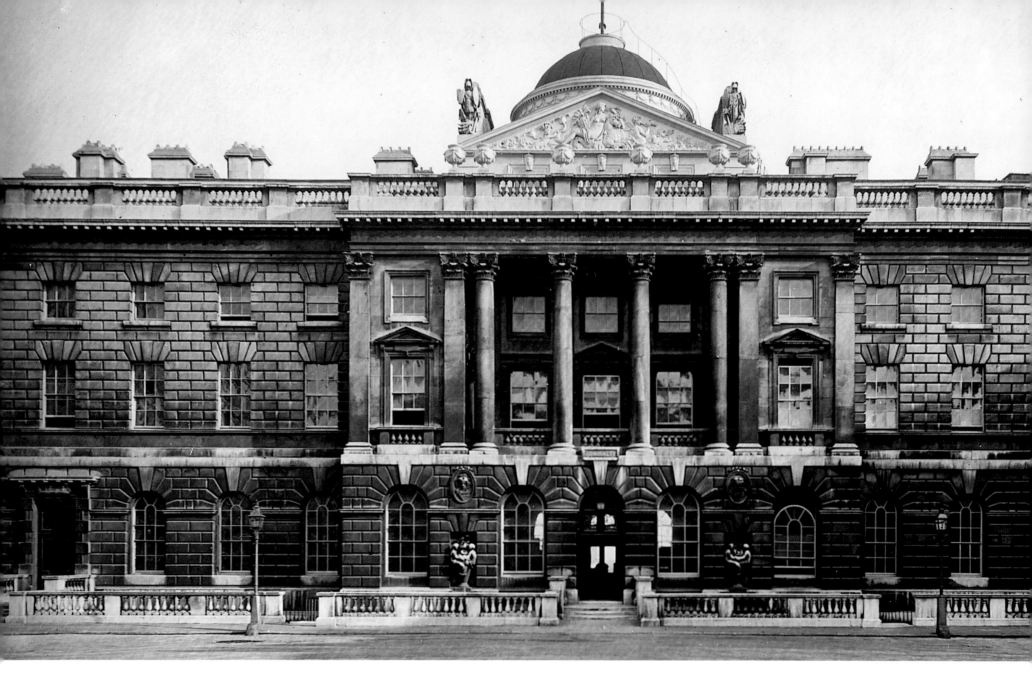

SOMERSET HOUSE

London's first specially designed government office building

Built in 1775 on the site of a Tudor palace, Somerset House was London's first specially designed government office building. Over the years it housed such disparate organizations as the Duchy of Cornwall, the Royal Academy of Arts, the Navy Office, the Inland Revenue, the register of births, marriages and deaths, as well as learned societies such as the Society of Antiquaries. Charles Dickens's father worked here at the Navy Office and Lord Nelson visited on several occasions. For many years, the courtyard was empty, as access was granted only to those who worked there.

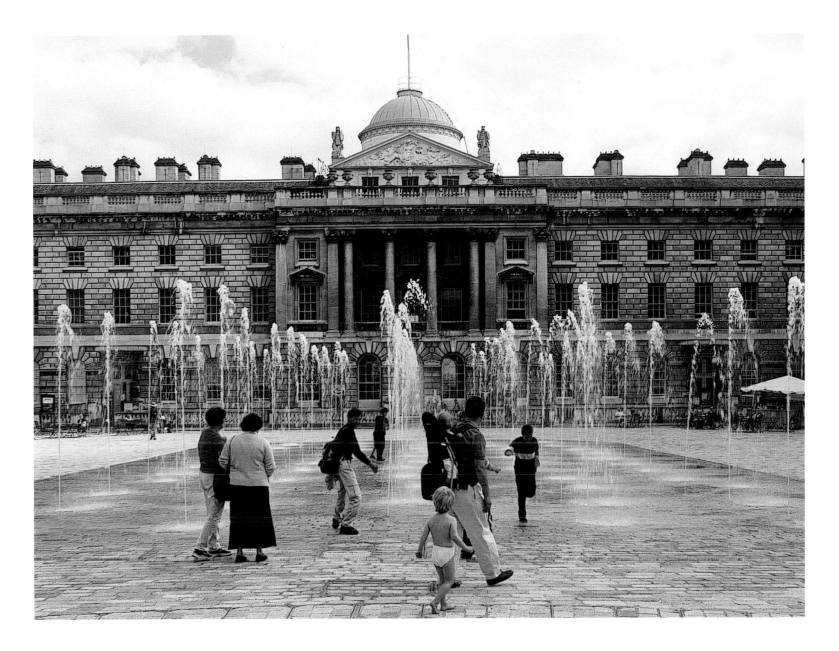

Today Somerset House looks much the same, but most of the old organizations have gone, replaced by the Courtauld Institute and Gallery, the Witte Art Library, the Hermitage Rooms and the Gilbert Collection of Silver. The Inland Revenue remains, but its staff no longer has exclusive access to the courtyard. Visitors to the galleries can take refreshment in the old Seamen's Waiting Hall and on a hot day, they can cool down among the courtyard fountains. At Christmas the fountains are replaced by an open-air ice rink, where skaters glide and tumble to the strains of classical music.

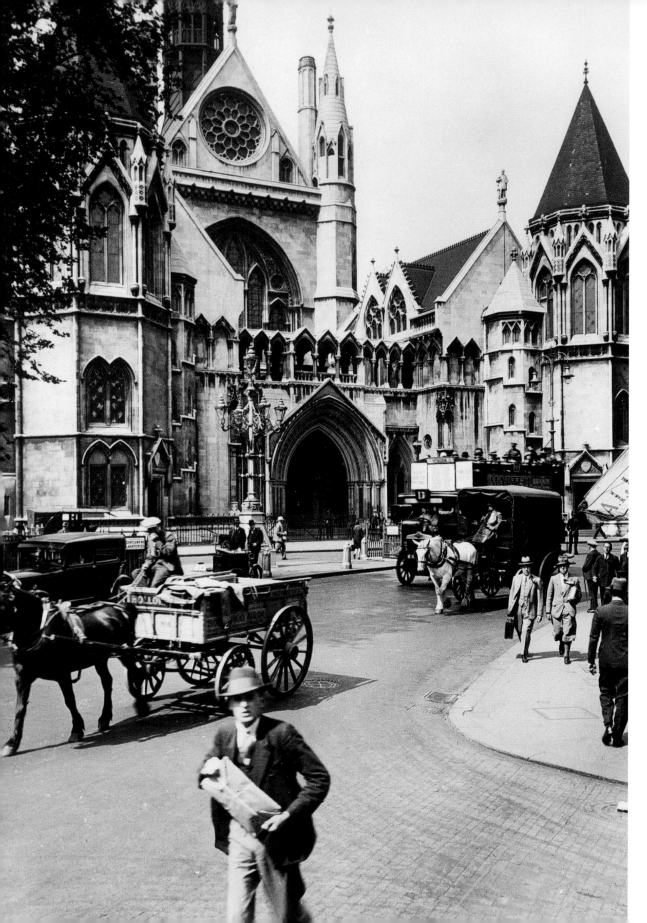

ROYAL COURTS OF JUSTICE

Designed by George Edmund Street and opened in 1882

Until the Royal Courts of Justice, seen here c. 1920, opened in 1882, trials were held either at Westminster Hall in the Palace of Westminster or at Guildhall in the City. The architect, George Edmund Street, usually designed churches and the Law Courts have the appearance of a magnificent Gothic cathedral. While criminal cases are heard at the Old Bailey in the City, civil cases and both civil and criminal appeals are heard here.

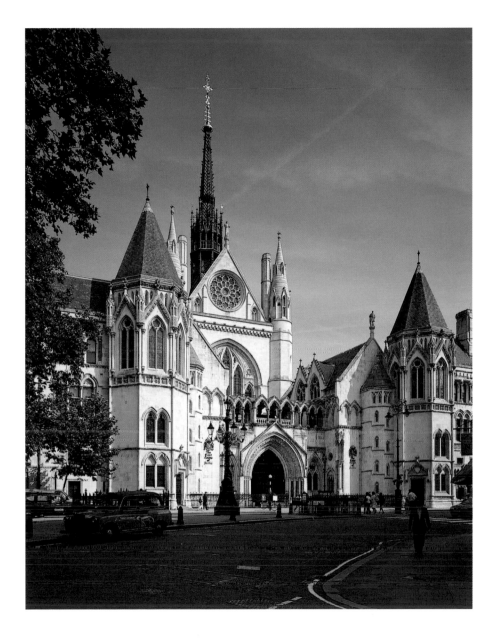

Today the Royal Courts of Justice provide a focus for members of the press awaiting the emergence of famous litigants. Elton John and George Michael are just some of the recent celebrities to appear in court here. On weekdays the courts are open to the public, who, in addition to witnessing a case, can admire the architecture, view the exhibits of historic legal costumes, or watch the barristers hurrying by in their distinctive wigs and gowns.

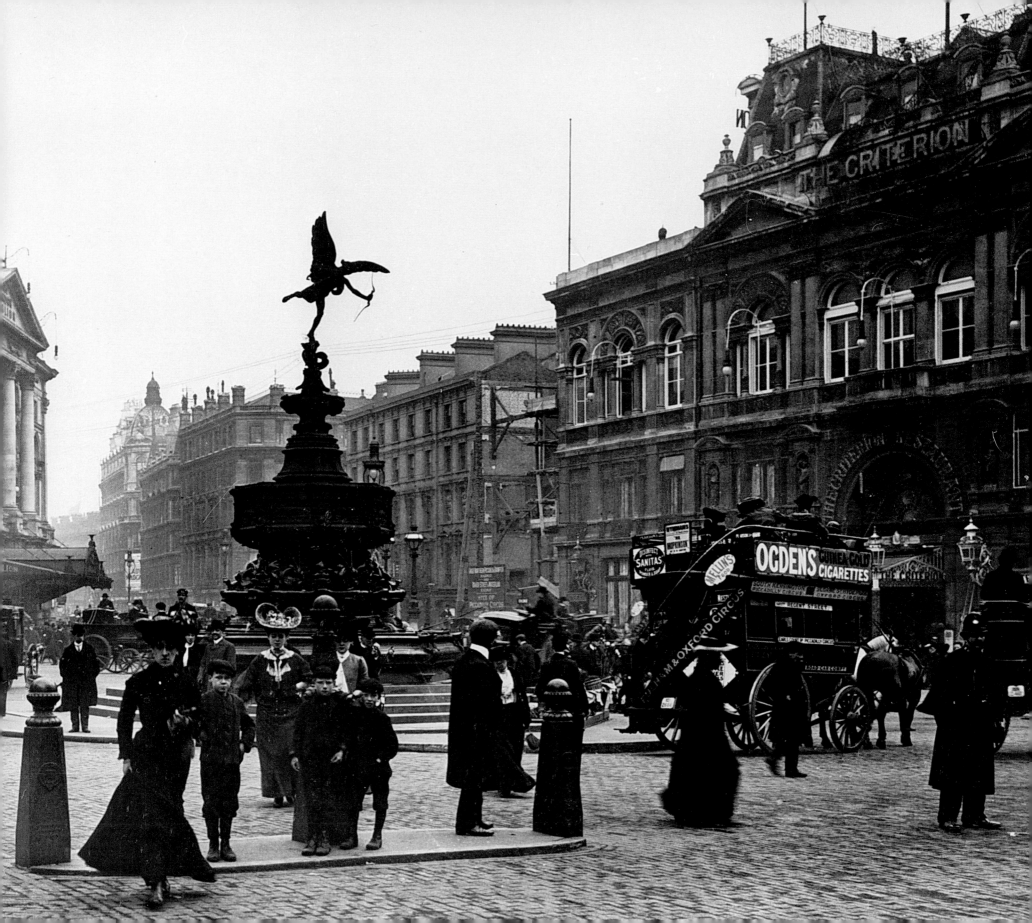

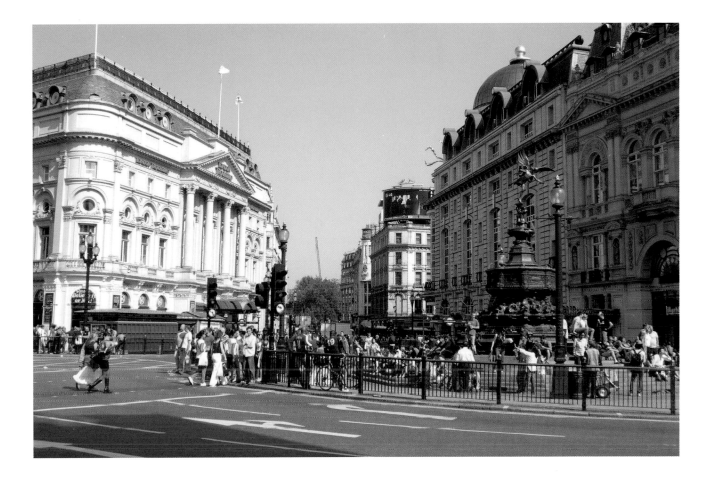

PICCADILLY CIRCUS

The London Pavilion, the Criterion and the statue of Eros

Left: Taken in the late 1890s, this photograph of Piccadilly Circus shows the London Pavilion on the left, which started as a supper room, became a music hall, and was later the home of spectacular revues. Another theatre, the Criterion, can be seen on the right. Built in 1874 beneath the Criterion Restaurant, this was one of the first underground theatres and air had to be pumped in to keep the audience from suffocating. In the centre of the picture is the famous statue of Eros, the Angel of Christian Charity, unveiled in 1893. It commemorates the nineteenth-century philanthropist and housing reformer the Earl of Shaftesbury.

Above: Piccadilly Circus looks much the same today. While the London Pavilion is now a shopping centre, the Criterion Theatre is still going strong and has been updated with air conditioning. Eros has been relocated to a pedestrian area and serves as a popular meeting place for visitors. On the left, beyond the frame of this photo, is the corner of one of Piccadilly's neon advertising signs. Illuminated advertisements first appeared in 1910, but were not allowed on the Regent Street side of the circus, which is owned by the Crown Estate and subject to strict planning regulations.

BURLINGTON HOUSE

Where the Earl of Burlington entertained Alexander Pope and Handel

Started in 1665 by architect Sir John Denham for his own occupation and sold unfinished to the first Earl of Burlington, Burlington House was one of many grand mansions that once lined Piccadilly. Most had been demolished by the time this photograph was taken in 1900, but Burlington House was a survivor. The third Earl of Burlington, after a grand tour of Europe, asked Palladian architect Colen Campbell to remodel the house on Italian lines. The earl was a great patron of the arts and invited authors John Gay and Alexander Pope, and the composer Handel to dine there.

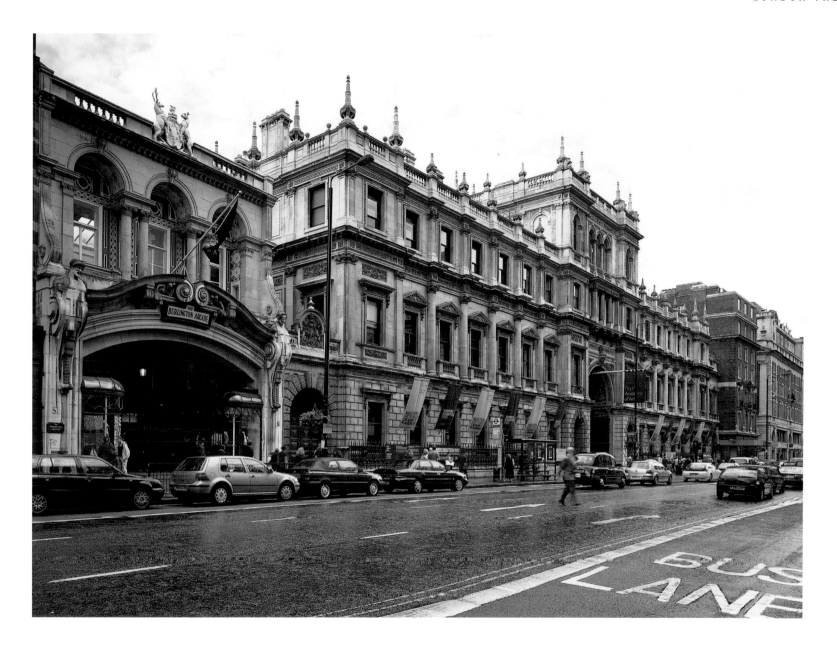

The exterior of Burlington House still retains its Italianate appearance. In 1854, the house became the home of the Royal Academy of Art and six learned societies, which moved here from Somerset House. The Royal Academy and some of the societies remain. Outside are banners advertising the academy's famous Summer Exhibition, which shows the work of contemporary artists who have been selected from over 10,000 entries.

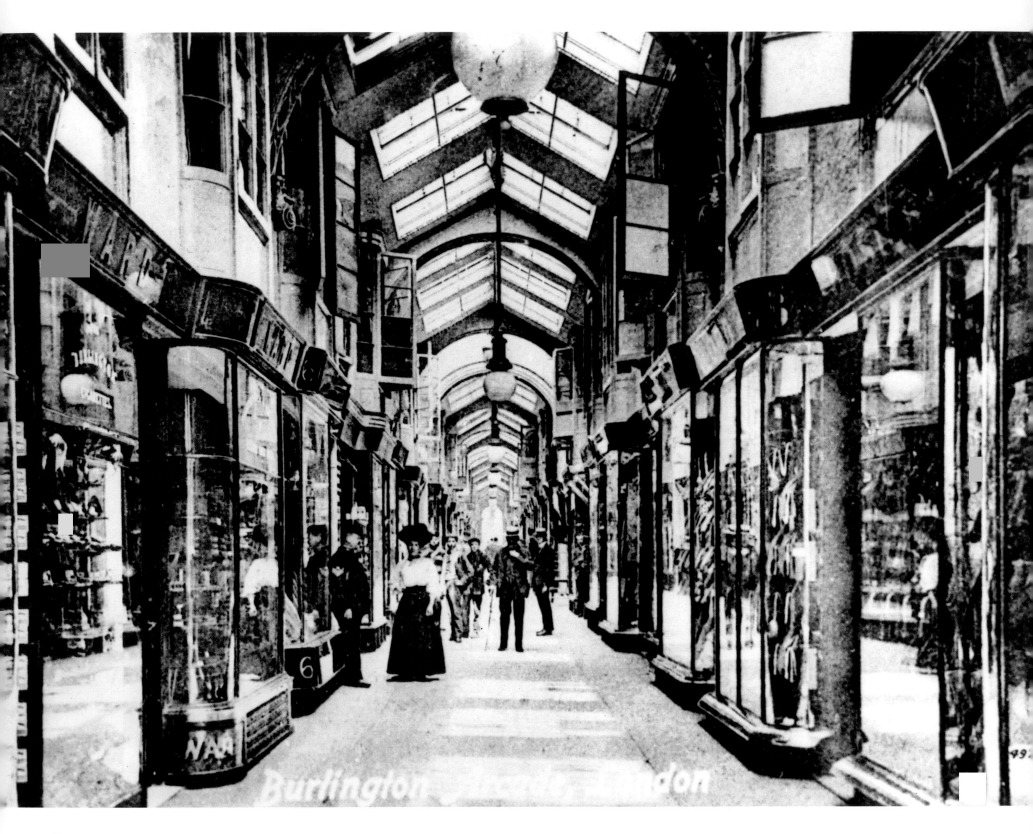

Burlington Arcade, London

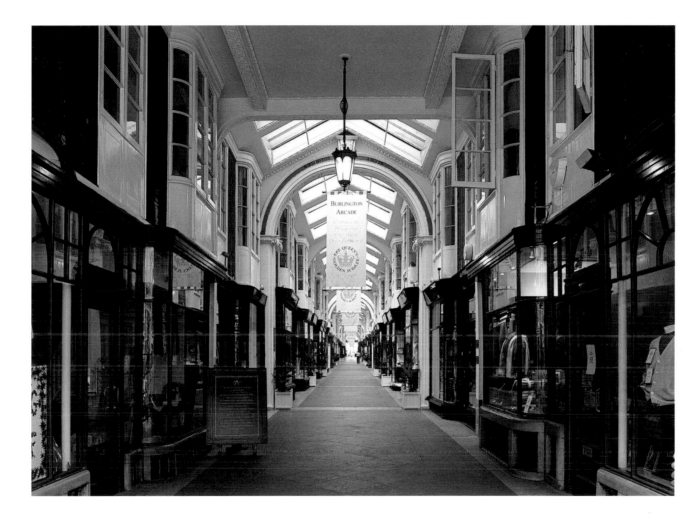

BURLINGTON ARCADE

Constructed in 1819 by Samuel Ware for Lord George Cavendish

Left: The interior of the exclusive Burlington Arcade, shown here in 1910, was constructed in 1819 by Samuel Ware for Lord George Cavendish, who was living in Burlington House at the time. It was built to cover an alley next to the house, which was a much frequented shortcut to Piccadilly. People using the alley threw their litter, including oyster shells, over the wall and into Lord Cavendish's private garden.

Above: Today the interior of the arcade looks the same. Restored after bomb damage during World War II, the shops sell luxury goods, including jewellery, gifts and cashmere knitwear. Uniformed guards (known as beadles) still wear Edwardian frock coats and top hats to enforce the arcade's rules, which include "no singing, running or carrying open umbrellas".

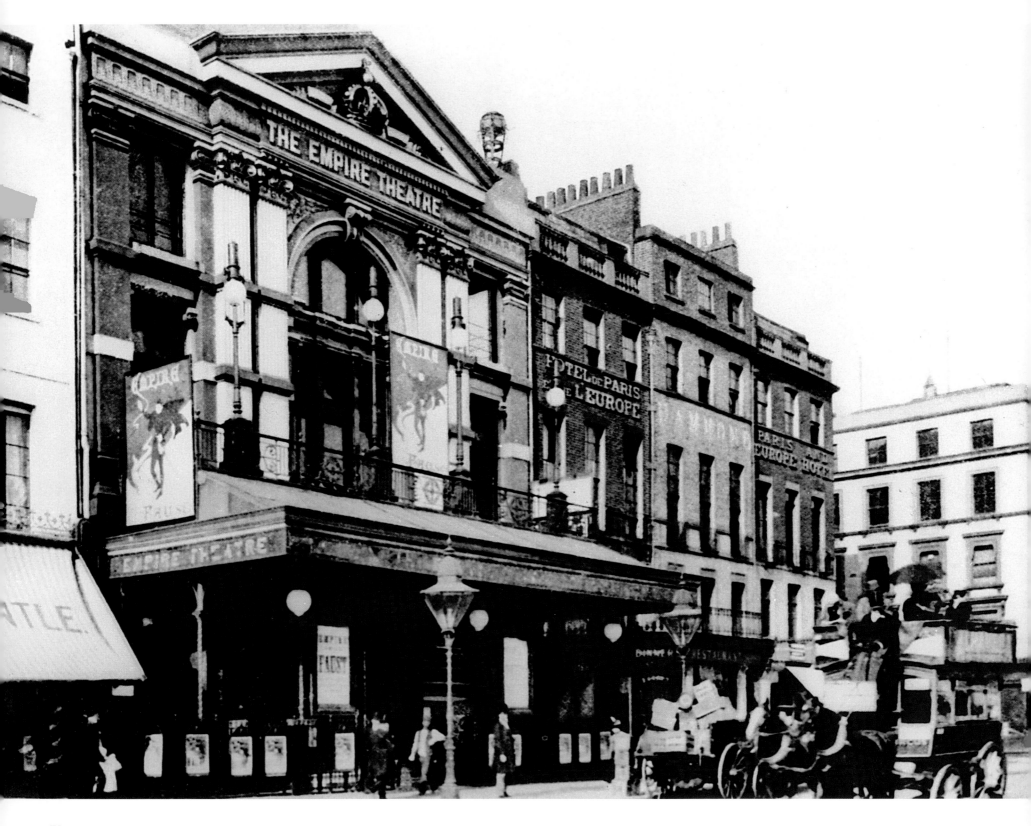

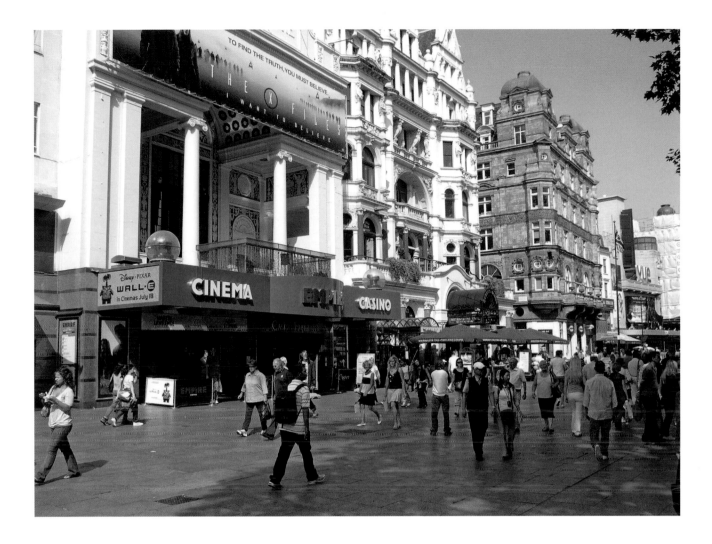

EMPIRE THEATRE, LEICESTER SQUARE

A popular venue where young gentlemen could meet good-time girls

Left: The Empire Theatre, Leicester Square, shown here in 1900, opened in 1881 as the Royal London Panorama and was later converted to a variety theatre and music hall. The back of the theatre was a notorious promenade where young gentlemen met good-time girls. When screens were erected to separate the promenade from the auditorium, they were destroyed by a rowdy audience, which included a young Winston Churchill.

Above: By 1928 films had replaced variety as popular entertainment and the old Empire Theatre was demolished and replaced by a cinema. The architect Thomas Lamb had designed the Albee Cinema in Cincinnati and the Empire's facade was almost identical to this, while the tea room and lobby were based on Lamb's design for the Capital Theater in New York City. Films were accompanied by spectacular stage shows in the manner of New York's Radio City. Reconstructed in 1962, part of the building is now a nightclub.

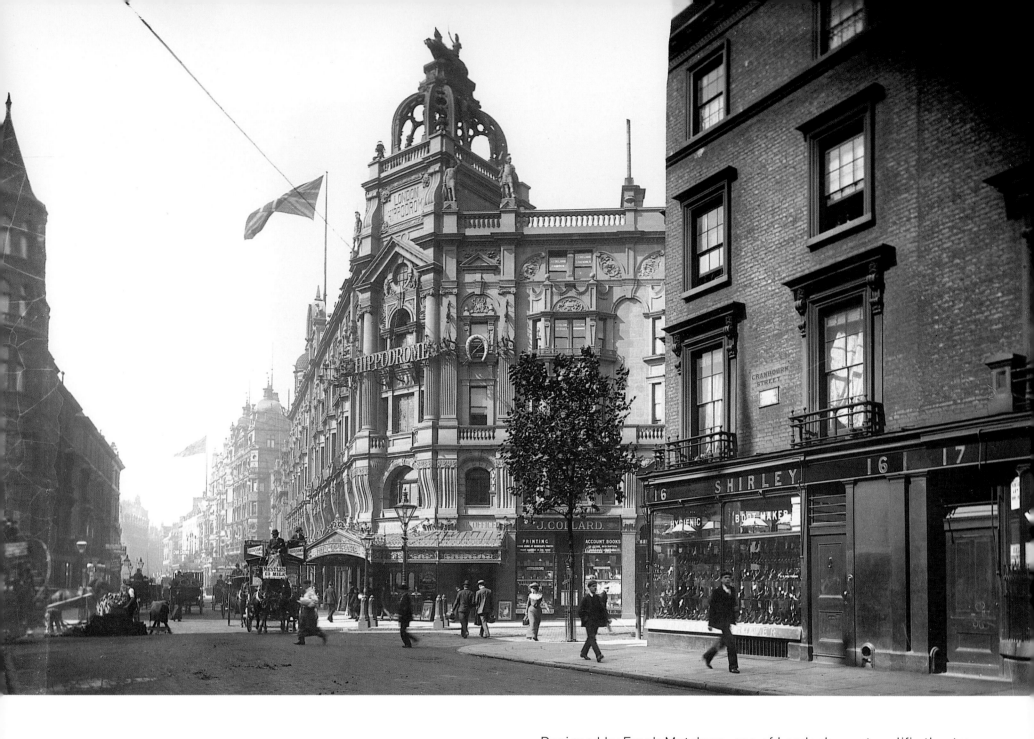

THE HIPPODROME

Offering variety shows, a circus and aquatic performances

Designed by Frank Matcham, one of London's most prolific theatre architects, the Hippodrome opened in 1900. Seen here in 1902, it provided spectacular entertainment, variety shows, a circus and aquatic performances. The circus arena could be transformed into a tank holding a hundred thousand gallons of water. The opening part of the show included 20 elephants and 70 polar bears.

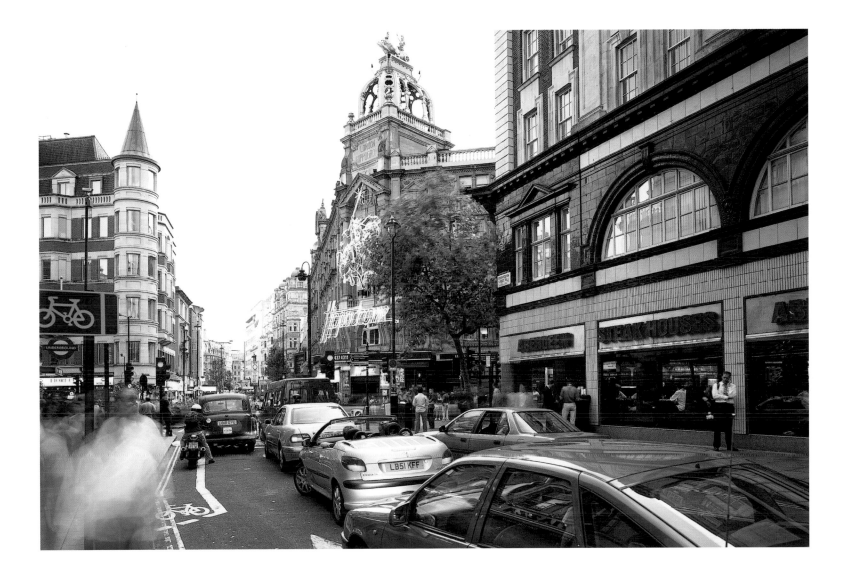

In 1912, new management adapted the Hippodrome for musicals
and revues, such as the Folies Bergère. By the 1960s, it had become
a cabaret restaurant, and today it is a nightclub. Still dominating
the corner of Cranbourne Street and Charing Cross Road, the
Hippodrome has lost its elaborate canopy, but has retained its
tower and horse-drawn chariot, a reminder of the horses that
once appeared here in its circus days.

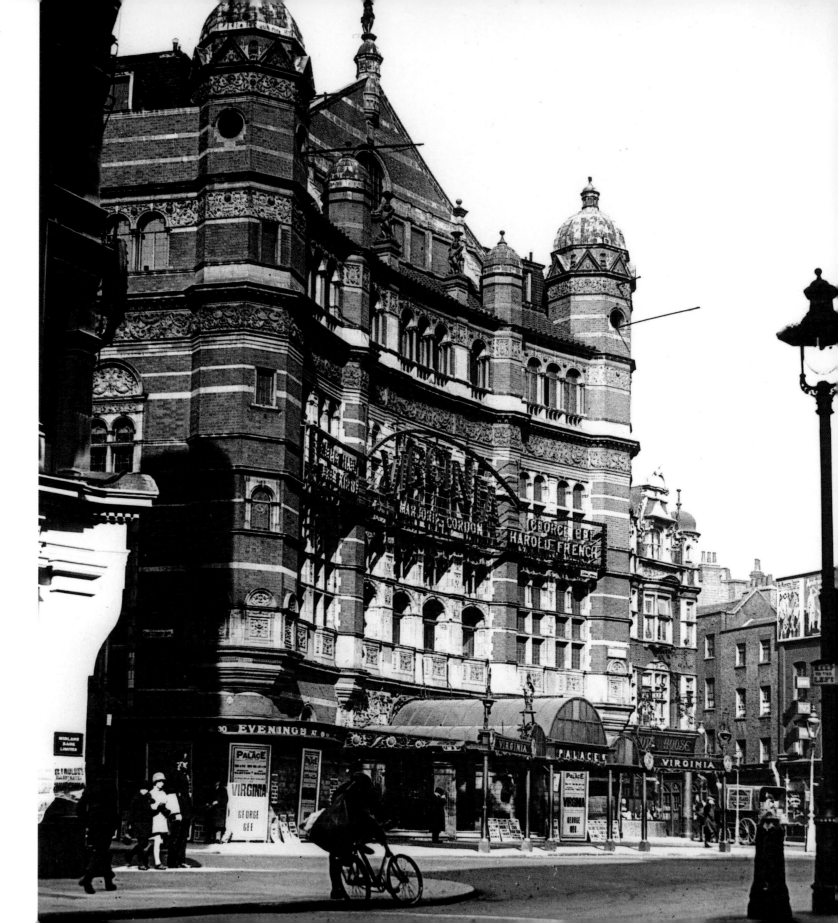

PALACE THEATRE

Where the ballerina Anna Pavlova made her debut

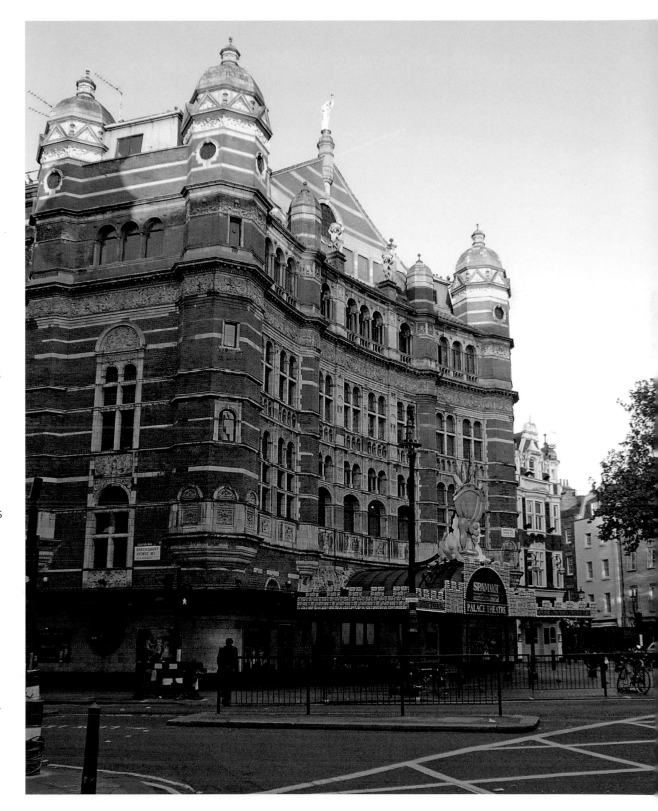

Left: The Palace Theatre was designed in 1891 by Colcutt and Holloway for Richard D'Oyly Carte, producer of Gilbert and Sullivan's operas. It was to be the Royal English Opera House, a home for operas by English composers, but *Ivanhoe* by Arthur Sullivan was the first and only English opera to be performed here. Eventually D'Oyly Carte sold the building and it reopened as the Palace Theatre of Varieties. Ballerina Anna Pavlova made her debut here. Later, as the Palace Theatre, it became the home of musicals including *No, No, Nanette* and *On Your Toes*. In 1928, when this photograph was taken, *Virginia* was playing here.

Right: Little has changed and the Palace Theatre still stands on its island site today as one of the most impressive theatre buildings in London. Musicals continued here with a brief interval in the 1950s for straight plays, such as John Osborne's *The Entertainer*, starring Laurence Olivier and his future wife Joan Plowright, who played his daughter. Notable musicals included *The Sound of Music* and *Cabaret*, starring a young Judi Dench as Sally Bowles. After *Jesus Christ Superstar* enjoyed a successful run, composer Andrew Lloyd Webber bought the theatre with a view to staging his own musicals here. *Les Miserables* played here between December 1985 and March 2004.

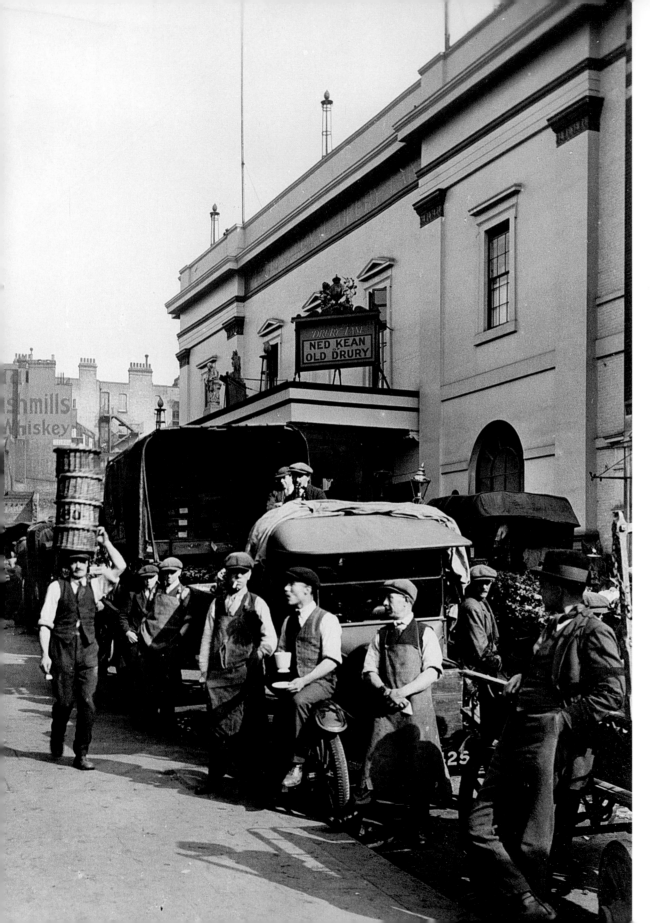

THEATRE ROYAL DRURY LANE

Nell Gwynn worked here as an orange seller and actress

Built in 1812, the Theatre Royal Drury Lane is the fourth theatre on the site. The first opened here in 1663 after a period when all London theatres had been closed under the Puritans. Personalities associated with Drury Lane include actress Nell Gwynn, who worked here as an orange seller and actress, the great actor/manager David Garrick, and playwright Richard Brinsley Sheridan. This picture, taken in 1923, shows the theatre surrounded by market porters and delivery vans from the nearby Covent Garden fruit and vegetable market.

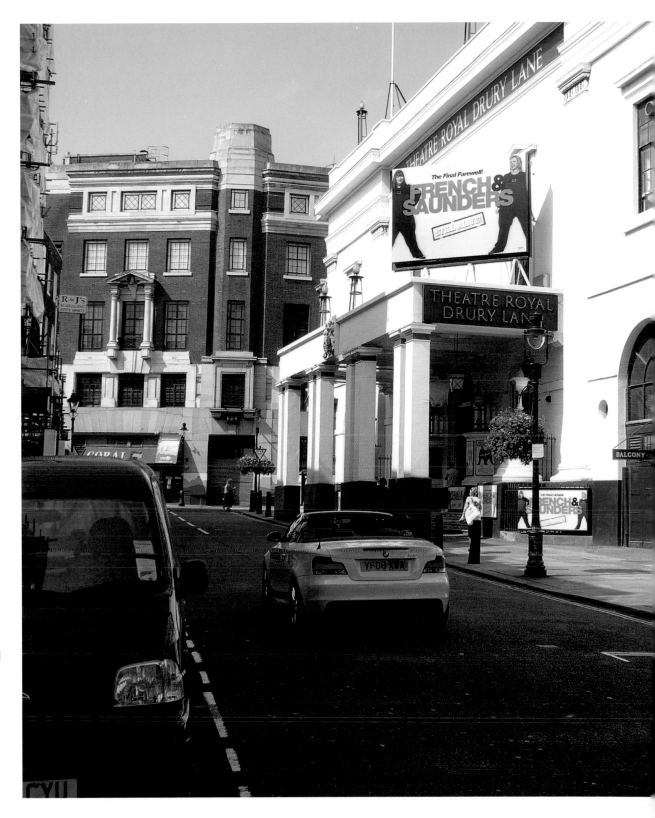

During the twentieth century, Drury Lane became the home of lavish musicals. In 1958, the original stage production of *My Fair Lady*, starring Julie Andrews and Rex Harrison, broke all box-office records. These records were surpassed by *Miss Saigon*. The 2001 production of *My Fair Lady*, with its opening scenes set in nearby Covent Garden, drew audiences once again. The market has now relocated and the porters have moved on.

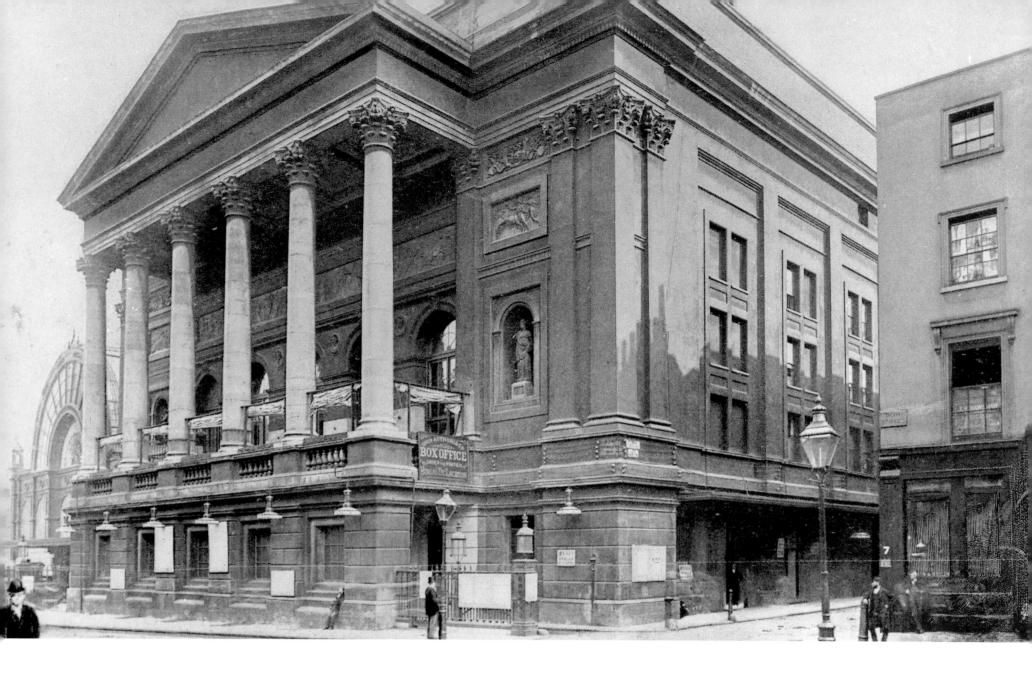

ROYAL OPERA HOUSE

The Royal Opera House was the third theatre on this site

The Royal Opera House, shown here in 1896, was the third theatre on the site. The previous two had burned down (theatre fires were a common occurrence in eighteenth- and nineteenth-century London). Originally known as the Covent Garden Theatre, it was the home of serious drama and the stage was graced by John Philip Kemble, Sarah Siddons and Edmund Kean. Opera was performed occasionally and

Handel's *Messiah* made its English premiere here. The theatre officially became the Opera House in 1847. Nine years later, it was destroyed by fire and the building seen in the photograph was opened in 1858. The architect E. M. Barry also designed the Floral Hall next door, which was initially used as a flower market.

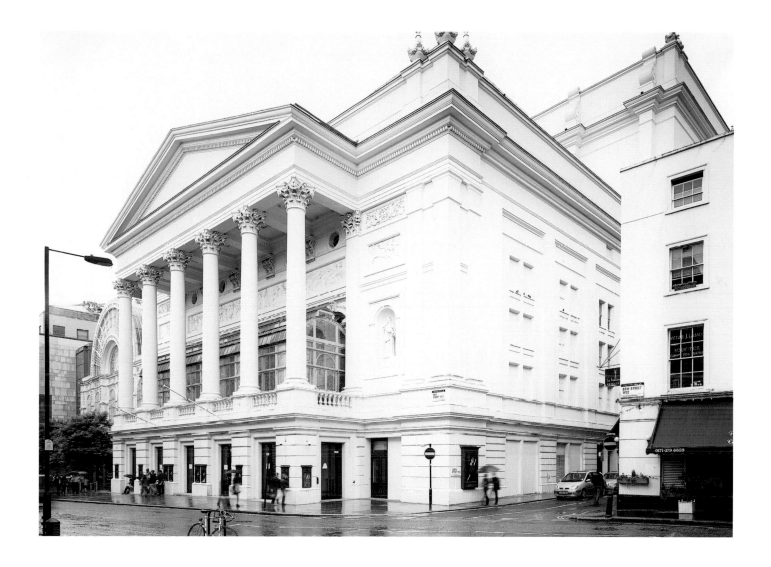

The Royal Opera House recently enjoyed a face-lift and Barry's
exterior and auditorium have been preserved. The Floral Hall, with
its curved roof to the left of the theatre, has also been refurbished
and now enjoys a new lease of life as an atrium and circulating area
for audiences. Since 1946, the opera company has been joined by
the Royal Ballet and studio theatres used for opera and ballet are
part of the building's new extension.

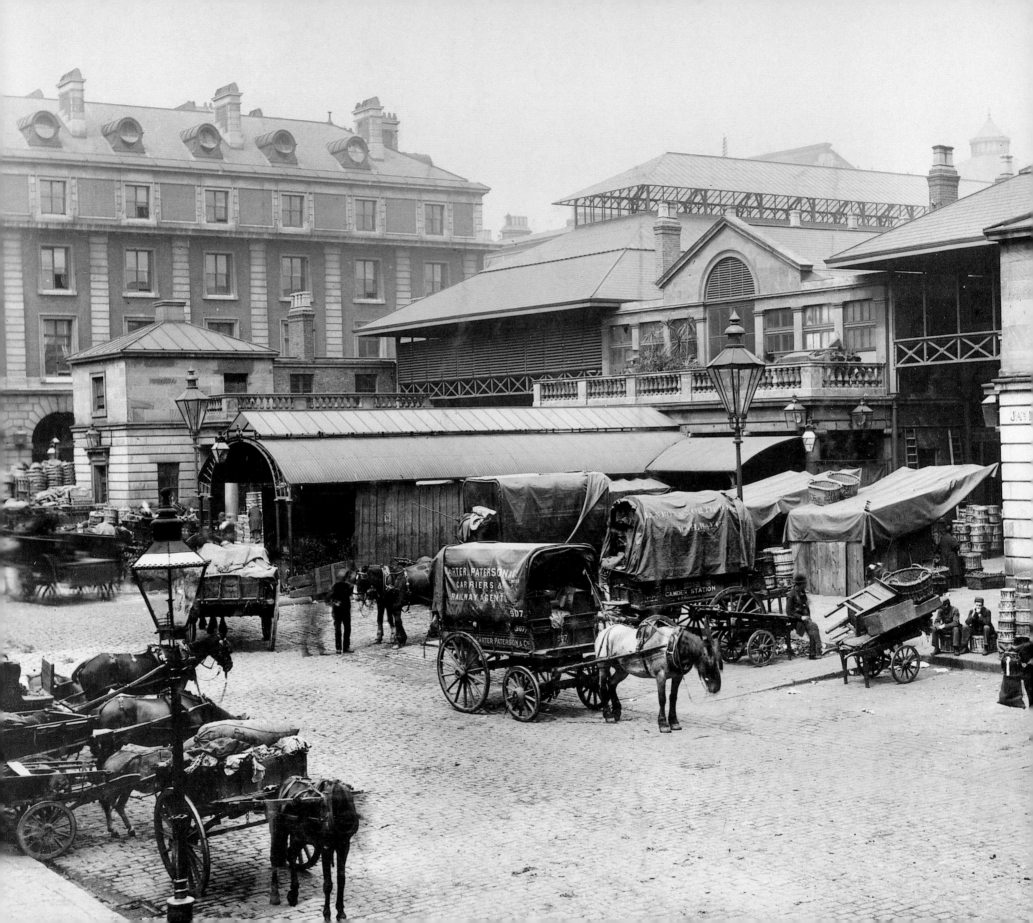

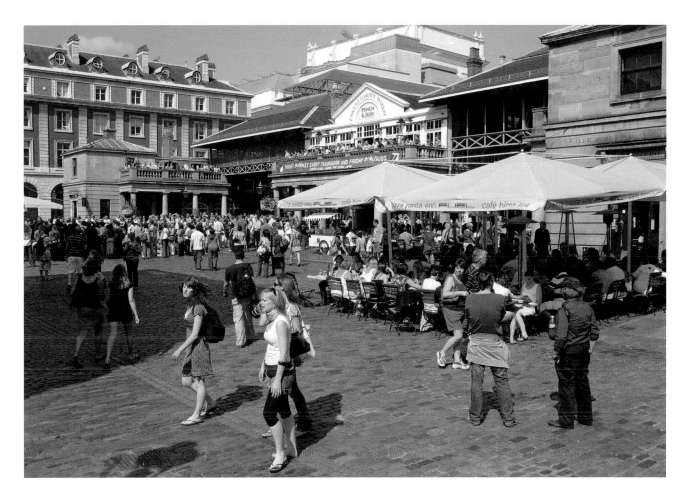

COVENT GARDEN MARKET

Inigo Jones designed the grand piazza surrounded by houses

Left: Covent Garden was once a market garden run by the monks of Westminster Abbey. After the dissolution of the monasteries, King Henry VIII granted the land to the Earl of Bedford. Francis Russell, the third earl, decided to develop his land and the architect Inigo Jones designed a grand piazza surrounded by houses. The earl allowed the market to continue and it grew into London's major wholesale fruit and vegetable market. Charles Fowler's central market hall was erected in 1830.

Above: The market relocated south of the river in 1974 as central London was becoming too congested and the narrow streets around Covent Garden couldn't cope with traffic generated by the market. After the closure, the buildings were refurbished and Covent Garden is now a lively area full of shops, restaurants and street entertainers. The upper floor of the market contains a pub called The Punch and Judy, a reminder of the puppet shows performed in the piazza as early as 1662, and recorded by the famous diarist Samuel Pepys.

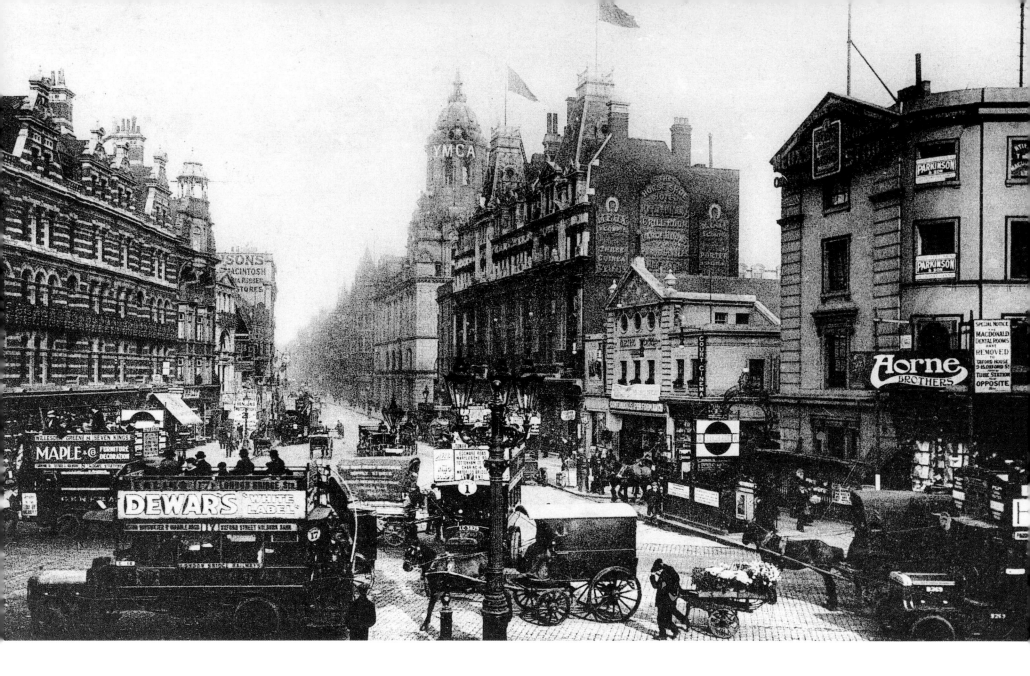

TOTTENHAM COURT ROAD

Once a market road leading to Tottenhall Manor House

Tottenham Court Road was once a market road leading to the Tottenhall Manor House, home of the Duke of Grafton. It was still surrounded by fields until the late eighteenth century, but by the time this photograph was taken around 1912, it was the centre of the London furniture trade. The motor bus on the left is advertising Maples, one of the major furniture stores. On the right is the Court Cinema, which was closed in 1918 under the Trading with the Enemy Amendment Act, because of its German manager. Next to the cinema is Meux's Brewery, The Horseshoe public house and the tower of the YMCA.

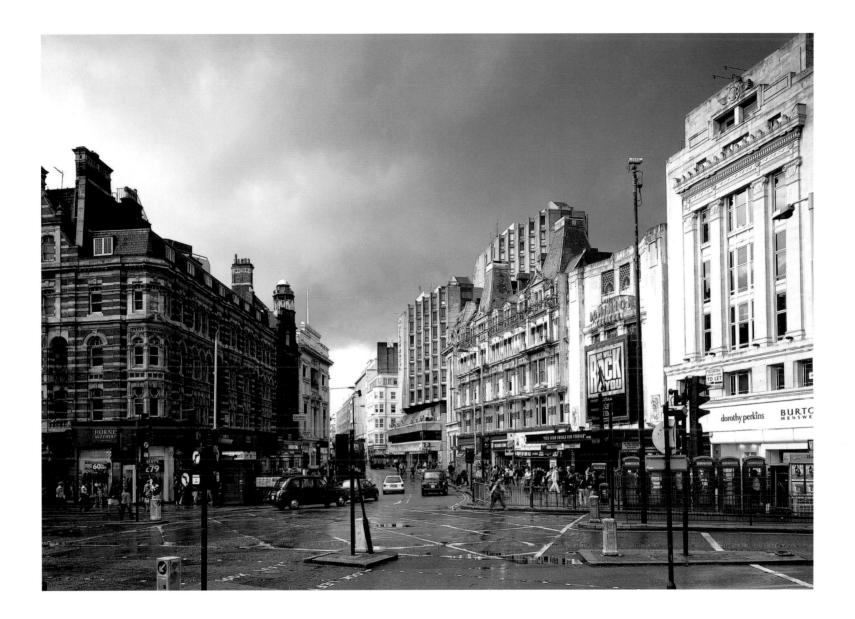

Tottenham Court Road's furniture stores have since been joined by shops selling the latest technology in computer and audio-visual equipment. The Dominion Theatre was built in 1930 on the site of the old Court Cinema and the auditorium was built on the site of the old Meux Brewery. Currently the theatre is showing the Queen compilation musical *We Will Rock You*. The Dominion was a cinema for many years, showing such classics as *Phantom of the Opera* with Lon Chaney and Charlie Chaplin's *City Lights*. The film version of *The Sound of Music* broke all records playing here from 1965 to 1968.

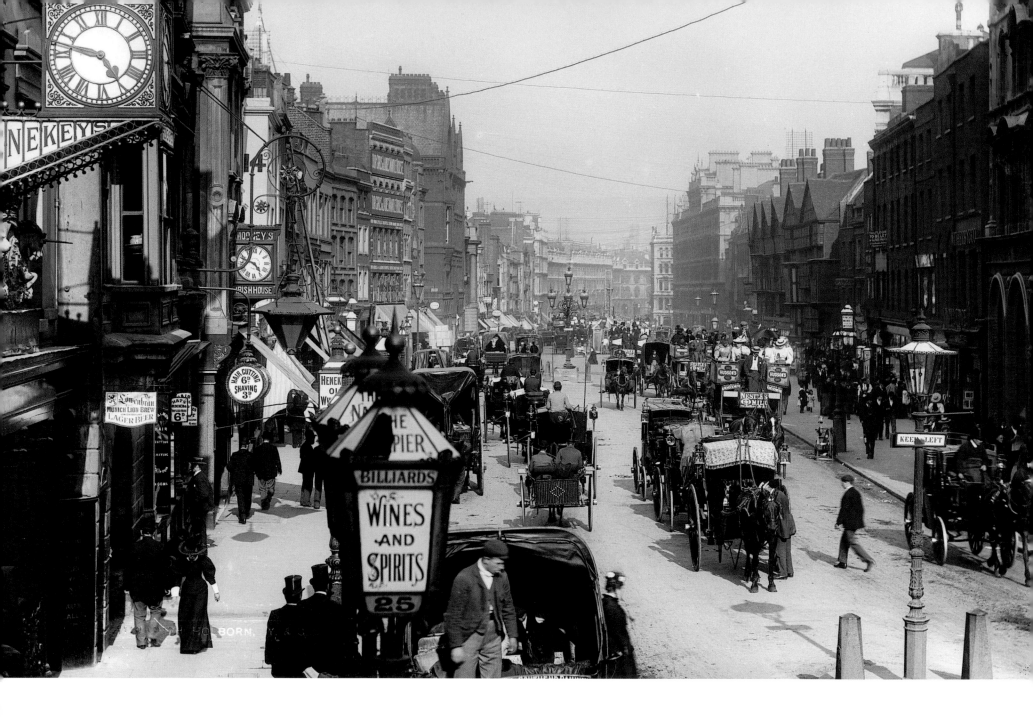

HIGH HOLBORN

A major highway since medieval times

High Holborn, seen here in 1890, has been a major highway since medieval times and, as a result, was lined with taverns. The prominent clock on the left belonged to Henekeys, the wine merchants who owned the premises until 1982. Further down on the left is the prominent roof of the Prudential Assurance Company's headquarters, later rebuilt in a more elaborate style. The gabled building on the right is the front of Staple Inn, one of the old Inns of Chancery where lawyers once trained before entering one of the Inns of Court.

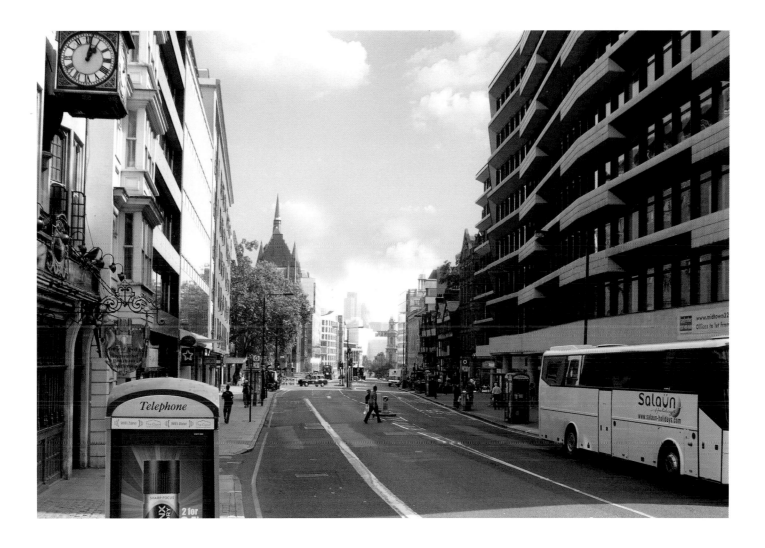

High Holborn is still a busy thoroughfare between the West End and the City and this picture was taken at a rare traffic-free moment. In the foreground is a modern telephone booth. These were added to the London streetscape in 1924 and some of the original phone booths designed by Giles Gilbert Scott are now listed monuments. The old Henekeys clock is still in position but the name has vanished. The pub is now the Cittie of Yorke, popular with the lawyers from nearby Grays Inn. In the distance on the left is the tower of the Prudential, enlarged in 1897 to cover the site of Furnival's Inn, where Charles Dickens lived when he was first married. Beyond the modern buildings on the right, the half-timbered frontage of Staple Inn still remains as a relic of old London.

FOUNDLING HOSPITAL /
CORAM'S FIELDS

Opened in 1745 as a home for abandoned or orphaned children

The Foundling Hospital, founded by retired sea captain Thomas Coram, opened in 1745 as a home for abandoned or orphaned children. Children were admitted by a ballot system and girls were trained for domestic service, while the boys learned trades or were encouraged to join the army. If left here by a single mother, the children were not allowed to see their mothers again. They were given new identities and some were even named after famous people of the time. There were many distinguished benefactors, including the composer Handel, who gave annual performances of *Messiah* to raise funds, and the artist William Hogarth, who organized some of London's first art exhibitions to benefit the hospital.

As London became more built up, the Foundling Hospital was not considered a good location for orphanages and they relocated to the countryside. The buildings were demolished but the colonnade remains, complete with the niches where distraught mothers would leave their offspring in the hope that the orphanage would train them for a better life. The fountain showing a kneeling girl with a jug of water remains, but Thomas Coram's statue, which stood above the entrance, has gone. Where the Foundling Hospital once stood, there is now a children's playground, park and the City Farm, which adults can enter if accompanied by a child. The area is known as Coram's Fields.

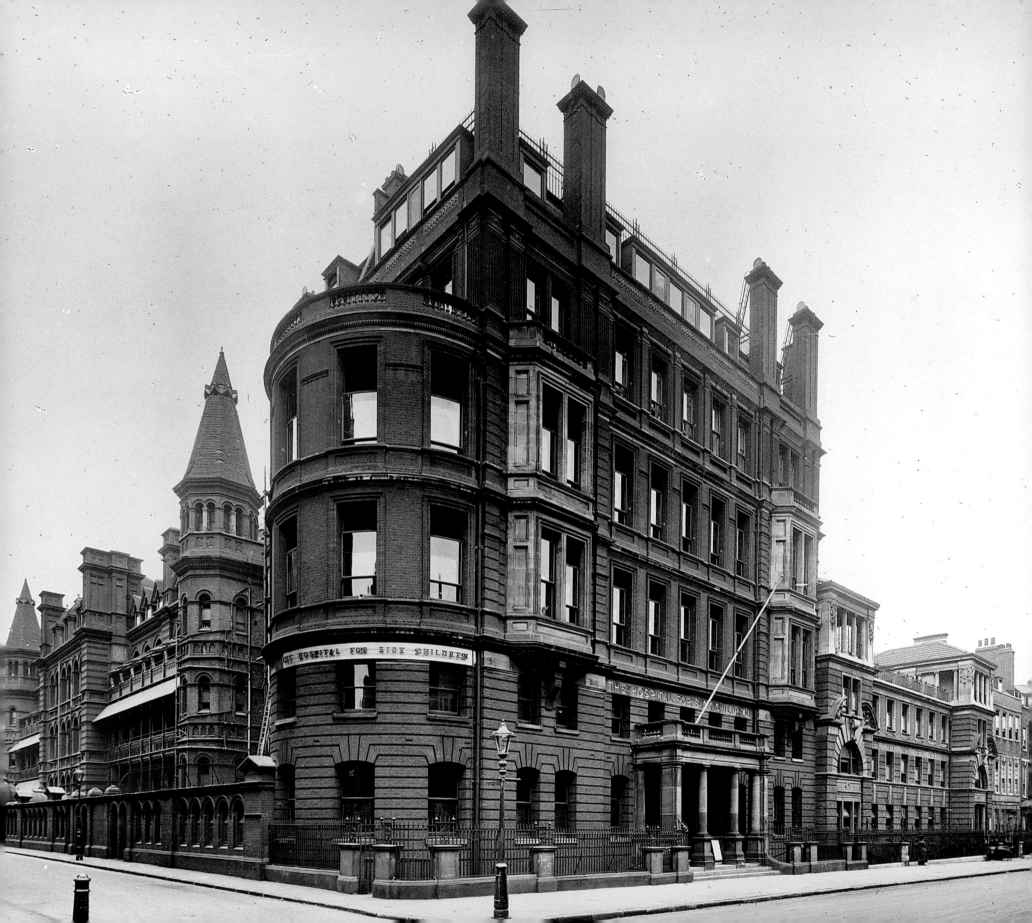

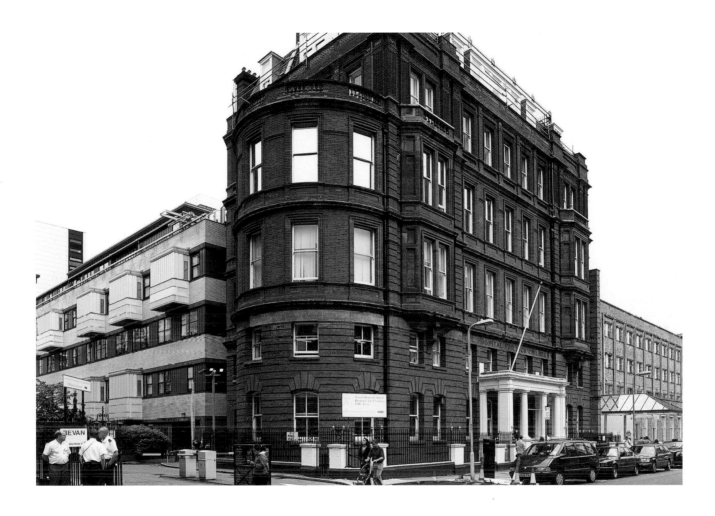

GREAT ORMOND STREET HOSPITAL

Charles Dickens helped raise money to build the hospital

Left: The Great Ormond Street Hospital for Sick Children opened in 1852 at a time when there were high rates of child mortality and no hospitals or wards solely for children. Charles Dickens helped raise the money to build the hospital with public readings of his novels and short stories. In 1929, another famous author, J. M. Barrie, left all future royalties from performances of *Peter Pan* to the hospital. The Victorian hospital buildings, designed by E. M. Barry, architect of the Royal Opera House, are shown here in 1872.

Above: Today only one late Victorian building remains. The rest of the Victorian hospital was demolished in the early 1990s. The modern hospital block was opened by the late Diana, Princess of Wales, and is a centre of excellence for critically ill children. Recent benefactors include film director Steven Spielberg, whose film *Hook*, a modern adaptation of *Peter Pan* starring Robin Williams, benefited the hospital.

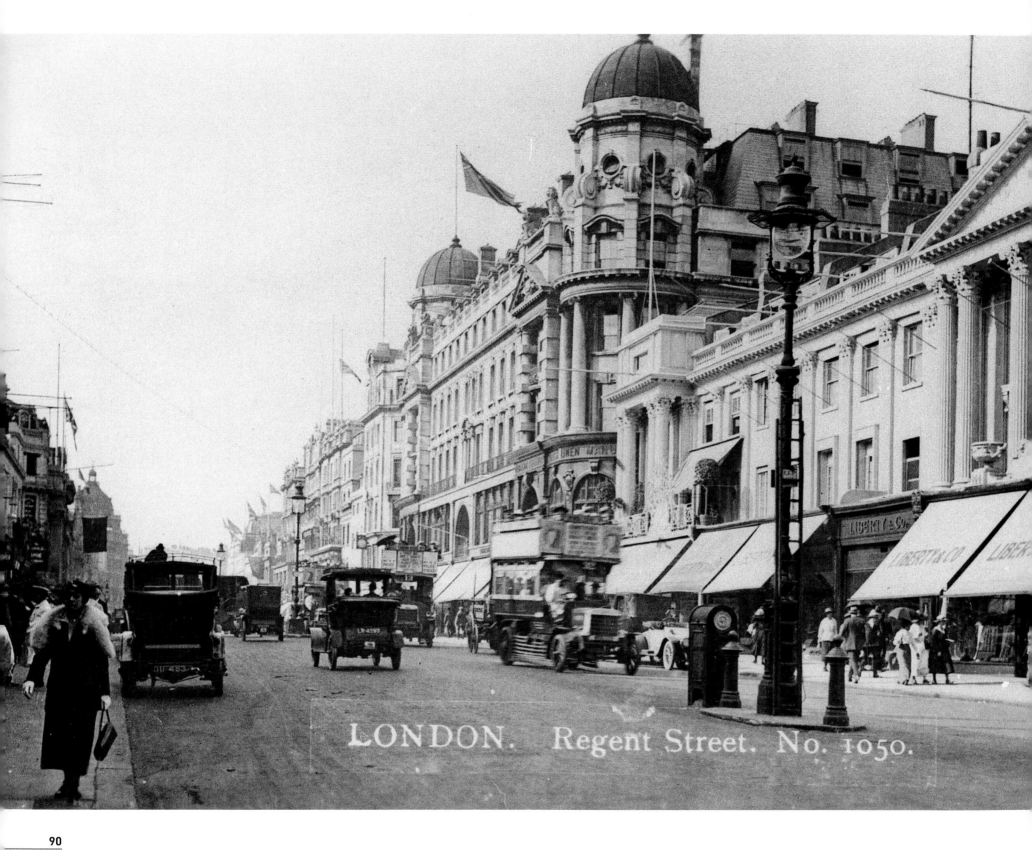

LONDON. Regent Street. No. 1050.

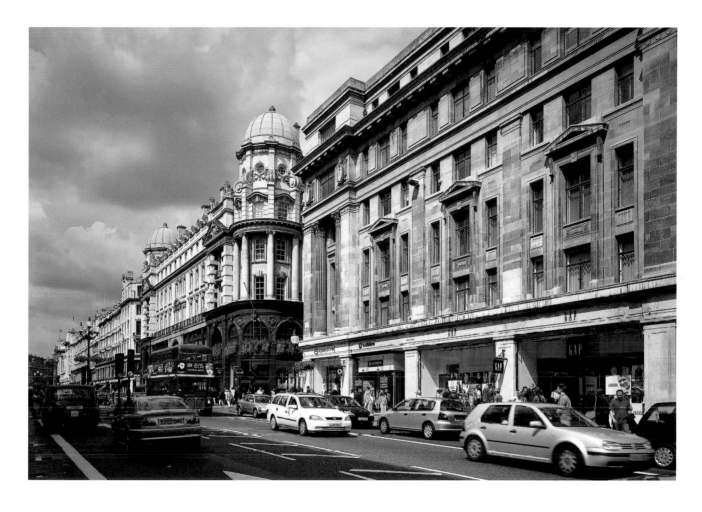

REGENT STREET

Designed by John Nash to link the home of the Prince Regent with Regent's Park

Left: Regent Street was designed by John Nash as part of a grand route to link Carlton House, the home of the Prince Regent (later King George IV), and Regent's Park, where the prince had asked Nash to build another grand house. This picture was taken in the early 1920s, shortly before the demolition of Chesham House, home of Liberty's department store. Famous for its distinctive fabrics and Arts and Crafts-inspired furniture, Liberty's past customers included Oscar Wilde, Gilbert and Sullivan, plus several pre-Raphaelite artists. The domed building housed Robinson and Cleaver, manufacturers and retailers of Irish linen.

Above: Today the Regency-style Chesham House with its Corinthian columns has gone, but the distinctive green-domed Robinson and Cleaver building remains, now home to a variety of businesses, including jewellers Mappin and Webb. In 1925, most of Regent Street was rebuilt and Liberty got a brand-new store further along the street. This well-established store now stands next to contemporary retailers.

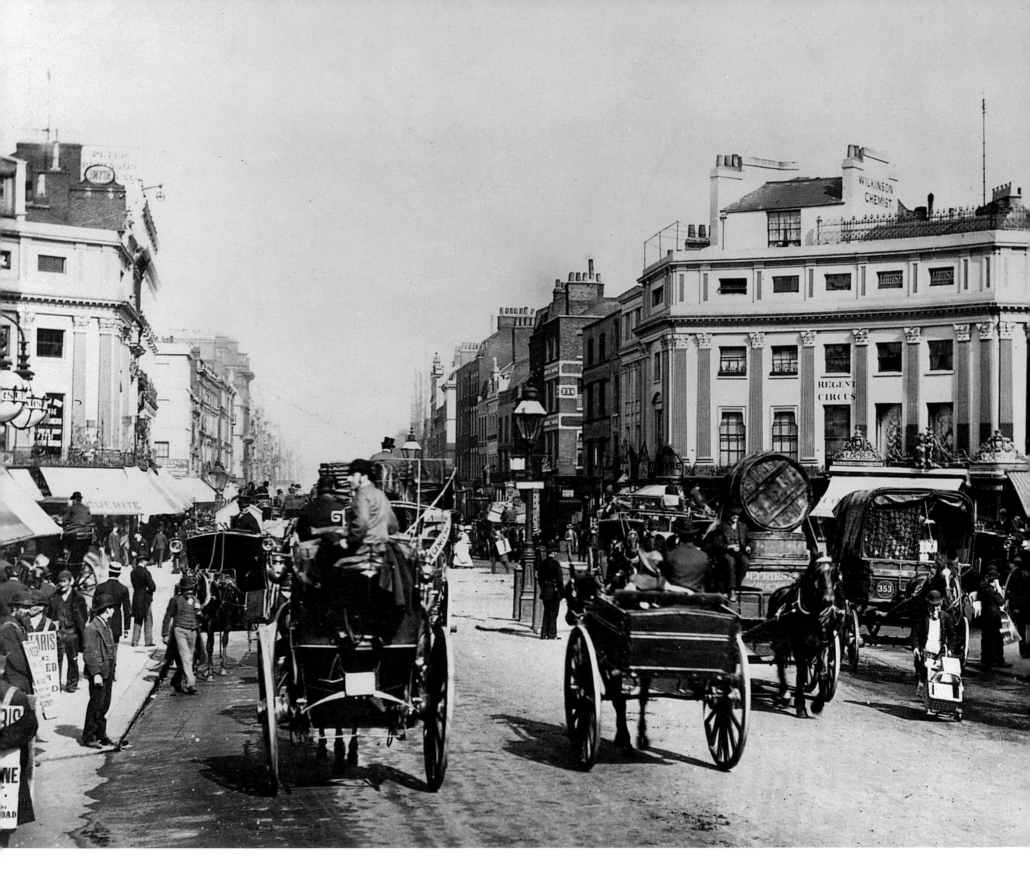

OXFORD CIRCUS

Originally known as the Road to Oxford

Left: This street was originally known as the Road to Oxford and later changed to Tyburn Way after the river that flowed nearby. When, coincidentally, the Earl of Oxford became the landowner, the name became Oxford Street. In the nineteenth century, its shops were interspersed with places of entertainment, such as the Princess Theatre and the Regent Hall, once a skating rink and now home of the Salvation Army. When department stores such as John Lewis arrived, the street became one of London's major shopping thoroughfares. This picture, taken in 1895, shows Oxford Street's junction with Regent Street, then known as Regent Circus, but now called Oxford Circus.

Above: In 1909, flamboyant American Gordon Selfridge opened his famous department store further along the street and this consolidated Oxford Street's reputation as a shopper's paradise. Today department stores such as Selfridges, Debenhams and John Lewis are still going strong while others come and go. The horse-drawn vehicles shown in 1895 have been replaced by buses and – below ground – the Tube. Oxford Circus Underground Station opened in 1900.

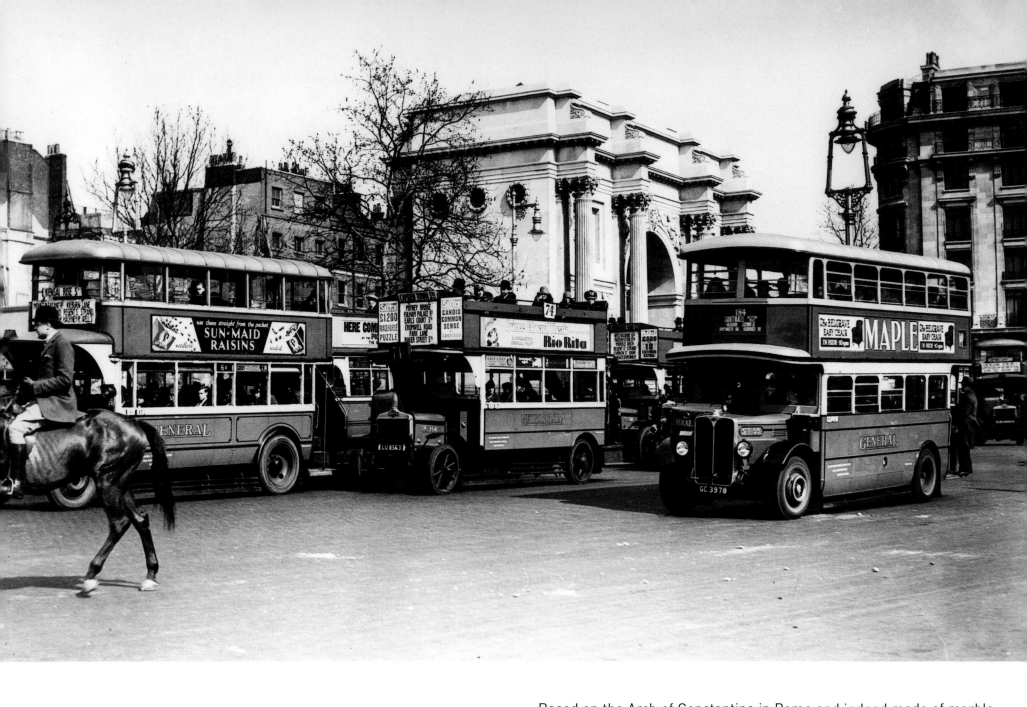

MARBLE ARCH

Moved from Buckingham Palace to its present location in 1851

Based on the Arch of Constantine in Rome and indeed made of marble, Marble Arch used to stand in front of Buckingham Palace as part of John Nash's redesign of the palace for King George IV. After further changes to the palace during the reign of Queen Victoria, this famous landmark moved to its current position at the top of Park Lane in 1851. It stands near the site of the old Tyburn Tree, where criminals and religious martyrs were hanged in front of large crowds. This picture, taken c. 1930, shows a horse rider, bravely manoeuvring among several buses, on his way to nearby Hyde Park.

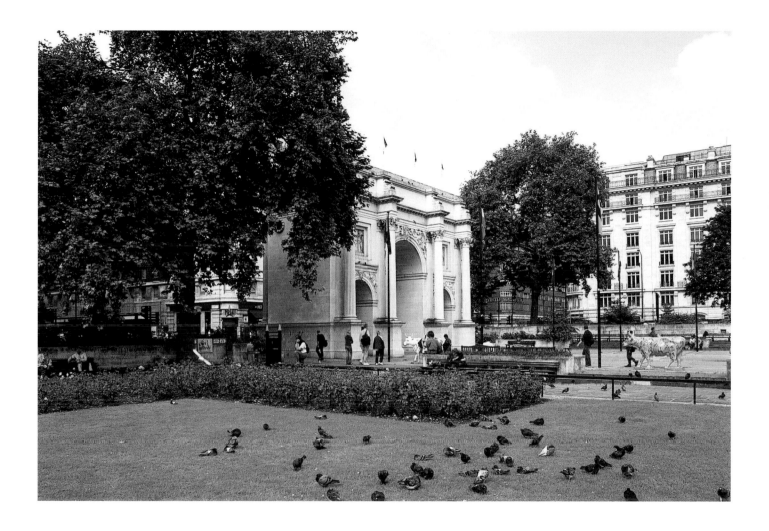

In the 1960s, the area around Marble Arch was redeveloped. Visitors managing to navigate the complicated system of subways nearby emerge in a pedestrian plaza where they can see the famous arch close up and admire elaborate carvings by sculptors Westmacott and Bailey. Pedestrians can walk through the arch, but only the Kings Troop Royal Horse Artillery and senior members of the royal family may ride through it. In nearby Tyburn Convent, an order of nuns exists to pray for the souls of the Catholic martyrs who died for their faith at Tyburn.

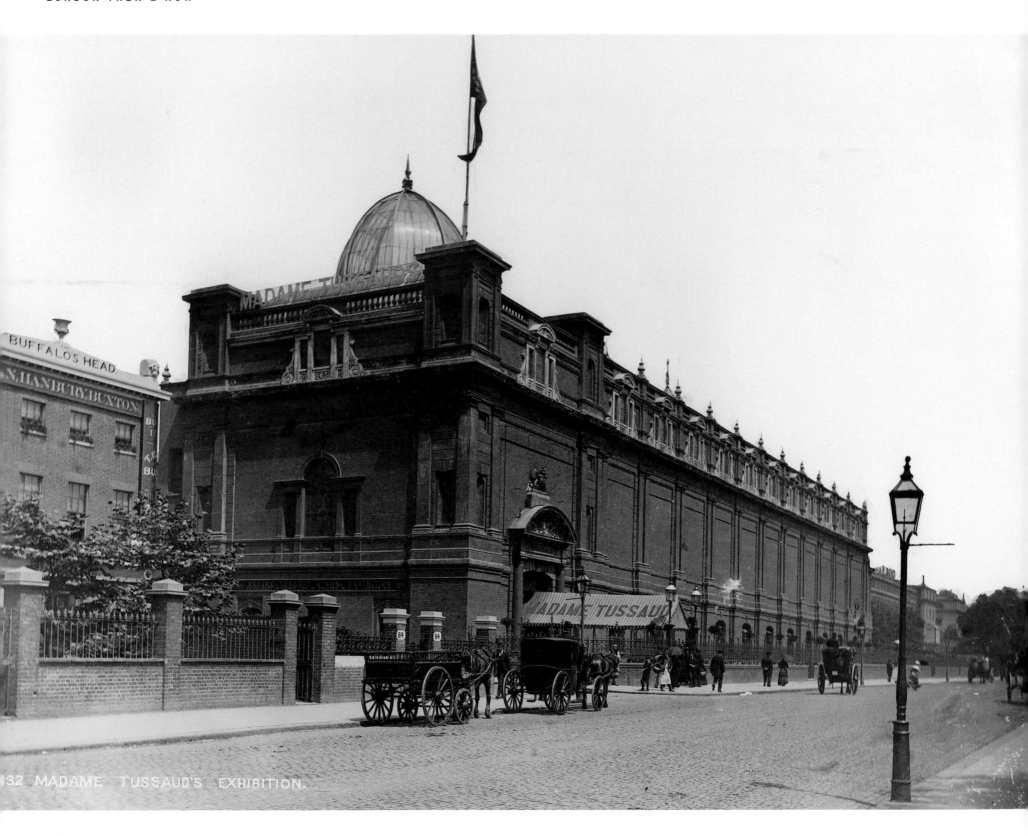

132 MADAME TUSSAUD'S EXHIBITION.

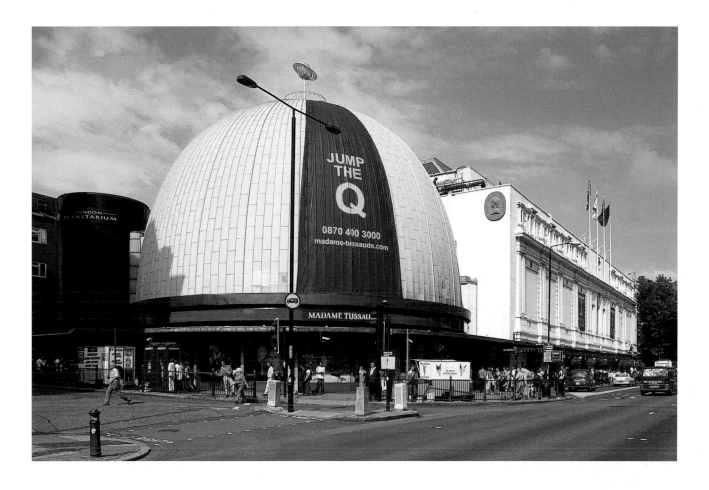

MADAME TUSSAUD'S

Home to the Chamber of Horrors

Left: This picture shows Madame Tussaud's as it was prior to the 1925 fire that gutted the building. Madame Tussaud learned and refined her craft of creating waxworks by making wax death masks of aristocrats executed during the French Revolution. When she came to England in 1802, she displayed her waxworks temporarily at the Lyceum Theatre near the Strand. The present site on Marylebone Road was acquired in 1884. There were other waxwork displays in London, but Madame Tussaud's was always ahead of the game, exhibiting wax effigies of celebrities as well as monarchs and statesmen. As a bonus, Tussaud's had the Chamber of Horrors, which attracted notable visitors such as the Duke of Wellington.

Above: Rebuilt following the 1925 fire and damage sustained during World War II, Tussaud's remains one of London's top visitor attractions. The green dome in the forefront of the picture housed the London Planetarium, which opened in 1958. In 2006 the planetarium was renamed Tussaud's Stardome and it is now a celebrity themed venue available for hire. Today the staff at Tussaud's scans celebrity magazines such as *OK* and *Hello* to see who is in the news. Those who are currently on the way up will be immortalized in wax, while those whose fame is waning are melted down unceremoniously.

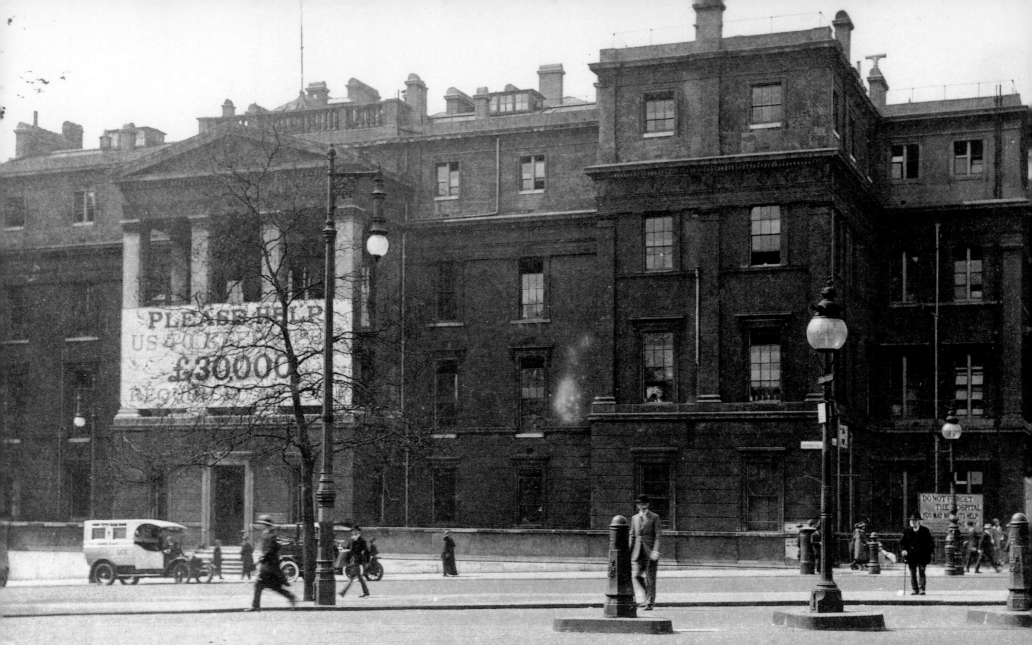

LONDON. St. George's Hospital, Hyde Park Corner. No. 1385.

ST. GEORGE'S HOSPITAL / LANESBOROUGH HOTEL

Designed by William Wilkins in 1827 on the site of Lanesborough House

St. George's Hospital c. 1920, Hyde Park Corner. The hospital was designed by William Wilkins in 1827 on the site of Lanesborough House. Once home to Viscount Lanesborough, the house was converted to hospital use in 1745. The healthy air of Knightsbridge, then a village just outside London, was thought to be beneficial for recuperation. The hospital's most famous surgeon was John Hunter, whose ideas about transplants and surgery were way ahead of their time.

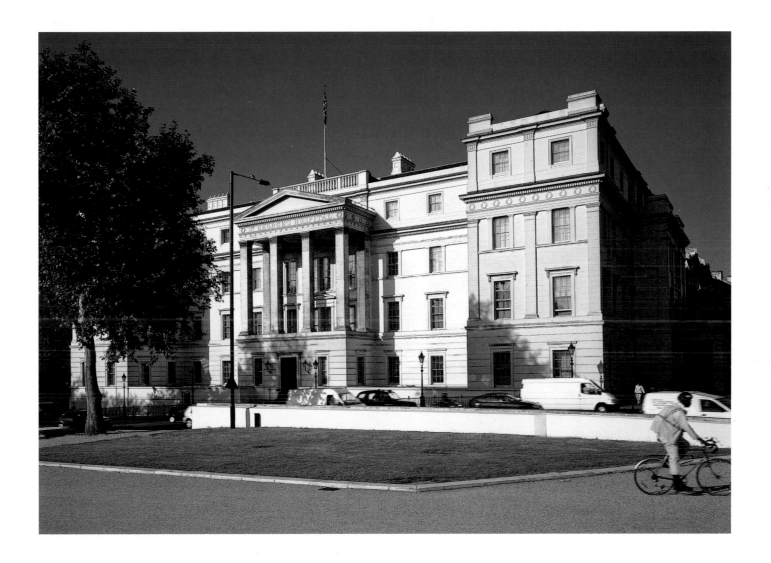

St. George's Hospital relocated to Tooting, South London, in 1980, and this building is now the luxury Lanesborough Hotel, one of the most exclusive in London. For £8,000 per night, guests can hire the Royal Suite complete with a butler to cater for their every whim. Madonna, Michael Jackson and other celebrities have taken advantage of the facilities. Today there is no need for signs outside the building appealing for financial help.

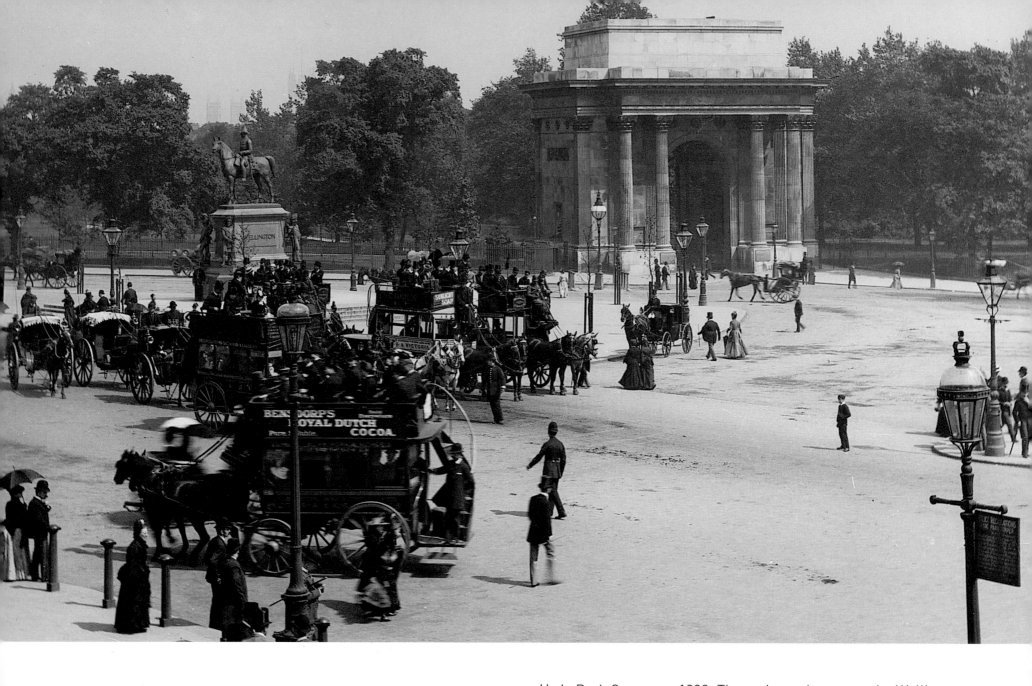

HYDE PARK CORNER

Showing the newly positioned Wellington Arch, c. 1890

Hyde Park Corner, c. 1890. The archway, known as the Wellington Arch, was originally erected next to Apsley House, the Duke of Wellington's London home, in 1828. When this picture was taken, the arch (sometimes referred to as Constitution Arch) had just been moved to its present position next to Constitution Hill, while the statue of the Duke of Wellington, which originally surmounted the arch, was removed to Aldershot. A different statue of the famous duke who defeated Napoleon at the Battle of Waterloo can be seen to the left. The trees on the right surround the private gardens of Buckingham Palace.

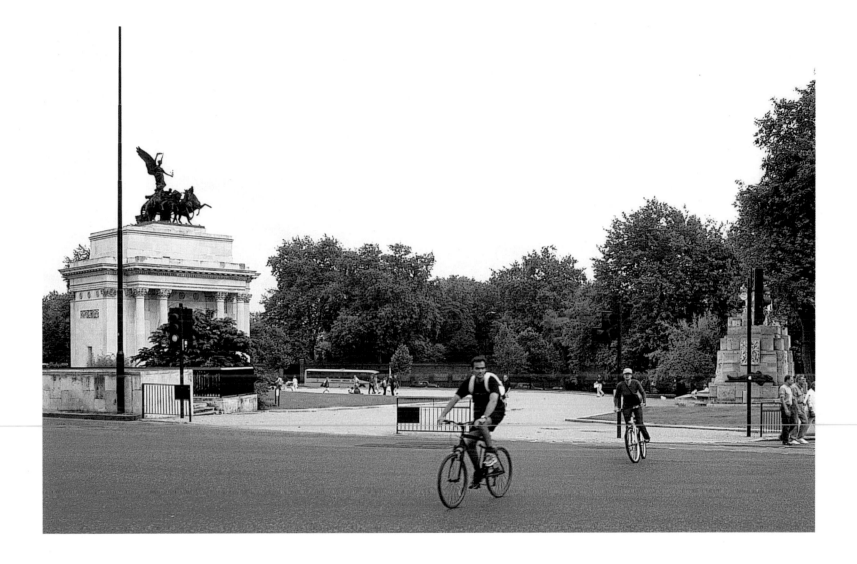

The Wellington Arch is now surmounted by a bronze quadriga designed by Adrian Jones in 1912. It represents the Angel of Peace descending on the chariot of war. At one time, the arch housed a small police station, but it has since been converted into a museum that tells the story of the arch's construction. From the top of the arch, you can look over the London rooftops and into the Queen's private gardens at Buckingham Palace.

SHEPHERD MARKET

Developed in the 1730s by the speculative builder, Edward Shepherd

Left: This photograph shows Shepherd Market in Mayfair in the 1940s. Mayfair was developed in the 1730s by the speculative builder Edward Shepherd. He created a delightful warren of streets and alleys behind Piccadilly with small shops selling provisions for the inhabitants of the grand Mayfair mansions. The streets were built on the fields where the annual May Fair was held before it was banned by Queen Anne for attracting rowdy crowds and prostitutes. Once the building was completed the crowds left, but the prostitutes remained. High-class courtesans, such as Kitty Fisher, who was the mistress of numerous aristocrats, had rooms here.

Above: Shepherd Market has retained its charm and surprises visitors wandering off the beaten track with its village atmosphere. In summer, the numerous cafés set their tables out on the street, and people can sit outside and enjoy the relaxed ambience. This is still an area for ladies of the night, but they operate very discreetly above the shops, and visitors will feel perfectly safe in this delightful corner of London.

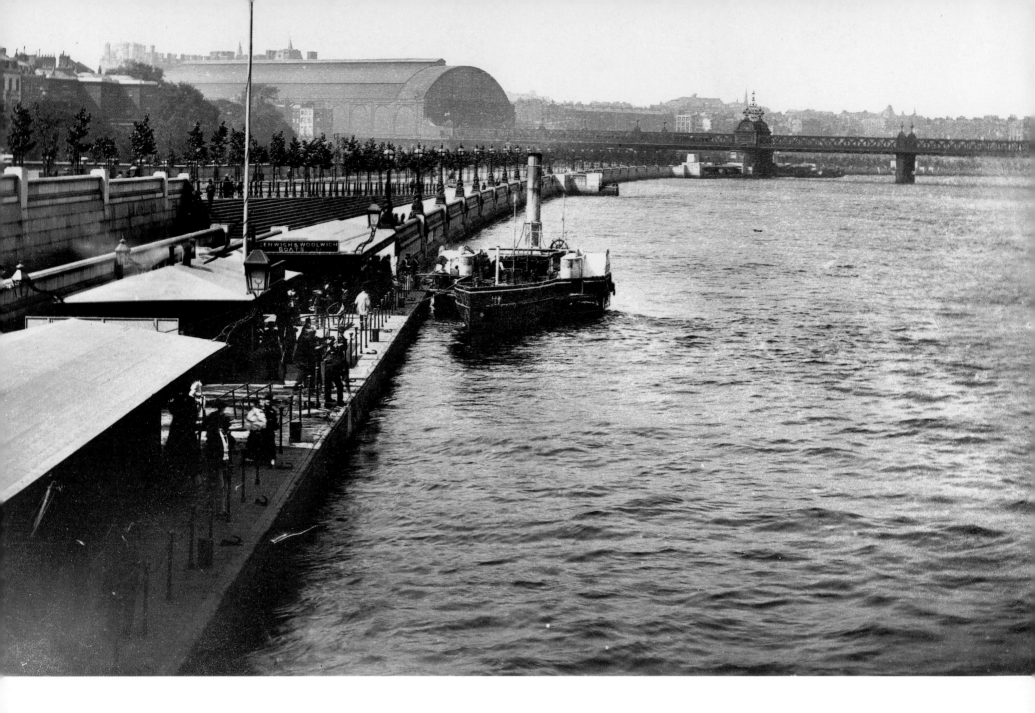

EMBANKMENT

Designed by Sir Joseph Bazalgette to cover London's sewer system

The Victoria Embankment was designed by Sir Joseph Bazalgette to cover London's new sewer system and completed in 1870. The Thames had been cleaned and pleasure trips from Westminster to Greenwich were popular. Here people are waiting by Westminster Pier for just such a trip. In the centre, the curved roof of Charing Cross Station can be seen before its collapse in 1905 and in the distance is the Hungerford Railway Bridge, erected by John Hawkins in 1864. The bridge carried the South Eastern Railway into Charing Cross Station.

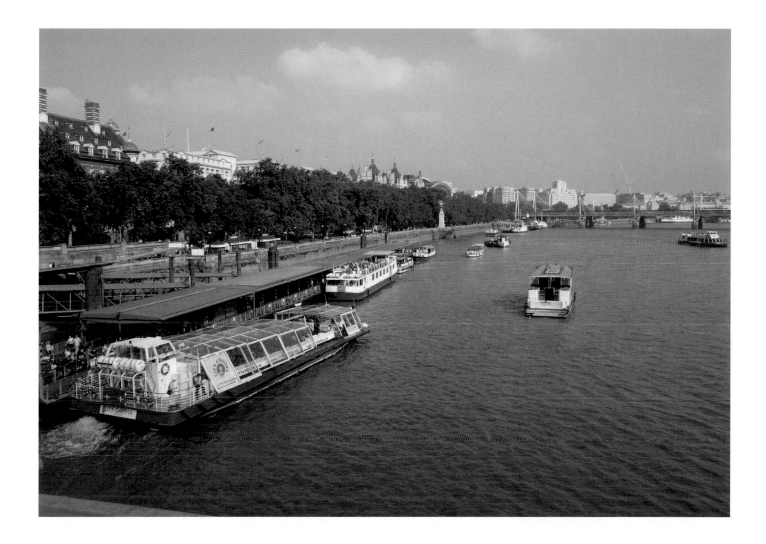

River trips to Greenwich are just as popular today, and boats such as the one in this photograph are a common sight on the river. In the foreground is the modern Westminster Pier, while in the distance, just above the trees, is the new curved roof of Terry Farrel's 1980s headquarters for PricewaterhouseCoopers, which rises over Charing Cross Station. The architectural firm Lifschutz Davidson recently remodelled the Hungerford Pedestrian Bridge, which echoes the design of a previous suspension bridge that was demolished due to the strong smell of the River Thames, prior to the creation of Bazalgette's sewer. In the centre, the eagle on a plinth is William Reid Dick's 1923 Royal Air Force memorial to RAF members who were killed in the two world wars.

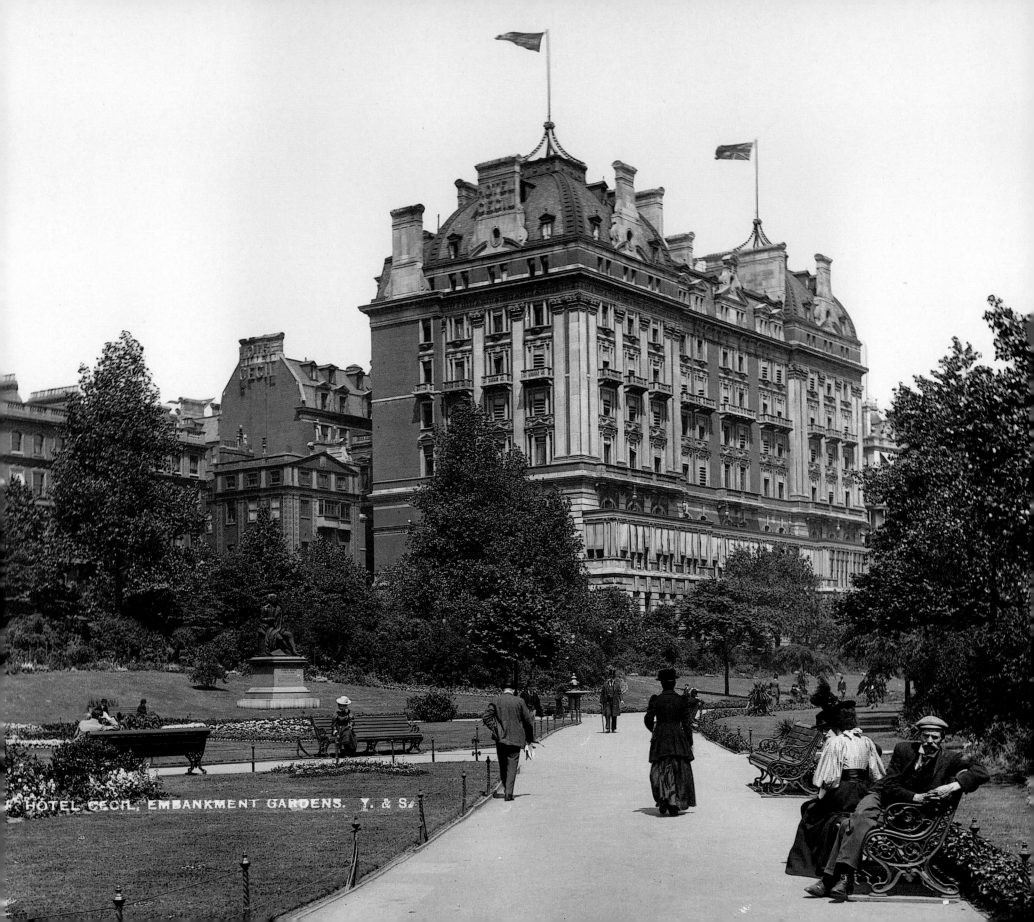

HOTEL CECIL, EMBANKMENT GARDENS. Y. & S.

EMBANKMENT GARDENS

A place for people to promenade by the unpolluted river

Left: When the Victoria Embankment was designed, gardens were included where people could promenade by the newly unpolluted river. Here they are shown in 1896. The impressive building that dominates this view is the Hotel Cecil, one of the grandest hotels in Europe in its day. To the left, a building known as the Adelphi – meaning "brothers" in Greek – was designed by the famous Scottish architects, the Adam Brothers. Past residents of the Adelphi Buildings, which directly overlooked the river before the creation of the gardens, included authors George Bernard Shaw and Thomas Hardy.

Above: Londoners still enjoy the Victoria Embankment Gardens on a summer's day. However, a massive rebuilding project in the 1930s led to the demise of the Hotel Cecil, which was replaced by Shell Mex House. The Adelphi Buildings were also replaced by a large Art Deco-style office block.

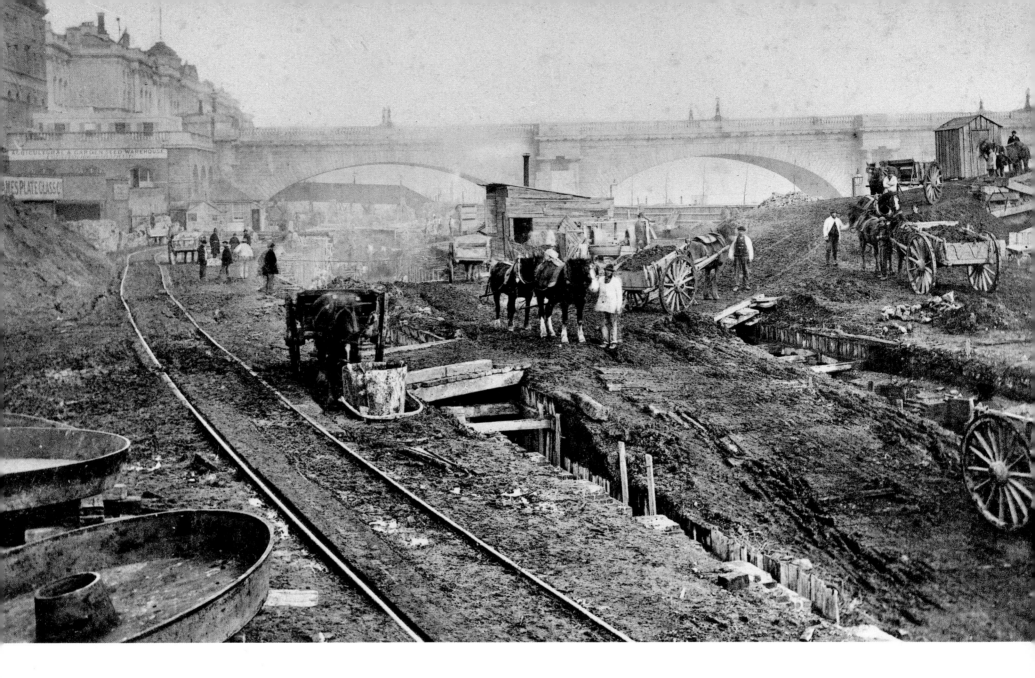

EMBANKMENT

Construction started in 1858 – the year of "the Great Stink"

The Victoria Embankment in construction between 1864 and 1870.
A riverside road linking Westminster and the City was proposed back in
the seventeenth century by Sir Christopher Wren, but nothing was
done until 1858. This was the year of "the Great Stink", when the
Thames smelled so bad that Members of Parliament could smell it
from the Palace of Westminster. Once Parliament was affected, action
was at last taken. Sir Joseph Bazalgette was appointed to build a
sewer, covered with a road and gardens, and to reclaim 37 acres of
land. The bridge in the distance is the 1817 Waterloo Bridge, renamed
after the Duke of Wellington's victorious battle.

The riverside road is shown here during a rare traffic-free moment.
It usually serves as a busy thoroughfare and has replaced the
River Thames as the main way of travelling between the City and
Westminster. Since the creation of the London Sewer, the Thames
has become so clean that the fish inhabiting the river can now be
eaten. Waterloo Bridge was rebuilt in 1942 with a team made up
mostly of women, while the men were away during World War II.

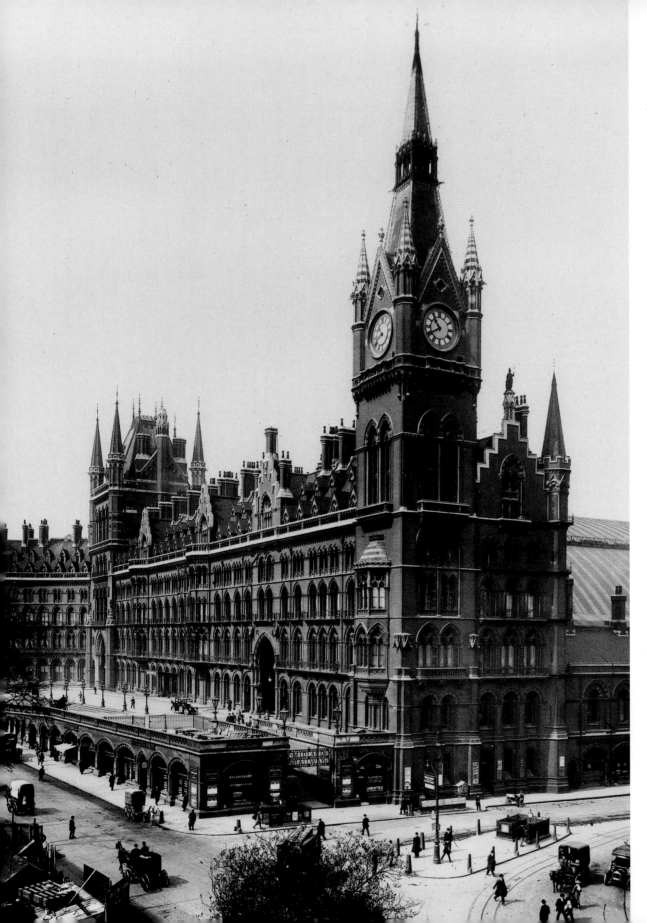

ST. PANCRAS

The Gothic Revival-style Midland Grand Hotel was built in 1872 by architect Sir George Gilbert Scott

This is not a grand church or cathedral, but in fact the Midland Grand Hotel, built next to St. Pancras Station in 1872 by architect Sir George Gilbert Scott in the Gothic Revival style. It had 250 bedrooms, a magnificent staircase, ascending rooms (early elevators) and the first ladies' smoking room, which caused quite a sensation. The hotel offered accommodation for people arriving in London via the Midland Railway, and business was good for a number of decades.

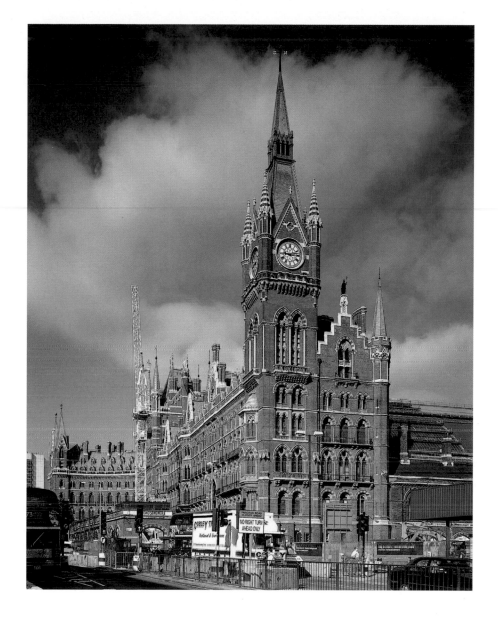

The number of guests declined in the 1920s, however, and the hotel was first converted to offices for the railway company and then remained vacant for many years. Its exterior was recently refurbished and work has started on the interior, restoring it to its former glory as a hotel to serve passengers arriving in the area via the Channel Tunnel rail link. The grand staircase has been used for films, fashion shoots and music videos.

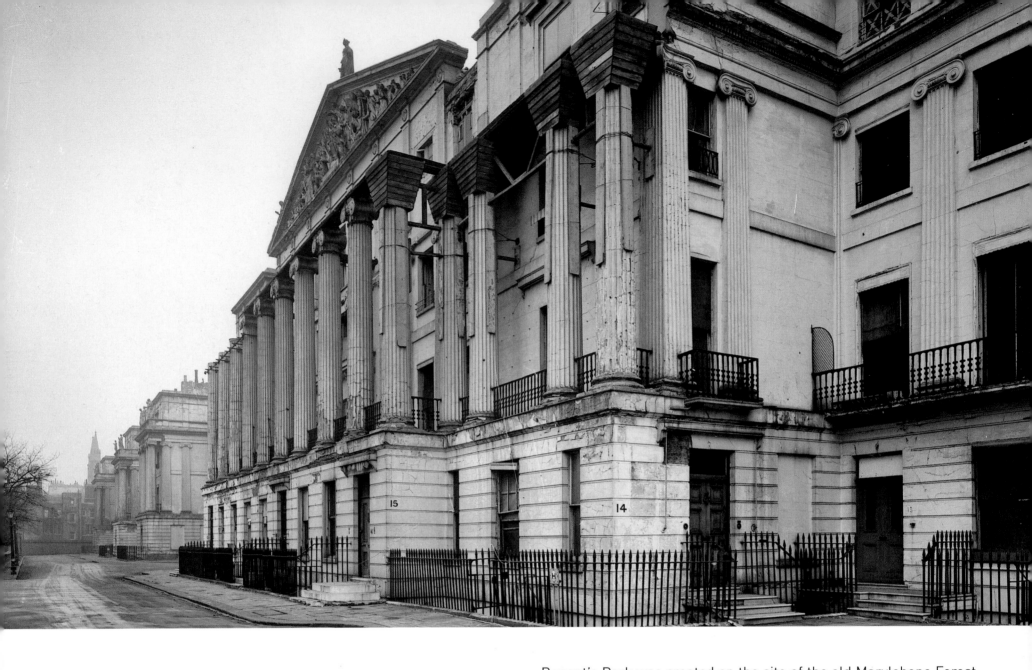

CUMBERLAND TERRACE

Created by James Thomson and completed in 1826

Regent's Park was created on the site of the old Marylebone Forest, one of King Henry VIII's hunting grounds, by John Nash, who was architect to the Prince Regent. The prince planned to live in a palatial home in the park surrounded by grand villas and terraces. His palace was never built, but several villas were erected and the park was encircled with elegant terraces. Cumberland Terrace, seen here in the 1940s after wartime damage, was the grandest of all the terraces. It was created by James Thomson, who designed it according to Nash's grand scheme, and completed in 1826. The pediment, designed by George Bubb, was carved with figures representing Britannia, the arts, sciences and trades.

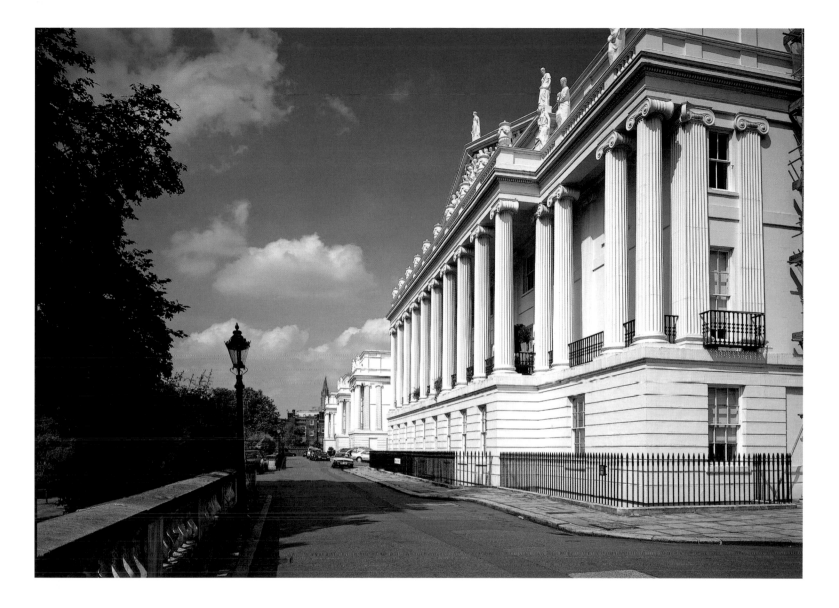

After World War II, there was talk of demolishing the terraces, but fortunately it was decided to preserve them. The facade of Cumberland Terrace was restored to its former glory and some of the houses were converted to flats. The terrace was originally designed to face the prince's palace, which was never built.

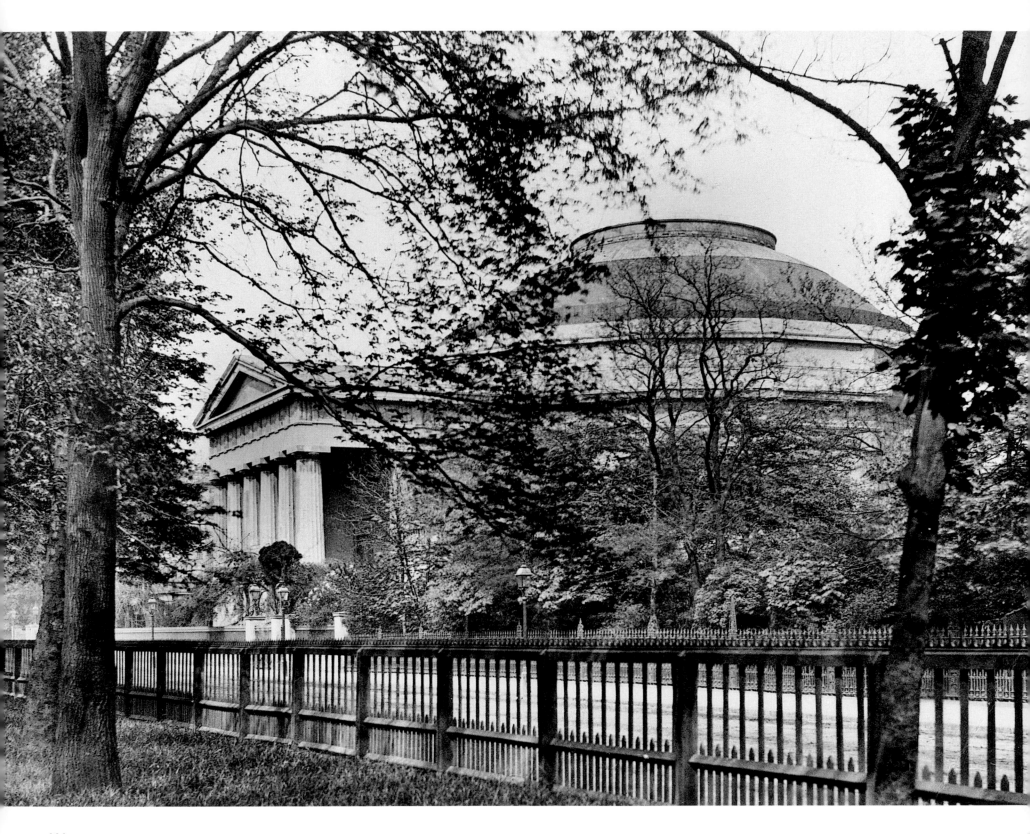

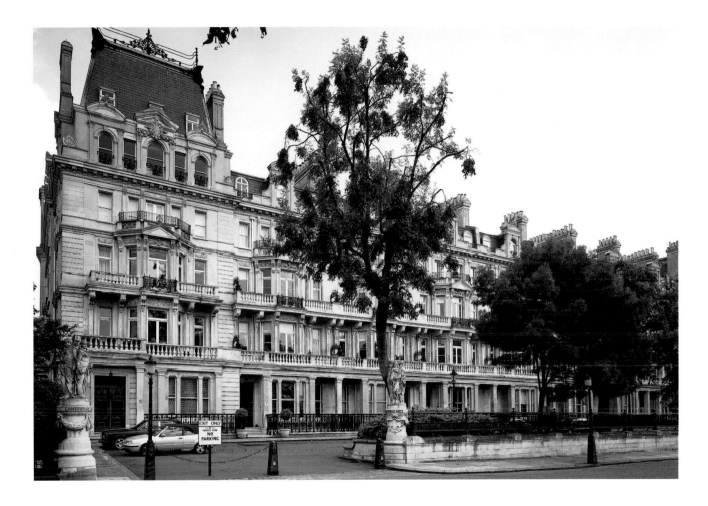

COLISEUM / CAMBRIDGE GATE

Built by architect Decimus Burton, who also designed the Wellington Arch

Left: The Coliseum, seen here before its demolition in 1875, was built by architect Decimus Burton, who also designed the Wellington Arch. It was erected in 1827 to house a panorama of London created by Thomas Horner, who made 2,000 drawings of London from the dome of St. Paul's Cathedral, and the young artist E. T. Parris, who used the drawings to create the panorama. After surveying the panorama in pictorial form, visitors could climb to the roof of the building and enjoy the real thing.

Above: Sadly, the panorama did not capture the public's imagination and the Coliseum was adapted for other uses, including housing concerts and becoming a museum of sculpture and a Gothic aviary. Today Cambridge Gate, a terrace of houses, stands on the site. The late Victorian architecture presents a contrast to the Regency stucco of Nash's terraces.

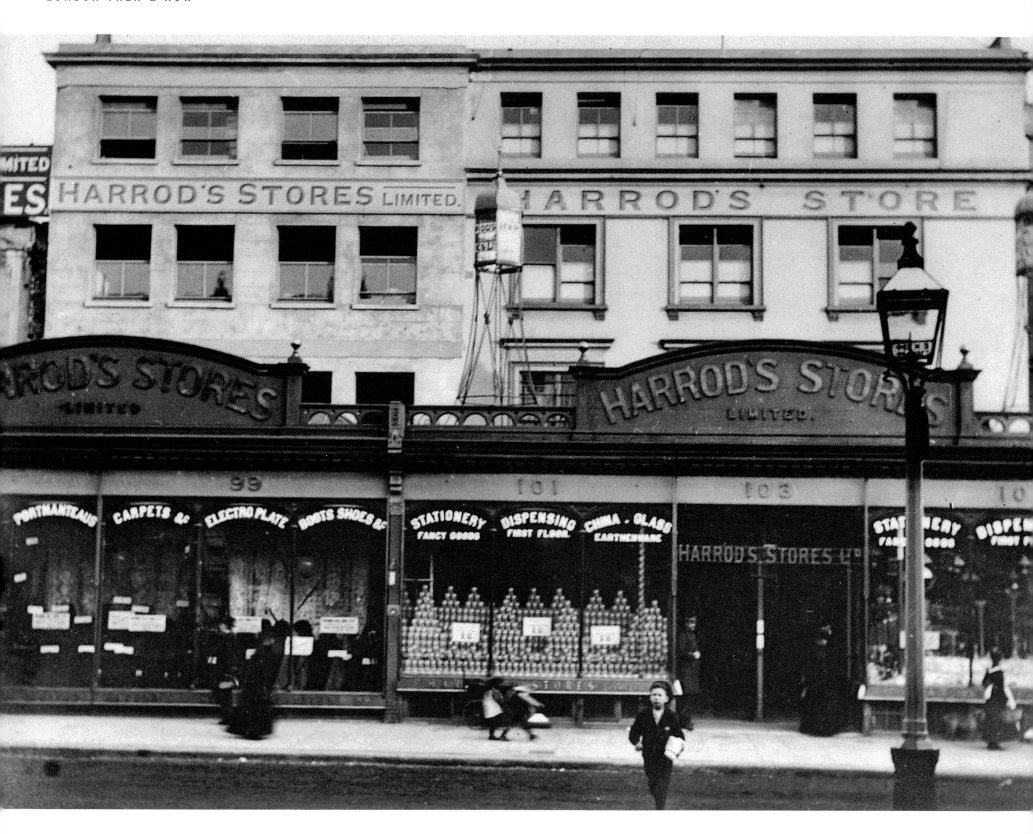

HARRODS

Henry Charles Harrod opened his first grocery business in the East End of London

Left: Harrod's Stores, Knightsbridge, c. 1890. Henry Charles Harrod opened his first grocery business in the East End. As he prospered he moved to the City and finally to Knightsbridge, which was a village when he initially arrived there in 1849. The Great Exhibition of 1851, held in Hyde Park, turned nearby Knightsbridge into a fashionable area and Harrod's son, Charles Digby, expanded the business, buying up adjoining buildings. In 1874, the lettering "Harrod's Stores" went up for the first time. In Christmas 1883, disaster struck when the building burned down, but in spite of this setback, all the Christmas orders were delivered on time and the store's reputation was established. By 1884, the store had been rebuilt as shown here.

Right: Harrods was rebuilt again in 1905 with its famous terra-cotta frontage and tiled food hall. In 1913, the store received a Royal Warrant from Queen Mary, wife of King George V, and patronage by other royals followed. A network of tunnels linked the store with a dispatch area in Trevor Square, which is now converted into apartments.

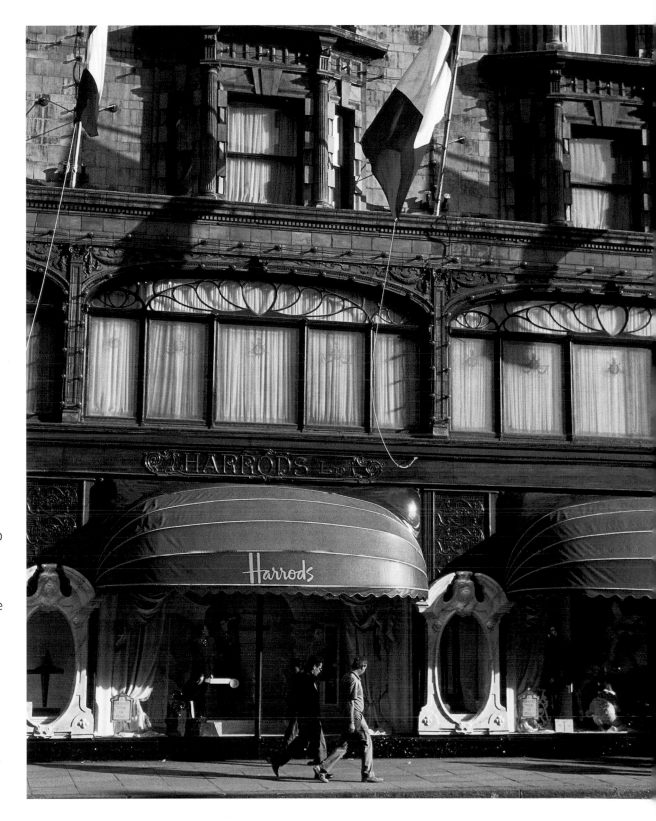

THE GREAT SYNAGOGUE / FOURNIER STREET MOSQUE

A building that represents the changing face of the East End

London is a cosmopolitan city and Spitalfields in East London has long been an arrival point for immigrant groups. This building represents the changing face of the East End. Built in 1743 as the Neuve Eglise, the new church for French Huguenot immigrants escaping persecution, it later became a Wesleyan chapel. This picture, taken in the 1940s, shows the building when it was a synagogue for the Jewish community that had arrived more recently from Eastern Europe.

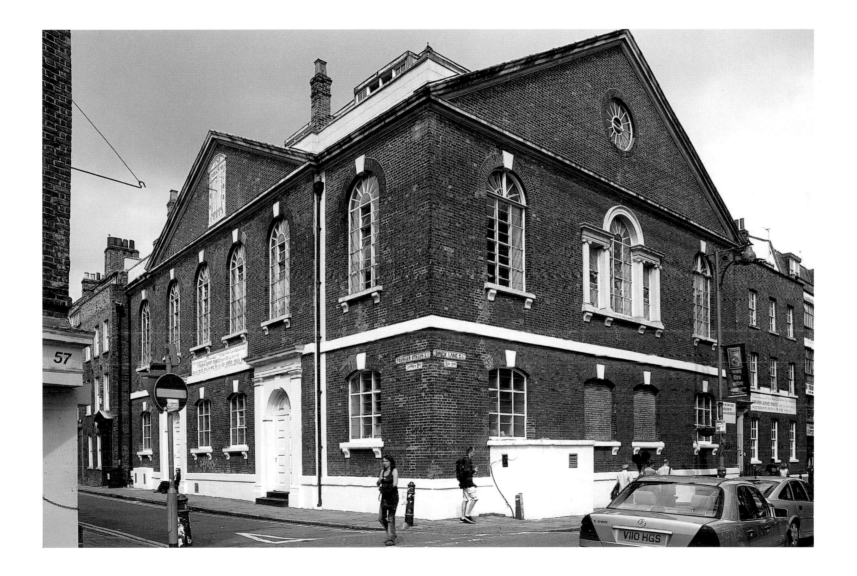

As London's Jewish community became more prosperous, its members moved out to the north and east London suburbs. During the 1970s, a new group of immigrants from Bangladesh arrived in Spitalfields and the old French church is now a mosque. The surrounding shops, once occupied by Jewish tailors, are now restaurants offering Bangladeshi cuisine.

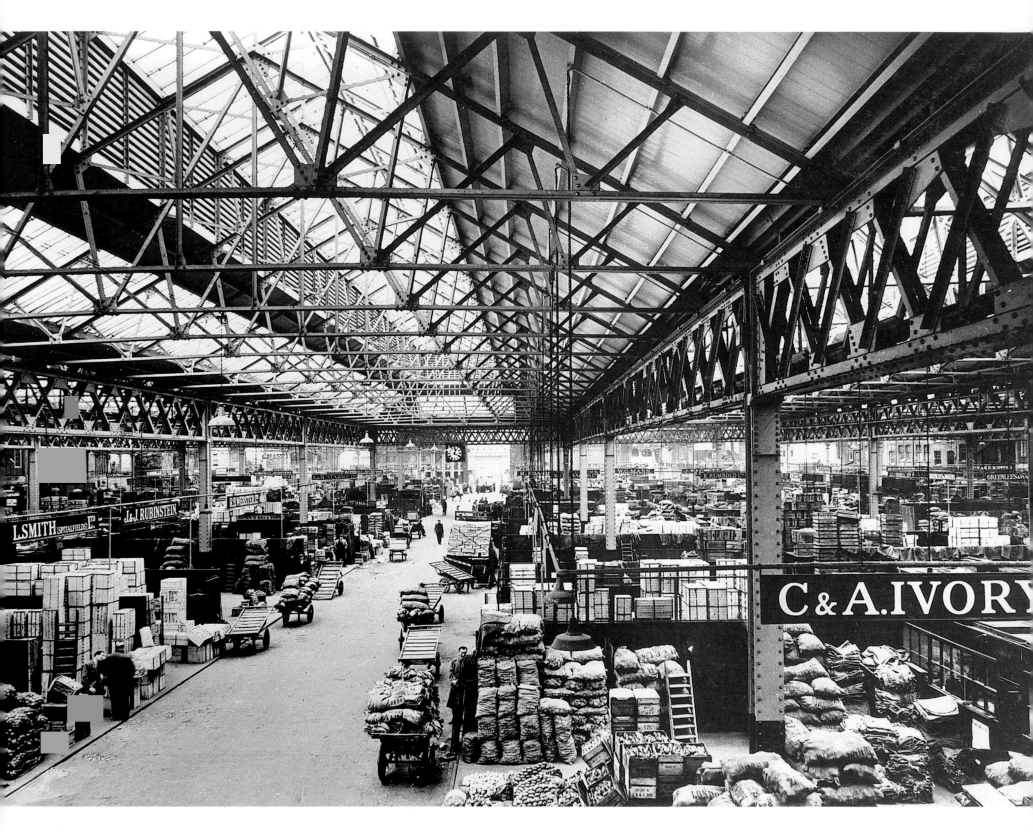

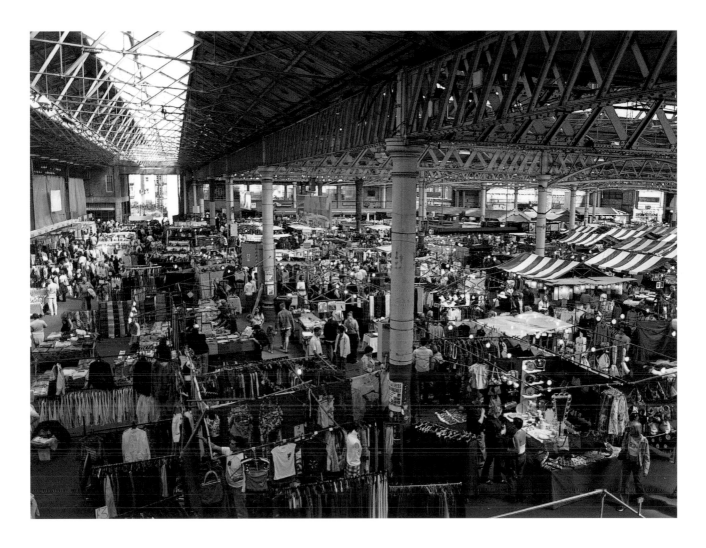

SPITALFIELDS MARKET

East London's answer to Covent Garden

Left: Taken in 1954, this photograph shows the Spitalfields fruit and vegetable market, one of London's many wholesale markets, and East London's answer to Covent Garden. The market was given its charter in 1682 by King Charles II and got new buildings in the 1880s, thanks to an endowment from Robert Horner, who rose from humble market porter to market benefactor. Up until 1991, the surrounding Spitalfields streets were filled with the banter of the market porters and dealers.

Above: When the fruit and vegetable market was relocated to Leyton in 1991, the old market building enjoyed a new lease of life. Every Sunday, Londoners flock to Spitalfields to purchase crafts, new and vintage clothes, CDs, used books and organic produce. At the time of writing, part of the market site was under threat of demolition to make way for an office development, but Robert Horner's listed 1880s buildings will stay.

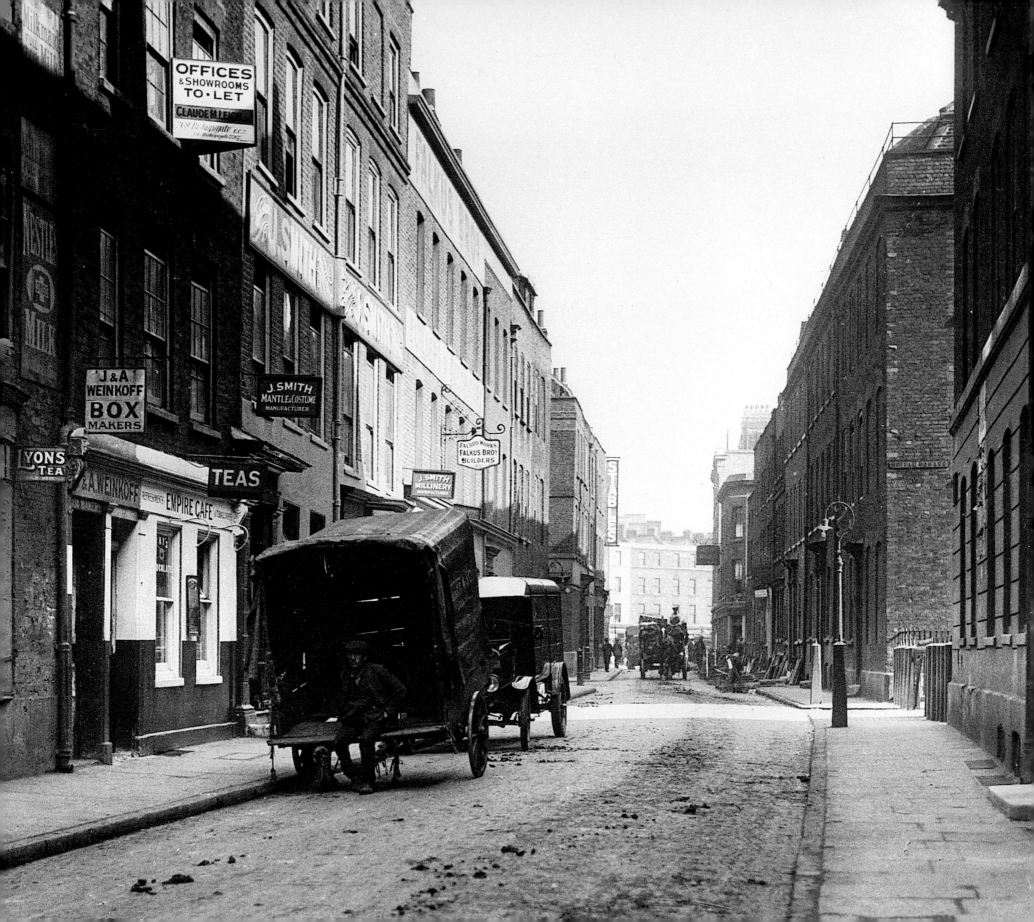

FOLGATE STREET

Most of these buildings were erected in the 1720s as homes for Huguenot weavers

Left: Horses and carts make their way along Folgate Street, Spitalfields, to the nearby market; the street is lined with a variety of businesses from milliners to box makers. Most of these buildings were erected in the 1720s as homes for Huguenot weavers, but were adapted for commercial use. This photograph dates from the early 1900s.

Above: Today the weavers' former houses have been restored to their eighteenth-century appearance and have become homes once again. Buildings that were damaged in World War II have been rebuilt to fit in with the original Georgian buildings. The house on the right with the red shutters was purchased in the 1970s by the late Denis Severs, who restored it to its original appearance, re-creating the atmosphere of a Huguenot weavers' dwelling. On special open days, visitors are welcomed to the house, where they are asked to leave their preconceptions behind, step into the past and soak up the atmosphere.

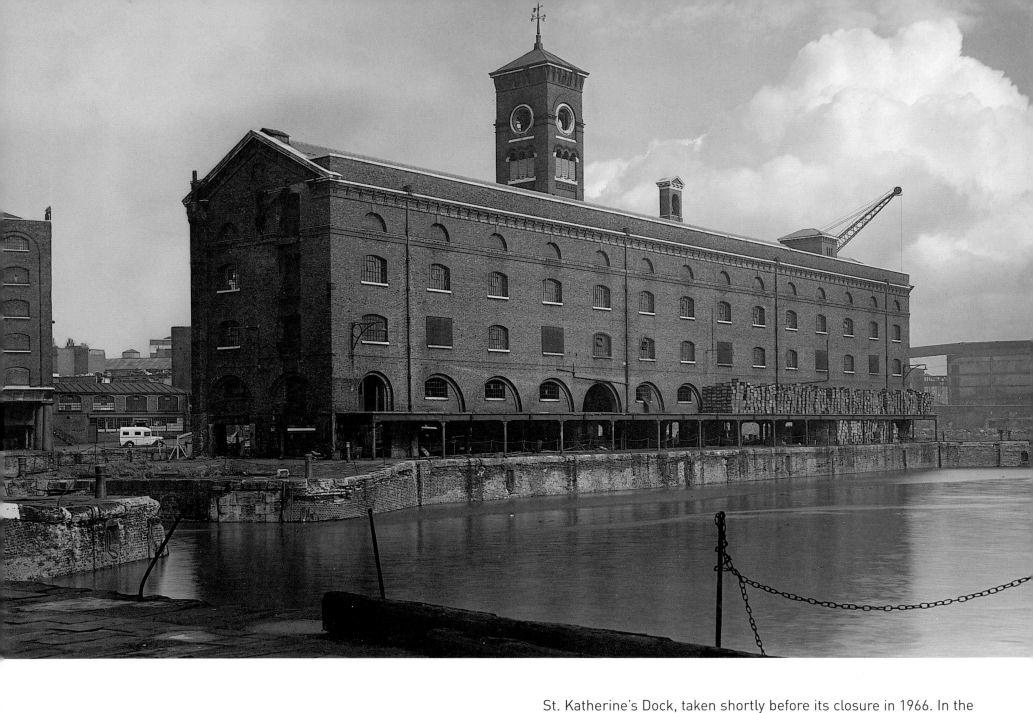

ST. KATHERINE'S DOCK

Photographed shortly before its closure in 1966

St. Katherine's Dock, taken shortly before its closure in 1966. In the early 1800s, a system of wet docks was created in East London to prevent the theft of goods from ships anchored in the centre of the River Thames. Opened in 1828, St. Katherine's was the smallest of the docks and was the centre of the ivory trade. By the late nineteenth century, however, it was too small for the large steamships of that period. In 1940, the dock was heavily bombed, and many of the warehouses were destroyed. The Italianate building seen here, the architect Thomas Aitchison's ivory warehouse, was one of the few survivors.

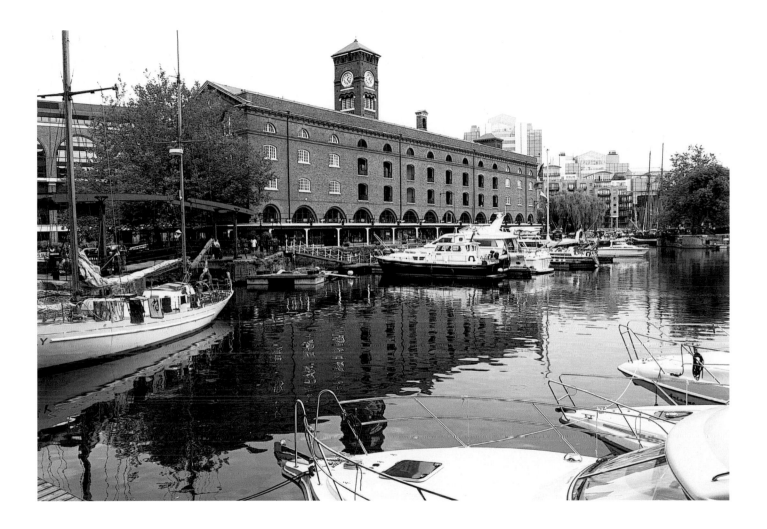

St. Katherine's Dock closed in 1966 and was redeveloped five years later to offer a hotel, offices, shops and a marina. Its location, just to the east of the Tower of London and Tower Bridge, attracts many visitors who come to enjoy this pleasant waterside setting. The old dock basins are used for the mooring of yachts, cabin cruisers and historic ships. The ivory warehouse has now been converted to apartments and retail units.

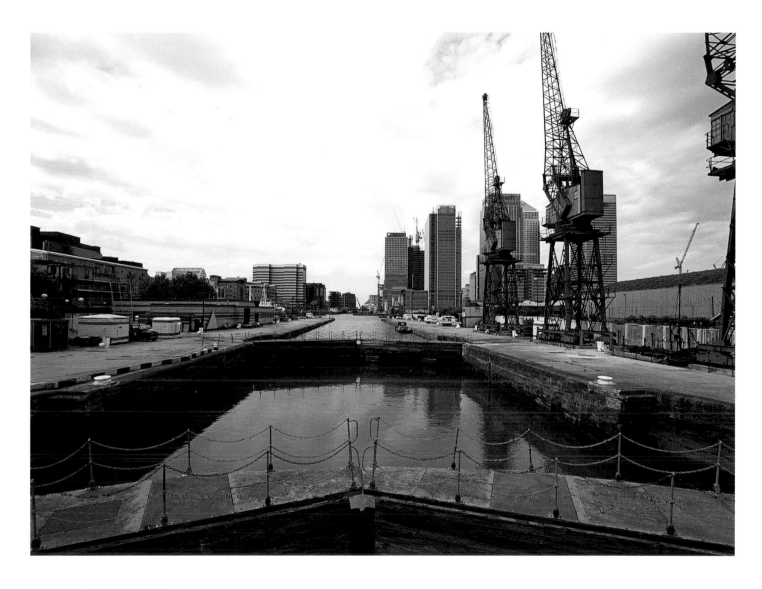

WEST INDIA DOCK

Opened in 1802, the dock was dug and built by manpower alone

Left: A nineteenth-century view of the West India Dock, which opened in 1802 and was dug and built by manpower alone. On the left, a line of warehouses stored sugar and rum imported from the West Indies. Much larger than St. Katherine's Dock, the West India Dock was a great success. Merchants discharged goods in a matter of days instead of weeks, and incidents of theft were minimized.

Above: Closed in 1980, the West India Dock is now the home of a new waterside city. On the right, towering skyscrapers house banks, insurance companies, newspapers and publishing companies. The old dockside cranes have been retained as a reminder of the past, when they were used to haul heavy loads from the ships entering the dock.

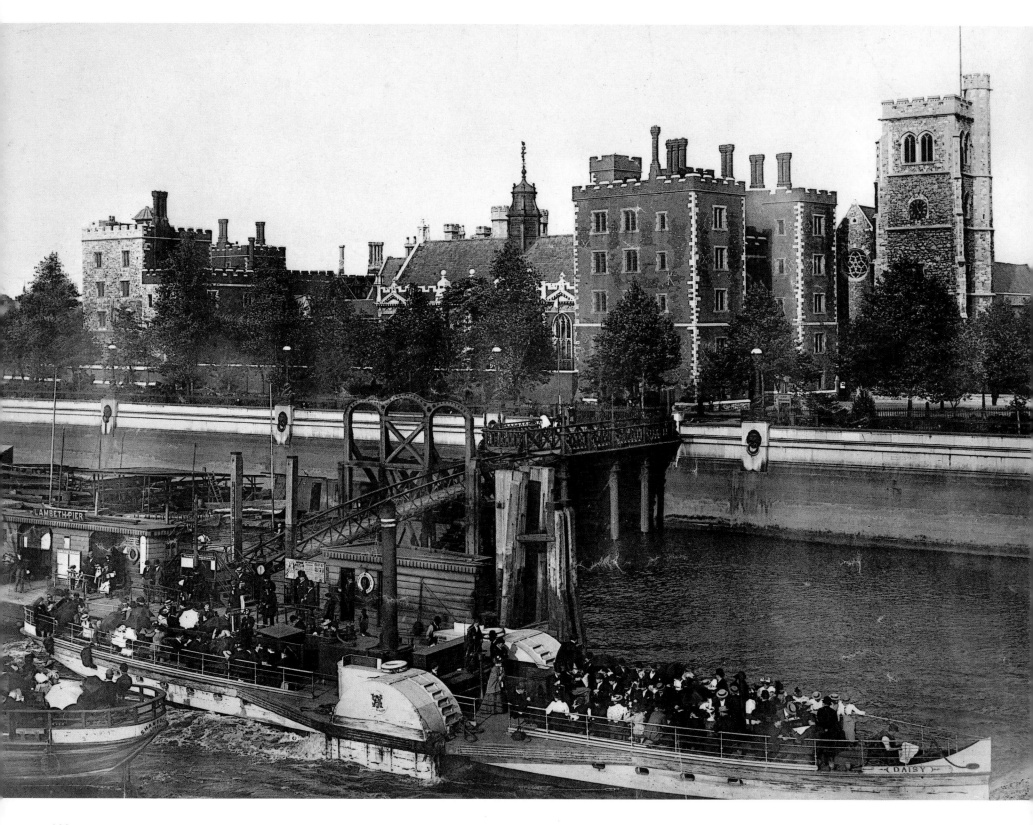

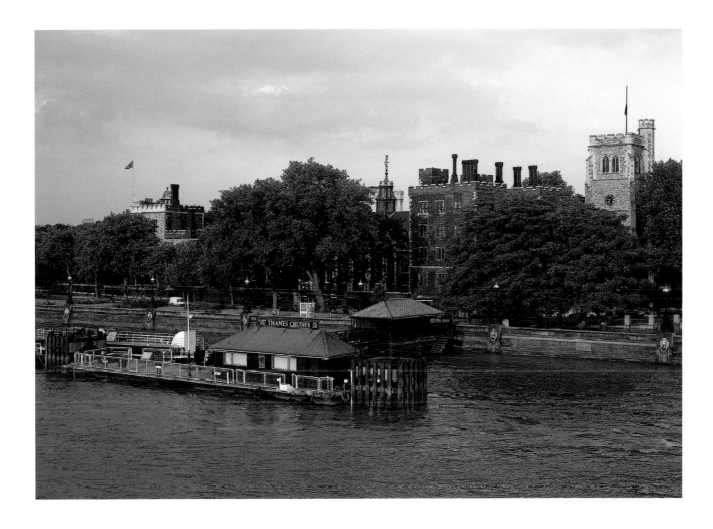

LAMBETH PALACE

The riverside home of the Archbishop of Canterbury

Left: Lambeth Palace, the riverside home of the Archbishop of Canterbury, as it appeared from the Thames around 1885. There has been a manor house here since the twelfth century. Lambeth House was extended over the years, and the palace we see today includes a thirteenth-century chapel, a fifteenth-century water tower and a Tudor gatehouse. Much of the palace was rebuilt in 1828 and the Great Hall was converted to a library. The tower on the right of the picture is St. Mary's Parish Church, where Captain Bligh of *Mutiny on the Bounty* fame is buried.

Above: Today the Archbishop of Canterbury continues to maintain a London home here on the south side of the river opposite the Houses of Parliament (where the Archbishop sits as a member of the House of Lords). St. Mary's ceased to be a parish church in the 1970s and, after years of dereliction, was converted into the Museum of Garden History.

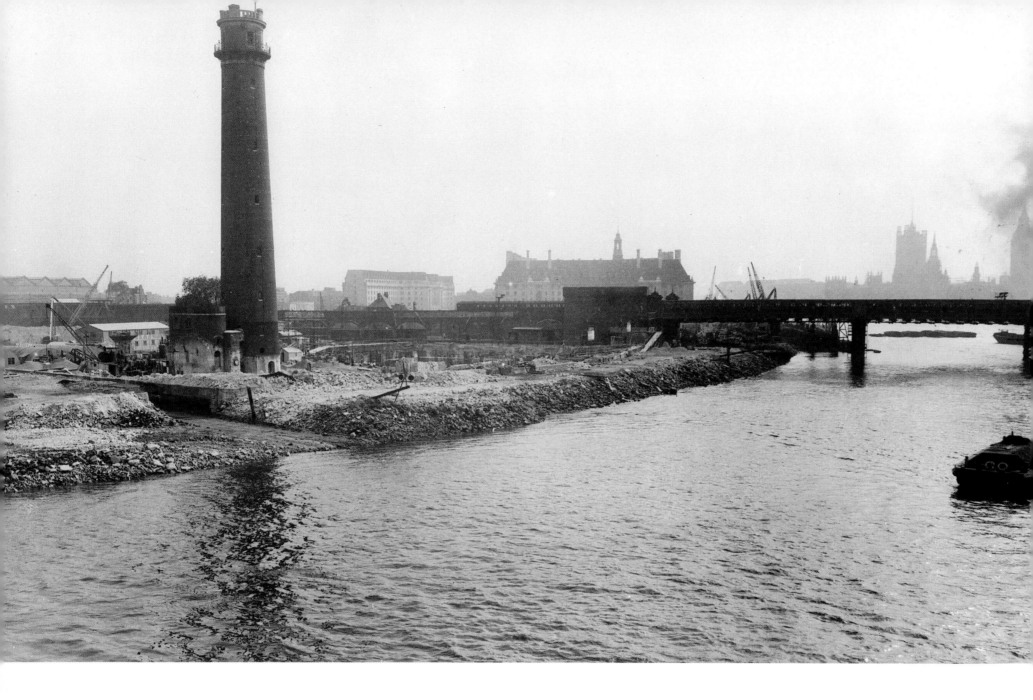

SOUTH BANK / ROYAL FESTIVAL HALL

The old Lion Brewery was demolished to make way for the Royal Festival Hall

The South Bank Festival of Britain site in 1950. After five years of post-war austerity, the government decided to hold the Festival of Britain Exhibition to promote the arts and manufacturing, echoing the Great Exhibition of 1851. An industrial site on the South Bank was chosen and buildings such as the old Lion Brewery were demolished to make way for the Royal Festival Hall, the Dome of Discovery and the Skylon obelisk. This picture was taken just before work began. The shot tower, part of the previous industrial landscape, was left and used as part of the exhibition.

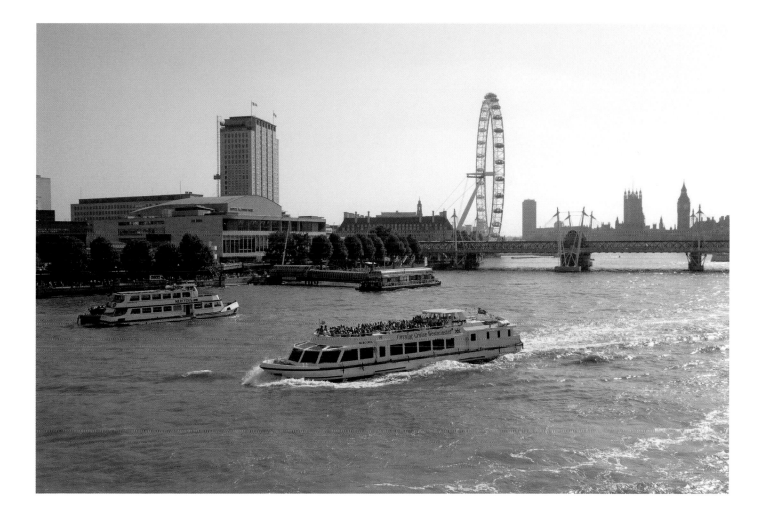

Although the Festival of Britain was very successful, all buildings and structures erected for this event were demolished afterwards, with the exception of the Royal Festival Hall, which is shown on the left. The venue now plays host to dance and musical performances from classical to contemporary styles. To the right, the redesigned Hungerford Pedestrian Bridge can be seen. The scene is dominated by the British Airway's London Eye, the big wheel that was erected to celebrate the millennium.

Taken around 1906, this photograph shows an industrial landscape with warehouses and factories, such as the premises of food manufacturers Crosse and Blackwell, and an inlet for barges with tall sails. This mostly riverside area was rural until the late eighteenth century, but once it became industrial, it was a stark contrast with the opulent Palace of Westminster on the opposite bank of the Thames.

SOUTH BANK BETWEEN WESTMINSTER AND HUNGERFORD BRIDGE

This mostly riverside area was rural until the late eighteenth century

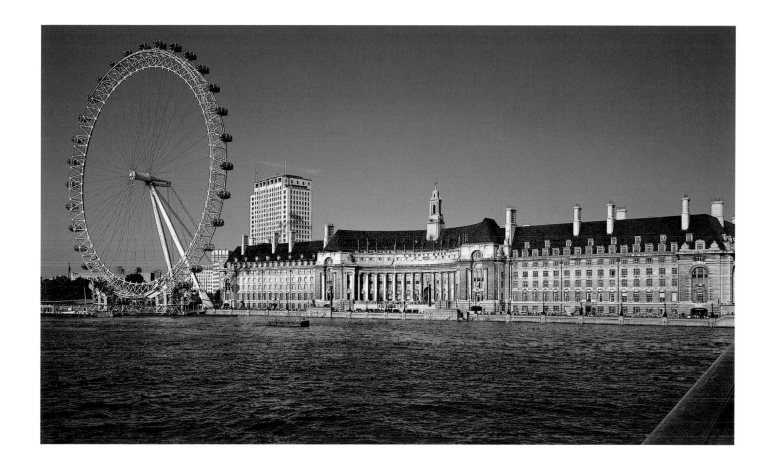

In 1922, the scene changed entirely with the building of County Hall, the new headquarters for London's local government, the London County Council. When the London County Council's successor, the Greater London Council, was abolished by Margaret Thatcher in 1986, the future of the building looked uncertain. However, it has now been transformed into luxury apartments, two hotels, an art gallery, an aquarium and the ticket office for the London Eye. Designed by David Marks and Julia Barfield, the London Eye is 135 meters (443 feet) high and takes 30 minutes to rotate 32 enclosed capsules that can hold 25 people each. Those who take a "flight" on the wheel are able to enjoy a bird's-eye view of London and its suburbs.

This photograph shows the Bankside, Southwark, and was taken in 1946. On the right are the chimneys of the old Bankside Power Station, and in the centre, the terraced houses of Cardinal's Wharf, possibly named after Cardinal Wolsey who was once Bishop of Winchester. (The bishops of Winchester had a palace nearby from the twelfth to the early seventeenth centuries.) The warehouses to the left indicate Bankside's industrial past.

SOUTH BANK / THE GLOBE AND TATE MODERN

The warehouses to the left indicate Bankside's industrial past

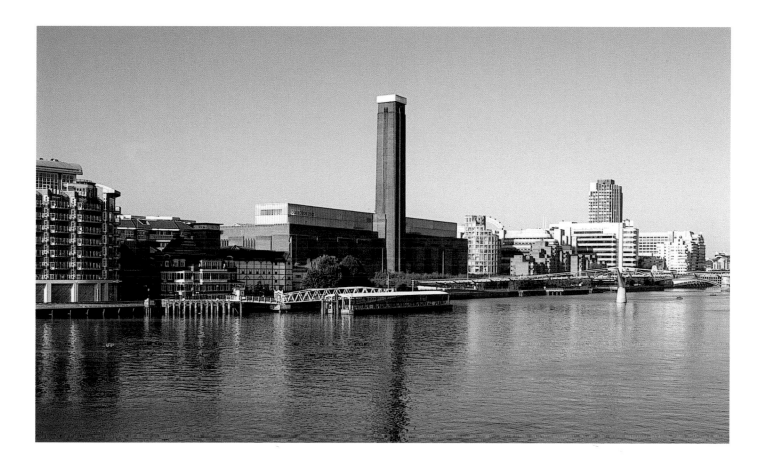

Before industry was developed at Bankside, this was London's
theatreland. The original Globe Theatre was built here in 1599.
At this theatre, most of Shakespeare's plays were performed,
sometimes by the great playwright himself. In 1997, at the instigation
of American actor Sam Wannamaker, the Globe was reconstructed.
The theatre mounts a season of plays by Shakespeare and his
contemporaries each summer and an educational programme
throughout the year. The tall chimney on the right belongs to the
rebuilt Bankside Power Station, which was decommissioned in 1981.
It now houses Tate Modern, a gallery of modern international art.
Cardinal's Wharf stands between the Globe and Tate Modern, and is
the site of houses that have survived the area's change in character.

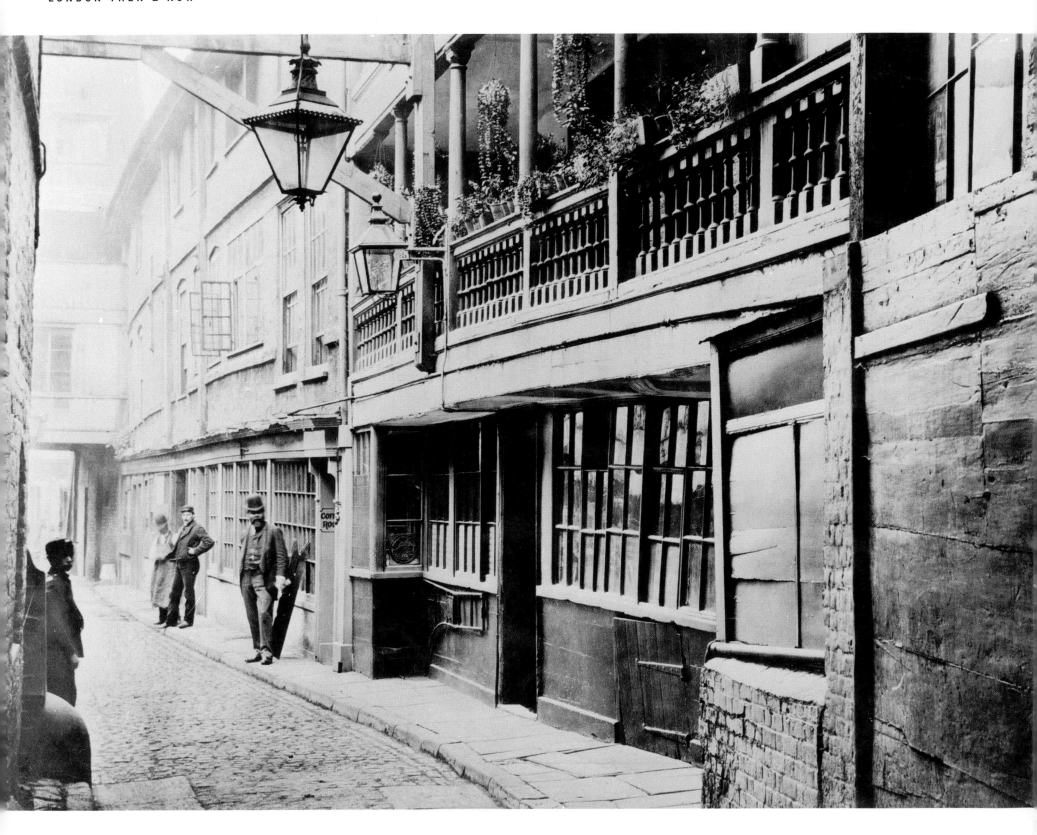

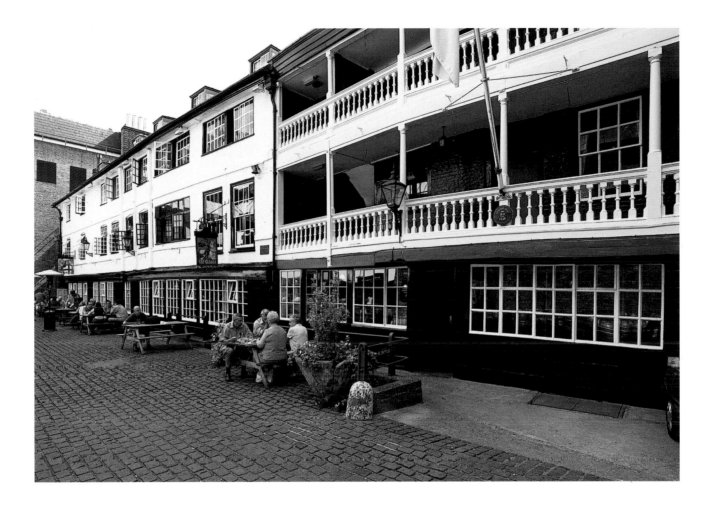

GEORGE INN

The George Inn is London's only remaining galleried coaching inn

Left: Seen here around 1896, the George Inn is London's only remaining galleried coaching inn. On the pilgrim's route to see Thomas Becket's tomb in Canterbury, medieval Borough High Street was lined with coaching inns, including the Tabard, where Chaucer's fictional pilgrims stayed. Groups of strolling players performed in the inn's courtyards and the galleried design inspired the builders of London's Elizabethan theatres, which lined nearby Bankside. The original George Inn was destroyed by fire and rebuilt in 1676.

Above: Part of the 1676 George Inn has been preserved intact and is now in the custody of the National Trust. The original inn was much larger, but in 1899 part of the building, including the old stabling for horses, was purchased by the railway company that operated near London Bridge Station. Today the George is a popular pub with visitors from the nearby Globe Theatre.

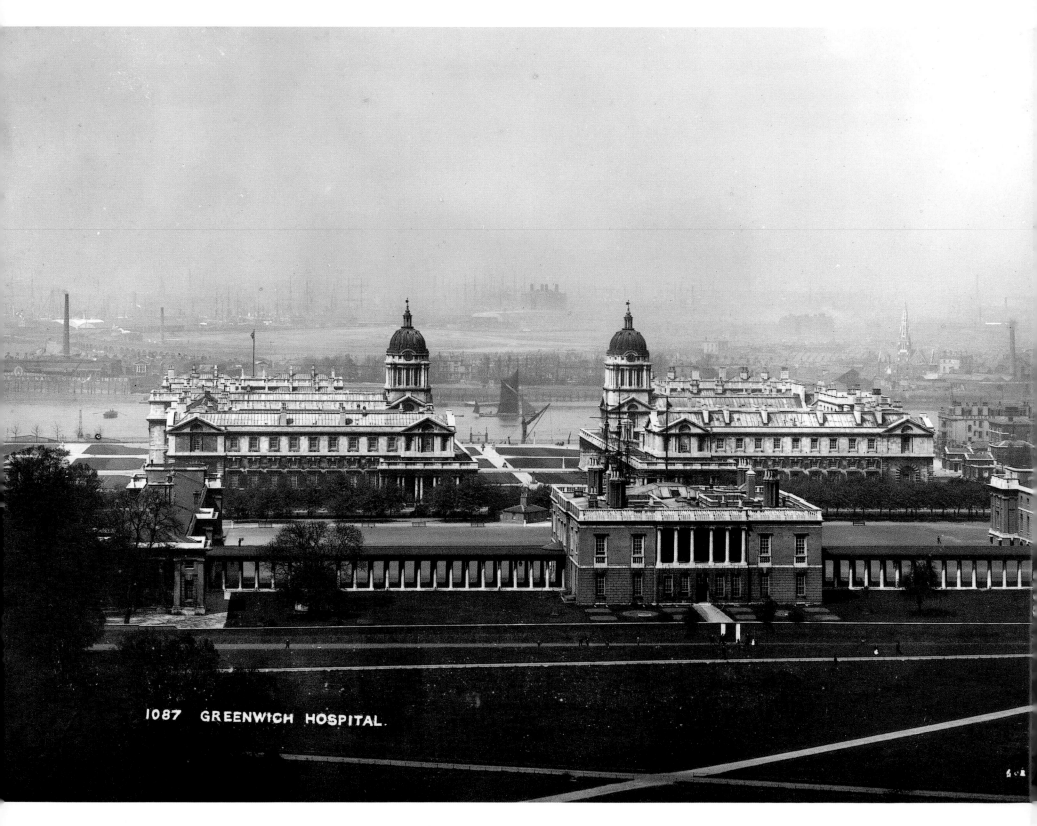

1087 GREENWICH HOSPITAL.

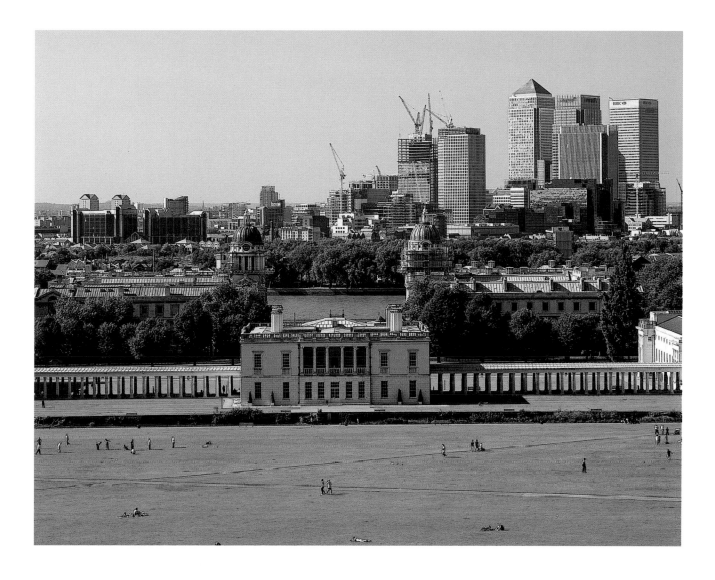

GREENWICH

The hospital was built by Sir Christopher Wren in 1695 as a home for retired sailors

Left: The Old Royal Naval Hospital and the River Thames from the Royal Observatory, Greenwich. The hospital was built in 1695 as a home for retired sailors by Sir Christopher Wren on the site of King Henry VII's Palace of Placentia. When the sailors left, it became a naval college for the training of officers. The college boasts a painted hall and chapel. The white building in the forefront of the picture is the Queen's House, built in 1916 by Inigo Jones for Queen Anne of Denmark, wife of King James I. In the distance, tall masts of ships can be seen on the Thames and in the West India and Millwall docks.

Above: Although little has changed in Greenwich itself, the view across the river has altered dramatically and the tall towers of the Canary Wharf commercial area dominate the docks. The naval officers have left Greenwich, and the Old Royal Naval Hospital is now the home of Greenwich University and the Trinity College of Music. The public can visit the beautiful painted hall and chapel, which have been used as locations for many movies, including *Quills*, *The Madness of King George* and *Four Weddings and a Funeral*.

CHURCH ROW, HAMPSTEAD

The churchyard contains the graves of John Constable, Sir Herbert Beerbohm and George Du Maurier

Hampstead was once a hilltop village four miles north of London. In the late seventeenth century a chalybeate spring was discovered with water that was said to have healing powers. Hampstead developed as a fashionable spa and some of the people who came for their health decided to stay. This photograph shows Church Row, an early eighteenth-century terrace of four-story houses. The church that gives the road its name was built in 1745, and the churchyard contains graves of artist John Constable, John Harrison, inventor of the marine chronometer, actors Sir Herbert Beerbohm Tree and Anton Walbrook, and author George Du Maurier to name just a few.

Today Church Row has hardly changed. The gas lamp in the foreground has been retained to add atmosphere, but the white weatherboarded house on the right has lost its sign advertising the services of a registered plumber. Hampstead can no longer be regarded as a village outside London, but it does retain its village atmosphere. Hampstead is still home to many famous artists and writers. Recent residents have included Martin Amis, Doris Lessing and Lucien Freud.

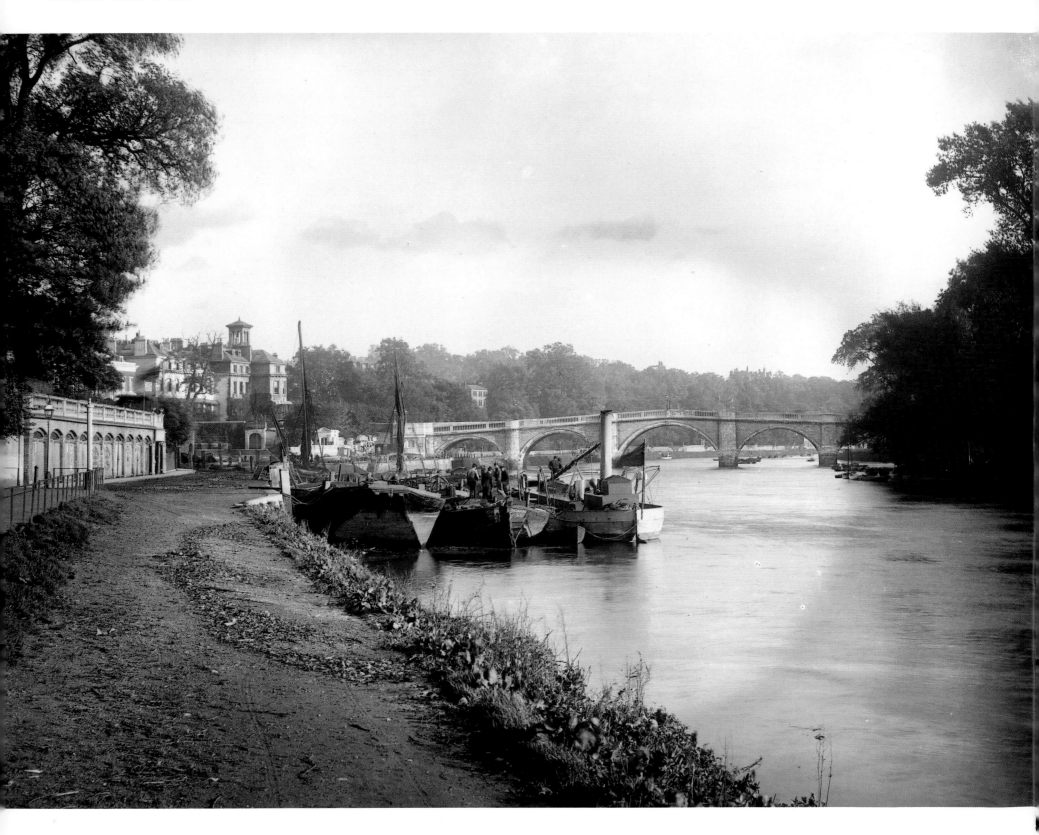

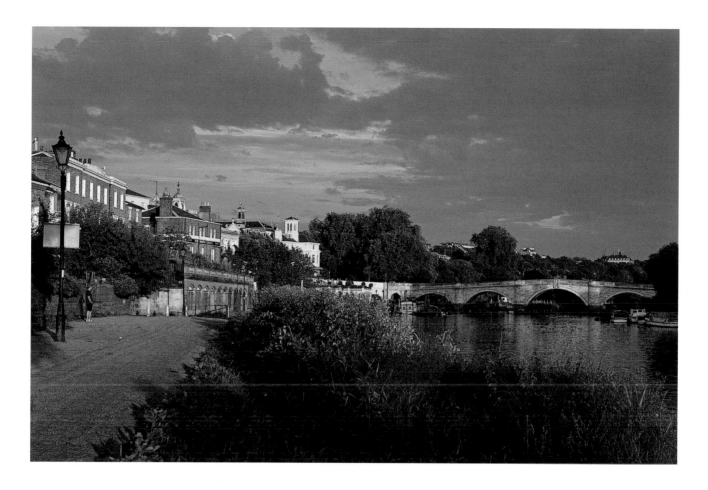

RICHMOND BRIDGE

Now the oldest surviving Thames bridge, dating to 1777

Left: Richmond Bridge, seen here in 1890, was not the first bridge across the Thames, but as other bridges have been rebuilt, it is now the oldest surviving one, dating to 1777. Richmond was a delightful Thames-side village to the west of London. A simple manor house nearby was transformed to a palace by King Henry VII, and the area became extremely fashionable. By the time this picture was taken, the palace had been demolished, but pleasure seekers came by boat from central London to admire the grand houses and the riverside walkway. To the left we see St. Helena's Terrace, built shortly after Napoleon's exile to St. Helena, and in the distance is the turret of one of Richmond's many hotels, built to accommodate the many visitors to the area.

Above: Today the scene is the same but with fewer boats. In the 1980s the riverside terrace on the left, including the Victorian buildings, was refurbished as offices and restaurants by Quinlan Terry. Unlike most modern architects, Terry believes in preserving the character of exisling buildings when adapting for new use. High on Richmond Hill, the Star and Garter Home is visible in the distance. It was built in 1924 for disabled servicemen.